How to Use Flickr™

The Digital Photography Revolution

Richard Giles

THOMSON

COURSE TECHNOLOGY ™

Professional ■ Technical ■ Reference

A DIVISION OF COURSE TECHNOLOGY

Publisher and General Manager, Thomson Course Technology PTR: Stacy L. Hiquet

Associate Director of Marketing: Sarah O'Donnell

Manager of Editorial Services: Heather Talbot

Marketing Manager: Heather Hurley

Acquisitions Editor: Megan Belanger

Marketing Coordinator: Jordan Casey

Project Editor: Dan Foster, Scribe Tribe

Technical Reviewer: Bryan Partington

PTR Editorial Services Coordinator: Elizabeth Furbish

Interior Layout Tech: Jill Flores

Cover Designer: Mike Tanamachi

Indexer: Sharon Hilgenberg

Proofreader: Brad Crawford

ISBN: 1-59863-137-3

Library of Congress Catalog Card Number: 2006920358

Printed in the United States of America

06 07 08 09 10 PH 10 9 8 7 6 5 4 3 2 1

THOMSON

COURSE TECHNOLOGY

Professional ■ Technical ■ Reference

Thomson Course Technology PTR, a division of Thomson Learning Inc.
25 Thomson Place
Boston, MA 02210
www.courseptr.com

To my dad: the strongest man I've known,
and a true inspiration.

Acknowledgments

Whenever I pick up a book, I love to read the acknowledgments. I think it's a little narcissism, because I'm usually hoping to see someone I know among the thanks. So writing this gives me great pleasure to mention the wonderful people who helped put this book together, which is not a simple task.

I'd like to thank Course Technology, including everyone I worked with and all those behind the scenes. Megan Belanger had enough faith in my idea and foresight to understand what a great application Flickr is. Countless times she discussed my ideas and fielded my questions.

Dan Foster, the project's editor, knew exactly the right amount of space I needed to finish the book, but without his editing I have no doubt I would have embarrassed myself.

The book's technical editor, a respected Flickr member called Striatic, helped by straightening out my facts. He went beyond the call of duty, providing me with background on Flickr's early days and offering amazingly sound advice.

I would also love to thank everyone at Studio B for their help in spreading my passion for Flickr. Without Neil Salkind's advice and hard work I wouldn't have started the proposal. He guided me from the concept to the final product.

Special thanks goes to Kirk McElhearn. I coauthored a previous work with Kirk, and he continued providing sage advice long after we finished it. He selflessly became my mentor, and he has helped me in numerous ways.

Hats off to the team at Flickr. They've created such a wonderful application and community that it was a pleasure to spend three months immersed in its world. Caterina Fake and Stewart Butterfield were also kind enough to spend time talking with me via phone, e-mail, and instant messages. Their genius, and a few words of advice, made this book a better read.

My family waited patiently and offered me much support. For several months I holed up in my home office and neglected Kilee and Mia. Fortunately for me, they loved me enough to be patient and waited until I surfaced. For that, and so much more, I love you both with all my heart.

Finally, but most importantly, I'd like to thank everyone in the Flickr community. Everyone, including you, make Flickr rich with fun and passion. It is the community that inspired me to write this book, and I look forward to many more years of inspiration.

About the Author

Richard Giles has been in the technology industry for more than 15 years. He started his career in the early nineties with the largest cell phone provider in the UK, and he was one of the first to demonstrate that thieves could steal people's phone numbers to make free phone calls. When he returned to Australia in 1992, Richard discovered the Internet and worked with organizations to build intranets and extranets before most knew what a Net was. After working for Sun Microsystems for almost 10 years, Richard set up his own consultancy, Clique Communications, to focus on authoring, consulting, and entrepreneurship.

Richard now specializes in online social software, like Flickr, weblogging, and podcasting. He consults with many organizations, explaining the ramifications of technology on society and business. He also produces The Gadget Show podcast (http://gadget.thepodcastnetwork.com), which was voted Best Australian Podcast in The 2006 Australian Blog Awards.

Contents

Chapter 5 Do More with Your Photos 73

Introduction

There isn't a single reason that you might want to read this book; there are several reasons. Although Flickr seems to be a simple application for anyone who wants to store, sort, search, and securely share their photographic collection, it's a little more complex, and a lot deeper.

One of this book's goals is to ensure that it is appropriate for all levels of expertise. This book caters to those people wishing to use the basics of the service, including uploading and storing photographs, and it also provides instructions on organizing and printing. This book is a resource for anyone, from amateur to professional, wishing to share photographs with family, friends, and even the world.

That's where Flickr excels. Flickr has created hundreds of communities that anyone can join. If you enjoy photography—anything from simple snapshots to professional portraits—then this book will help you get involved with other like-minded people at every corner of the world. In any way you can imagine for using a camera, you'll find people doing it and sharing the results in Flickr. You'll also find a bunch of ways you would never have imagined.

This book also offers a firsthand look at how the Internet is creating new ways for people to communicate. The planet has morphed, and technology is enabling everyone to communicate and share in ways we've never experienced before. Flickr is a great example of how nurturing a community can inspire not only a useful application, but also wonderful art and meaningful relationships via technology.

This book explores the culture of Flickr. It contains interviews with Flickr members and staff, who share their thoughts and favorite photographs. There are also some interesting stories and anecdotes that have occurred in Flickr's two-year history, including some fascinating stories about how Flickr has enriched or changed people's lives.

Although it is a how-to manual, which aims to introduce you to almost every facet of using the service, this book is also an exploration of a community that is bursting from Web browsers around the world.

How This Book Is Organized

This book is written such that you can read from cover to cover, going step-by-step from a new member to an expert on Flickr and its community. However, it also allows you to jump straight to an individual chapter if you would like to skip any content. For example, if you've already created a Flickr account, you might prefer to skip Chapter 2, although it does offer some useful advice about creating your profile.

The first part of the book presents the basics of Flickr. It's necessary to cover most of the features so you can become familiar with using the service. Chapters 1 through 3 provide details for everything you need to create and set up an account and begin uploading your photographs.

Chapters 4 and 5 cover the more advanced features of Flickr—the more useful functions once you're beyond just uploading your photographs. These chapters take you from utilizing print services to organizing your collection. They really set you up with the knowledge to begin using Flickr in earnest. You will eventually use the features discussed in these chapters on a daily basis to make your photo collection worthwhile.

Having laid the foundation, the book then truly starts to explore Flickr's community. Chapters 6 and 7 provide everything you need to know to become more involved, from inviting family and friends to making new contacts and starting groups.

Finally, Chapters 8 through 10 investigate Flickr's openness. By intention, the people at Flickr have made sure that many different aspects of Flickr can be explored by third parties. These chapters provide resources for finding out the latest news about photography and Flickr, and they also show you the many ways in which you can make use of photographs in some wonderful ways.

This book's chapters are laid out according to the way you would likely discover how to use Flickr if you were to begin exploring the service unguided.

Chapter 1, "Introducing Flickr," spends time setting the scene. You'll learn what has happened on the Internet in just over a decade. Then you'll learn how Flickr was created, and I'll share a look at the fantastic team that helped the community blossom.

Chapter 2, "Getting Started," provides the details required to create an account and to log in to Flickr. It explores how to create your Flickr identity, Web address, and buddy icon. You'll also learn the difference between a free and a Pro Account.

Chapter 3, "Uploading Photographs," introduces a range of different ways to upload photographs to Flickr, including a built-in Flickr tool and the ability to e-mail photographs to the service. This chapter also introduces the most popular range of third-party Flickr-friendly applications for your computer.

Chapter 4, "Organizing Photos," provides details on the variety of methods that Flickr provides for sorting your photographs, including titles, descriptions, notes, and tags. It then outlines the method for a comprehensive search through your collection. Also explored in this chapter is the Organizr tool that allows more complex management and information about sets. I'll also explain how Flickr uses EXIF and IPTC information.

Chapter 5, "Do More with Your Photos," teaches you how to use Flickr's printing services and delves into other third-party applications that allow you to print anything from stamps to books. If you'd like to do more with your photographs, such as creating real-world items that make great gifts, this chapter will guide you through the process.

Chapter 6, "You and Your Friends," explains how to invite people to use Flickr and how to add them to your contacts. It also takes a look at groups, a great way to encourage sharing and interaction with family, friends, or like-minded members. This chapter also delves into the use of your profile as a way to discover other people, and to make contact with them using the FlickrMail feature.

Chapter 7, "Joining the Community," introduces you to Flickr's social aspect. Tags, hot tags, and most popular tags make for interesting and exciting ways to explore Flickr. Because tags are added by millions of members, some interesting results are produced, such as related tags, clusters, and interestingness. Comments, notes, and favorites are also described to further enhance your social connection. I'll then take some time out to explore some of Flickr's interesting groups, such as "transparent screens" and "cream of the crop." Also of note is the ability to license your photographs using the variations of Creative Commons.

Chapter 8, "Flickr Communications," provides information on communication features that are as varied as the community's photographs. You'll learn about some methods for keeping up to date with the latest news and hot topics by using features such as Flickr News and FlickrBlog. This chapter also covers forums, which provide everyone a chance to help others, as well as helpful resources like podcasts and weblogs. For the more information hungry, this chapter describes how to monitor photo feeds.

Chapter 9, "Flickr, Weblogs, and Camera Phones," expands the boundaries of the Flickr service to include other ways of publishing and capturing your photographs. This chapter explains how to use Flickr to publish your photographs to your weblog, and ways to decorate a weblog with badges and the Flickr Zeitgeist. I'll also describe several ways to upload to Flickr directly from a camera phone.

Chapter 10, "Third-Party Flickr Tools," finishes the book with a flourish of third-party applications that extend Flickr beyond belief. Working with a combination of several applications together allows you to display your photographs on satellite maps of the earth, graph your contacts, or play a memory game. The chapter describes several popular Flickr extensions, and how you can use them.

Additionally, throughout the book you'll find interviews and sidebars that explore interesting features and community quirks. It is my hope that these will provide a taste for the amazing ways that the Flickr community can enrich your life.

In the time it has taken you to read this introduction, several hundred photographs were uploaded to Flickr. An average of 5 photographs are uploaded every second, with up to 15 in busy periods. With new digital technology and camera phones, the world is exploding with content. Some have labeled our generation as the "digital decade" and the "content generation." And it's time for you to get involved.

That's why using Flickr makes sense—not only for storing your own collection of photographs, but also for sharing it with this new generation. This content sharing brings with it a range of benefits, several of which are explored in this book, and all of which add other dimensions to your photography.

I hope you find this book useful and an interesting read. I've certainly enjoyed my time exploring Flickr, and I hope to be an active member for many years to come. So, when you've set up your account and you're enjoying Flickrdom, send me a Flickrmail and we can share our experiences further. If you're really enthusiastic, join the *Flickr Book* group to meet others who have also read this book.

Chapter 1
Introducing Flickr

One evening, at the end of February 2004, while I was online in a chat room channel called #joiito (started by the Japanese entrepreneur Joicho Ito), someone mentioned an application called Flickr. At the time I didn't know, but it had just been launched at the O'Reilly Emerging Technology Conference, a happening shindig that is an amazing barometer for soon-to-be popular technology. I visited the Web site and logged in.

In those early days, Flickr was a little different. It was born from an online multiplayer game called Game Neverending. Rather than approach online photography in a traditional sense— uploading photographs to share and print—Flickr's approach was socially based, sharing photographs with the world in real-time. It took its lead from game interactions rather than making money from prints.

The interface for Flickr loaded into my Web browser and displayed a chat space and contacts (see Figure 1.1). I could join any number of groups and discuss any number of topics. The twist, however, was the ability to instantly share photographs, dragging and dropping images into the middle of the discussion.

Figure 1.1
FlickrLive, the early version of Flickr, captured by Aki Jinn on February 28, 2005.

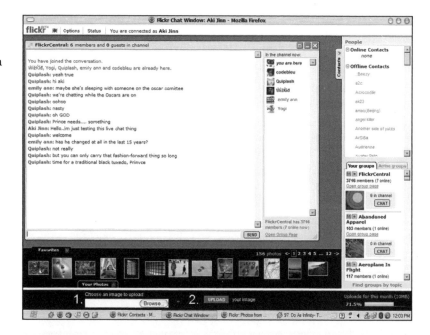

To my delight, the first photograph that was shared with me was a picture of a fish, with a nose. Unnervingly, the fish, known as a blob sculpin, looked like it had the face of an unhappy human—and who wouldn't be unhappy with a face like it had? It was a great way to illustrate how easily someone could share an interesting photograph.

The fish photograph, and one I uploaded of my 8-week-old daughter, sat in my "shoebox"— a frame in the application that stored my favorite photographs. When I needed to, I could drag the images from my "shoebox" into a chat window, displaying them to members of a group.

Flickr was fun, but jamming another piece of social software into my crowded evening wasn't going to be easy. So I bookmarked the site and I kept an eye on it until later in the year.

By September of 2004, Flickr had morphed into a completely different application. The team had been working obscene hours and produced a plethora of new features. Photos could be uploaded, stored, tagged, described, and discussed. But the feature that caught my eye was the ability to send a photograph straight from my camera phone. I could now capture an image, and instantly send it online.

Flickr became my new best friend. I used the mobile posting feature intermittently for the next couple of months, until I had some real time to play with some photographs in December. I live in Australia, and Christmas break here is long and quiet, and I now had a year's worth of baby photos from my daughter's first year. So I spent the next week uploading over 500 photographs.

I'd become a Flickr addict.

FLICKR ABBREVIATED

Distilling Flickr into a few paragraphs is difficult. That's why I needed to write this book. But, I wanted to offer a quick synopsis here. After all, you needed something to read while standing in the bookstore.

According to the site, "Flickr is almost certainly the best online photo management and sharing application in the world." It's true.

To elaborate a little, Flickr allows its members to store, sort, search, and securely share photographs.

Flickr provides a variety of tools to upload photographs to its Web site. They are then stored in their original format, and in a variety of convenient sizes.

Members then have a variety of features at hand to sort their collection. Data can be added to the photographs, including titles, descriptions, comments, notes, tags, and sets—all providing their own particular value for organizing images.

It's then simple to find photographs. Search or browse your own collection, or view other people's photos. Flickr even provides a few smart features so you can see related photographs or images that are deemed the most interesting.

Finally, share your photographs, securely or openly, with friends, family, groups, or the world. You receive your own personal Web page, and the ability to post to a weblog or moblog from camera phone.

Describing Flickr in so few words doesn't do it justice. That's why I highly recommend reading the rest of this book.

What Is Flickr?

Flickr is an online application that allows anyone to share and organize photographs. It's become the poster child for a new wave of online services, and is touted as one of the Web's best examples of social software.

Since the heady days of the dot-com boom, when money was invested in technology startups as if San Francisco's hills were made of it, there has been an increase of online communities. In the last few years there has been a growing realization that the Internet is more than just a business marketplace, and that real people can congregate and share with other like-minded people anywhere in the world.

That's exactly where Flickr fits. When Ludicorp, Flickr's creator, launched the first beta at the O'Reilly Emerging Technology Conference in 2004, one of the presenter's slides read, "Don't build applications. Build contexts for interaction." Flickr now interacts with over 2 million people.

Flickr's context for interaction means that it can be used for a number of different reasons. On the surface, Flickr is similar to a number of other photo repositories, but if you dive into its universe—in some William Gibson cyberspace-like leap—you can discover just how rich the interaction has become.

At its most basic level, anyone can upload a bunch of photographs and use Flickr as a photo repository. A Pro member can upload an unlimited amount of photographs, making the application a very cost-effective form of offsite backup, and never losing another photograph again.

Take me, for instance. I have over 1,400 photographs stored in Flickr. I know that they have a greater chance of survival stored on computers run by Yahoo!, the new owner of Flickr, than on my laptop. After all, running reliable online services is their core competency. Why wouldn't I trust them with my precious memories? (Don't answer that; it was a rhetorical question, as I'm sure there's an ethical debate about trust, which could consume another book.)

A Flickr member might then decide to share photographs. Members can specify people they consider a contact, whether they are friends, family members, or acquaintances. The privacy level of each photograph can then be set, determining who can and cannot view them. It's a great way to share snapshots with friends and family, no matter where they are in the world.

My mum lives just down the road, and my brother lives a couple of plane flights away in China. I can share my life with them both in the same way, without discrimination. Both can watch through my camera's lens as my daughter grows up, in almost real time. Ten years ago, I'd need to send photo prints via mail, and hopefully they'd be received within the week.

But Flickr doesn't stop there. Members can join groups and participate in topics that vary from *animal bellies* to *yo-yoing*. Literally any form of topic, photography or not, can be found amongst Flickr's groups. If you're keen to widen your online connections, Flickr provides mechanisms to meet new friends.

In addition to storing and sharing my photographs, I use Flickr as an adjunct to a range of social software. People whom I've met in business, whether online or in real life, can get a snapshot of

my life in pictures. It adds another dimension to my personality, which normally is saved for my closest friends. Likewise, I can view what my contacts have been up to: a day trip to San Francisco, or a walk through a Brazilian rainforest.

The repercussion of so many photographers sharing their photographs is the enormous catalog of images. By December of 2005, Flickr housed over 70 million photographs, with 80 percent of them made public. That's a vast collection that is tagged and searchable.

Tagging provides another context for interaction. Every Flickr member can add keywords to their photographs. It turns out that when large communities—like Flickr's 2 million members—collectively tag photographs, they produce an amazing amount of information. Check Flickr's Hot Tags section and you'll see the major events that are happening around the world today.

Speaking of world events...place a digital camera in millions of individuals' hands worldwide and you've enabled citizens to report on any topic. Flickr has bred a new type of news reporter, called the citizen journalist. Millions of people around the world can snap a photo and share it with anyone in the world. It's been proved through tsunamis and hurricanes.

By providing a context for interaction, Flickr has leapt from a photographer's album to a new form of media. Flickr is much more than just a photo album; it's a community.

FLICKR MEETUPS

Flickr is not all virtual. There are a bunch of active members who enjoy getting together in real life. It might not suit you, if you're a private person, but if you think you'd enjoy a drink or a meal with likeminded folk, there are several Flickr meetups.

According to Meetup.com—an online tool to organize group get-togethers—there are 434 people in the Flickr Fan group (http://flickrfan.meetup.com/).

There is also a FlickrMeet group in Flickr, and a thread in the Flickr Folk International group dedicated to providing meetup-related information (http://flickr.com/groups/flickr_folk/discuss/56255). Alternatively, you can search in Flickr's tags and groups for the keyword "meetup." I'll explore how in future chapters.

Regardless of how you find a Flickr meeting, make sure you take your camera.

The Internet: Background to Flickr

The Internet has changed dramatically in the last 10 years. So it's worth exploring a little of its history to set the scene for Flickr's foundation. Its influence can be seen in several online trends.

In 1993, the World Wide Web, although interesting, wasn't as pretty and rich as today's incarnation. A Web page's grey background was a designer's only choice. Educational institutions had concocted a clever channel of communication. But despite its original blandness, it wasn't long before businesses fell in love with the new cyber world.

Companies plastered the information superhighway with posters and billboards reminiscent of brochures they sent out in the mail. The Net was deemed a quick and easy way of blasting out information laced with corporate-speak.

But, at the same time, a bunch of smart netizens realized that there were two other possibilities: conversations and disruption. The Internet had begun to change the economics of communication, and it meant that individuals were vested with the power to speak cheaply and quickly to millions of others. By repercussion, it also meant that many traditional business models were challenged.

A famous example is Napster, a company started by student Shawn Fanning in his university dorm room. By providing a tool that enabled anyone with a computer and Internet connection to swap music, Napster almost single-handedly changed the future of the music business.

Now known as peer-to-peer, or p2p, several other applications appeared that connected millions of people instantly to share computer files. Formal distribution for digital media was now staring down a long digital pipeline connecting their old customers to each other. They'd found a much more convenient way to access music, software, movies, and even television shows, by sharing them amongst themselves.

Eventually the law stepped in and put a halt to Napster's network, but it demonstrated that many businesses need to be mindful of a new powerful force—their customers.

Other ways of using the Internet were more subversive. Not created by single companies or individuals, new applications of the network world were popping up to empower people. A group of visionaries realized what was transpiring and penned a document together. *The Cluetrain Manifesto* became a catchphrase. Written by Rick Levine, Chris Locke, Doc Searls, and David Weinberger, its 95 principles suggested that markets were conversations, and that customers were quickly outpacing corporations' intelligence.

It was true. The Internet was a way for people to speak to people, and companies were being rapidly left behind. Sprouting up from the fertile new world were innovations that brought people together, not least of which were *weblogs*, an easy form of online publishing for the masses to adopt.

In a single decade the Internet had morphed from an institution's collaboration to consumer's savior. New ways to provide services quickly began to appear, and old, tired business practices were checked at the door. It was in this new incubator that several new online services emerged to show the "suits" a new way of capturing a community's hearts and minds.

You might very well ask why you would want to share anything on the Internet. Well, opening up and sharing has some fabulous repercussions. When large groups begin sharing, a large pool of benefit appears, such as learning about other Web sites from like-minded Web surfers at del.icio.us (http://del.icio.us), or trading your DVD titles for ones you haven't watched yet at Peerflix (http://www.peerflix.com/).

A new Internet had formed. Rather than a collection of stale corporate billboards, it became a network of people—everyone contributing to a worldwide conversation.

METADATA

Metadata is important. It's the name of data that is used to describe other data. When it comes to searching or organizing photographs, metadata can save you time and add significant value.

Photographs aren't just pretty pictures. In many cases they tell a story. However, unless you add a little extra context, the story can be lost. So Flickr provides tools to add a bunch of metadata.

Flickr automatically collects the time and date a photograph was taken, a few other details about the digital camera used, and the time and date you uploaded the image.

It also provides a range of extra fields that you can complete to provide extra value. For instance, if you tag all your holiday photographs with the keyword "holiday," they'll be much easier to find later; if you provide the names of everyone in the family's festive photograph, your relatives will make more sense of it; or, if you make a note on a photograph, pointing out the exact room you stayed in at a hotel, it'll be more fun when you look at it again in a year's time.

Sharing tags turns out to be an amazing way to organize information. In 2003, Joshua Schachter, a computer programmer, designed another Yahoo!-owned application called del.icio.us (found at http://del.icio.us/). It's described as a social bookmarking application, a place to store your favorite Web sites.

It uses tags—a form of metadata—to categorize. Stumble upon a site containing tips for parenting, like (www.parenthacks.com) Parent Hacks, and mark it with the keywords "parenting," "kids," "tips," and "children." Later, other desperate adults can find your reference to the Web site, along with 546 or so other people, by searching for "parenting tips" at the del.icio.us site. This means the more people who share their tags, the more useful a search result becomes.

It's all in the metadata.

FLICKR COINCIDENCES

With a community that is 2 million strong, it's not surprising that on the odd occasion various members will photograph the same subject. However, there are some amazing coincidences.

Flickr member SuperDaveNM moved to a new apartment in 2005. He took a few snapshots and uploaded them to Flickr, adding a few descriptions.

One of SuperDaveNM's contacts, curiouskiwi, was browsing through his photostream. She noticed his new apartment, and its likeness to one she lived in as a child. As she shuffled through the photographs she came on a shot of the courtyard, and realized it was the same apartment, or at least the same complex.

Curiouskiwi dug up a Polaroid from 1971, scanned it in to her computer, and uploaded it to her own Flickr account.

You can find this, and dozens more coincidences in the Flickr Central group, and the "flickr coincidence" conversation thread.

A Brief History of Flickr

Flickr is a community. However, it didn't just appear; it took hard work by the team at a company called Ludicorp. The members of the team ingrained in Flickr a feeling of belonging. For instance, Caterina Fake and George Oates spent countless hours greeting and introducing the first 5,000 members to the fledgling application.

Every Ludicorp employee was well versed in the new Internet. They were all skilled in different facets of creating online communities. Every one of them was a weblogger before they joined the company, and was versed in "cluetrain" conversations. Each of them helped shape Flickr's community, who in turn gave back to Flickr by starting hundreds of conversations requesting and recommending countless features. Ludicorp's hackers then worked to the still hours of the morning, spinning a Web of code that became new features. The community then became larger, and more conversations begat more features, which is an inspiring way to create a service.

Ludicorp

Ludicorp was founded in Canada in June 2002. It was based in Yaletown, an area of Vancouver that had become boutique and trendy after it was revamped for the World's Fair in 1986. The company's founders, Caterina Fake, Stewart Butterfield, and Cal Henderson, rented a loft-like office in a warehouse, with exposed brick walls, timber beams, open spaces, and a collection of cheap desks for workspaces. It couldn't look more like a company devoted to game development had a team of Hollywood set designers dreamed it up.

The company's focus was Game Neverending, also known as GNE (see Figure 1.2). It was a virtual-social-software world, not really a game. A player would log in to the world via their Web browser, a feature that Ludicorp touted as a way to access the game anywhere with an Internet connection and a Web browser. Citizens could buy plots of land, design a new home, open a store, gain powers, interact with objects and with other players via instant messages. It mirrored the real world in many ways including the ability to start a political party or community, or even create a religion.

The amazing thing about GNE wasn't the game's goal—there didn't appear to be one—but instead a resident's aim to make something of their in-world character. The GNE site explained, "Develop dozens of different talents, gain new levels, and new powers in the game, keep your mood, karma, health and well-being up and the wheels of nature will roll smoothly."

TRACES OF GAME NEVERENDING IN FLICKR

When using Flickr, pay attention to the Web address in your browser. You'll note that some of the extensions include ".gne," a hangover from the Game Neverending (GNE) platform.

Figure 1.2

A screen capture of the Game Neverending (GNE) user interface by Mina.

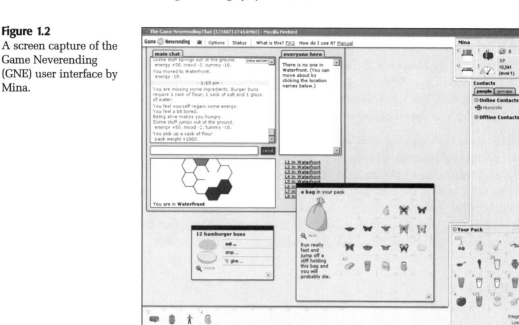

GNE, and eventually Flickr, existed in no small part due to Caterina Fake's attitude toward the Internet. When I spoke with her, she overflowed with passion and understanding about the real heart of the virtual world.

> "I've always had this feeling that the best thing about the Internet was it has what I call the 'culture of generosity.' I first went online prior to the Web, but when the Web came about and more and more people started experiencing it, it was really just full of regular folks who put up recipes, discographies from their favorite band. They would post essays, and it was full of all this stuff that regular folks had contributed. To me, that 'culture of generosity' is really the core, the heart, of what the Internet is all about.

> That kind of got lost in the late nineties, I think, with business and corporations, and the whole dot-com thing kind of buried what I think the magic of the Internet was, which was connecting people to each other."

Caterina's understanding has been built over many years as she created other amazing online ventures. Her blog alone reaches 5,000 to 6,000 readers every day. In 1994 she created a personal "home page," adding details about Vladimir Nabokov, the famous author of the book *Lolita*. In 1996 she started a webzine called Wench (www.wench.com), an online magazine dedicated to women (which she has just revived). And in 1998, just after the term's inception, Caterina started her own weblog showing amazing insight into the Web's future.

The many skills Caterina learned from these creations empowered her to create communities—in my opinion, the best part of the Internet. She brought this magic to GNE, and at the same time worked on the game's design, graphics, names, and concepts.

Jason Classon, who eventually left Ludicorp to continue his studies, worked with Caterina and Stewart to build an early prototype of GNE. He'd previously built an online application called

GradFinder, a service that allowed people to reconnect with school and college friends. So his skills in coding helped establish the prototype's back end. Initially, the service ran on a small server that he owned.

Stewart Butterfield had picked up his Web design skills while he was an undergraduate, and he was tasked with the development of the Web interface to the game. However, an ambitious project like GNE required some assistance. So Ludicorp began hiring a batch of skillful people.

Eric Costello, an adept hacker who lives with his large family in New York, was famous for his early publication of instructions about cascading style sheets (a method of designing Web pages) and designing highly useable interfaces. He helped Stewart and Caterina work on further iterations of The 5k (see the sidebar "The 5k"). His skill with code helped Ludicorp respond quickly to the community's discussions. He worked tirelessly and used modern hacking skills to create a simple interface that is intuitive to use, which is not an easy task.

George Oates built a respectable reputation in Adelaide, Australia, where she started a company called "by George! Web design." She was well respected for developing Web-based applications for banks, universities, government departments, and other major organizations. George has over 10 years' experience in building the online world, which served her well not only for coding some of the Flickr application, but for helping nurture the community.

George joined Ludicorp in 2003 as she traveled through Vancouver. Starting as an intern, she quickly lead the charge in production and design. She also introduced a good old Australian tradition to the team: a barbeque.

The Birth of Flickr

As development of the game's user interface powered ahead, the back-end processes used to control much of what happened in game lagged behind by several months. It was a complex beast that required a lot of computer programming. So looking for something to challenge the developers working on the front end, the team decided to think of a service that could leverage the functionality of the existing back-end code.

Ludicorp decided to introduce the ability to share photographs within the community, and began development of the new project on December 8, 2003. Two months later, after what must have been furious computer coding by the team, they launched the first beta of Flickr at the O'Reilly Emerging Technology Conference on February 10, 2004.

In this rapid development phase, the Flickr team expanded to cope with the added workload. They hired Cal Henderson, who worked from two hours outside London. In his spare time Cal would write code and then upload the results to the Internet via a dial-up modem. I can only imagine that he is an insomniac, as he worked on an amazing variety of projects in his spare time, such as co-founding B3TA, another online community. In March 2004, Ludicorp convinced him to move to Canada.

The initial incarnation of Flickr was more akin to a chat room. Members could join groups, chat with others who were online, and share photographs from their "shoeboxes." The team added the ability to display the photographs on a Web site, and added other features like tagging and other annotation. The original version became a simple feature called FlickrLive, contained within a larger application.

Flickr received approval from many communities around the Internet, such as webloggers and technology journalists. Its open approach and focus on building useful features attracted the digerati—the hip online crowd who are often early adopters. It was a great sign that Flickr would gain traction.

Something amazing happened to Flickr: its community began to imagine amazing ways of using each feature. It went beyond what Ludicorp imagined, with tags being used in social games, and groups used to create collaborative art. Each feature, although constrained, was exploited in new and original ways.

When I spoke with Stewart, he explained how he believed that constraints produce creativity.

> "If you think about any creative endeavor: poetry, music, and architecture...in poetry there are often forms that are imposed, so if you want to write a sonnet there are 14 lines divided into an octet and a sextet, and there is a rhyming scheme. In music it is the same thing: tempo and key. In architecture obviously the constraints are a little less obvious, but include things like the laws of physics, and what's actually useful for people. Like buildings have to have doors that are close enough to the ground so people can get into them.
>
> A lot of times, when people get really creative, especially in the 20th century, they look at either tightening or getting rid of the constraints."

THE 5K

In a previous company, as a way of expressing his constraint concept, Stewart had created "The 5k." Stewart challenged the Web design community to create a Web page with a total size smaller than 5 kilobytes (5k)—not an easy task because of the bloat that computers usually encourage. The page was to be judged based on its size, aesthetic appeal, function, overall concept, and originality. The contest's prize was 5,120 cents, or $50 (5,120 is the true number of bytes in 5 kilobytes). As the competition site suggested, "It's not much. Do it for the honor."

In its second year Stewart relied on help from Caterina and Eric to continue The 5k.

The End of the World

Ludicorp began to realize the potential for Flickr. No longer a slice of GNE code, it had grown into a large, living, breathing community. It was apparent that the team had to work hard on the service, and GNE's production fell behind.

Speak to any member from the Game Neverending community, and you'll hear a similar sentiment: "It was more than a game." Speak too long and they might even tear up, because GNE is sorely missed. Many former GNE members joined Flickr at its inception as a security blanket, a way for them to deal with the loss of their world.

Caterina Fake wrote about GNE's passionate members on her blog.

> "We were developing both in parallel for about four to five months, but sometime in July of 2004 we decided that we were too small a team to work on two products—we were only six people at the time—and Flickr was growing at an astonishing rate.

It was great that Flickr was growing, and yet we really loved GNE, and so did the users. It was a game people got very emotionally involved in. I'll never forget how, when we shut down the prototype for GNE in 2003, people logged in all over the world for what we called "The End of the World"—from remote locations and time zones such as Berlin, Australia, and the Philippines—and many people cried. We were really amazed by this, and moved."

Ludicorp's Rapid Growth

The rapid growth that Flickr achieved didn't come without a price. To keep pace with the number of new members joining—a growth of 5 to 10 percent a week—the systems needed to be maintained and taken offline. Given the team's sense of humour, the error messages would often poke fun at the events, usually proclaiming, "Flickr is having a massage." It occurred so often that a Web site was created: www.ishavingamassage.com (replace the "www" with any word for a little fun).

To deal with this growth, Ludicorp continued to add amazing talent.

Aaron Straup Cope, an artist who has lent his hand to some amazing Web sites over the years, joined Ludicorp as their lead developer. He was an advocate of open source, a way of building software through an open community process. He'd contributed to projects including several data formats. He also helped nurture a couple of Internet Service Providers with his development and administration skills.

John Allspaw was placed in charge of systems and hardware because of his wealth of experience in building scalable systems, tuning them to produce their best. He'd helped build large computer systems that enable the U.S. government to run vehicle crash simulations. With his skills he also helped another online community, Friendster, and built a computer system to deal with millions of users.

John's Flickr profile sums up his work: "I spend a good deal of time helping machines figure out how dumb they are, and teaching them better ways to talk, think, work, and learn. That said, I think I'm starting to understand what a kindergarten teacher feels like."

Ludicorp was also successful in tempting Serguei Mourachov to the team. They had wanted to hire him since the early days of Game Neverending, but he wasn't available at the time. Since his introduction to Flickr he's added amazing functionality, such as Interestingness (see Chapter 7), one of my favorite features.

With an inspiring online history, Heather Champ also joined the team in 2005. Having run her own Web site since 1994, only a year after the first public graphical Web browser was launched, she went on to create The Mirror Project and *JPG Magazine* (see the sidebar in Chapter 8). The recipient of the Lifetime Achievement Awards in the 2004 Weblog Awards, Heather became Flickr's Community Manager. She spends her days and nights looking after Flickr members in the groups and at events.

With Ludicorp's lineup, it's not surprising that they were able to build Flickr. Each employee was skilled at crafting online communities. Not only did they get their hands dirty creating new features, but also they were active in Flickr groups and commenting on members' photographs. This helped create the open and sharing Flickr community.

It's also not surprising that the team and its burgeoning community attracted the attention of investors. In the middle of 2004, Ludicorp talked with several firms such as Yahoo!, CNET, and Kodak, but Ludicorp deemed it too early; they wanted to flesh out the application. They felt that GNE had only realized 5 percent of their vision, so they had high expectations for Flickr. They decided to wait a little longer before entertaining money from big institutions.

Individuals willing to invest, known as angel investors, were a different matter. Three high-profile entrepreneurs invested in September 2004: Joi Ito, an influential businessman based in Japan with a reach right across the Net; Esther Dyson, a noted consultant who analyzes the impact of emerging technologies and markets on the economy and society; and Reid Hoffman, the founder of LinkedIn and former Executive Vice President of PayPal. These entrepreneurs are well respected online and amongst major technology organizations.

ESTHER DYSON

Esther Dyson is the editor of CNET Networks, where she is responsible for the monthly newsletter called *Release 1.0*. In it she focuses on emerging technologies, emerging companies, and emerging markets. In part, this led her to discover Flickr, and she became an early investor.

I spoke with Esther on the phone and asked her a few questions about her interest in the community.

What do you like about Flickr?

Well, it is a much simpler way to blog. I write for a living, and I like it, but the problem is I'm a journalist, and so I feel very uncomfortable not checking my facts. If you write a blog, the effort of checking facts is just huge, so it's much simpler to just do photos and caption them.

I like the photos. They are great. One photo is worth a thousand words, and it's fun.

So do you use Flickr as a diary?

It varies. Sometimes the photos explain something, sometimes they are just funny weird, and sometimes they should just be for friends. Like photos and text in general, they do a lot of different things.

What's one of your favorite photos you've taken and shared in Flickr, and why?

No single one, there are different kinds. The one that got the most views is the sun from under some clouds I was flying above. Oh, you know, there are various ones of different friends that I am fond of.

Any different day I'll have a different one. One of my favorites today is the one I took of Madeleine Albright looking at her own entry on Wikipedia, with a certain degree of horror.

I have a really, really enjoyable life; I have lots of interesting pictures. One thing I do is take pictures of every swimming pool I swim in, because that's what I do every day. The swimming pools are all different. I put in the hours, so that if I go back to a hotel or something I know the hours.

I have one that I call "remindr," that are usually interesting warning signs. Like, "You will be electrocuted if you cut this line, and you will be fined." Once you're electrocuted, do you really care?

Do you tag all your photos?

Usually someone else tags them for me. That's something I like about Flickr—it's a social thing.

If you look at the tag "tags" in my Flickr photostream, you'll find a picture of a women at a checkout counter, and her name is Irene, and the picture shows some price tags, and that has a little essay I wrote about tags. The interesting thing about (tagging someone else's photo) is, my brother used to have a monkey that used to sit on his shoulder and go through his hair looking for lice in a very loving way. Again, it is social grooming behavior. To me, I kind of like that social grooming—people do it for you and you do it for them sometimes.

Anyway, also looking for a picture of monkeys, I looked at the "monkey" tag on Flickr, and at least a third of the photos were not of monkeys but of people's children. So you just find these odd little human things when you look in Flickr.

Any interesting stories about Flickr?

I've made one online friend through Flickr, and I would say that there are some people who I know in real life that I have gotten closer to because of it, like Steve Jurvetson and a guy named Ed Vielmetti.

I guess the thing is I don't use Flickr to try and meet people. And some people might be really interested in cats or dogs or whatever, and I'm interested in pools. I guess there is probably a swimming pool group that I should join, but to me it's more the variety and I share it with my friends rather than use it to find friends. So the people that join groups are trying to find people that share their interests, whereas I am trying to share my interests with existing friends.

My mother looks at it religiously, and makes mother-like comments.

Continuing its trend to keep the company as open as possible, Ludicorp decided to open its Application Programming Interface (API). You can find it published on the Web, and it enables anybody who is granted an API key to create an extension to Flickr. Essentially someone can create another application that can speak with Flickr's core service. This news spread rapidly, and before long extra features were being added to Flickr, but from outside Ludicorp.

You'll meet some of these developers in this book. John Watson and Jim Bumgardner, for example, are among hundreds of people who have created an amazing array of third-party applications (see Chapter 10), that allow people to play with Flickr photographs in new ways.

Yahoo! Acquires Flickr

In light of Flickr's continued stellar growth, Yahoo! returned for further talks.

Yahoo! was also riding high. Its 2004 revenue was $3.574 billion, over 200 percent more than its previous year. Its gross profit exceeded $2 billion, enough to quiet its bubble-day skeptics. It was ranked number one for the volume of traffic it received on the Internet, attracting 80 billion page views a day—almost double Google and MSN combined, the second- and third-ranked Web sites.

After further consideration, Ludicorp decided to accept Yahoo!'s offer, rumored to be $30 million by magazines like *Forbes*.

There were mixed reviews. Many people congratulated Ludicorp and expressed excitement. Others, such as a branch of members, expressed their concern. Ludicorp was seen as a small, responsive, company, and some suggested that the Internet giant would corrupt its culture.

Surprisingly, the reverse happened. Yahoo! understood that the Internet was changing, and it needed to embrace community-driven services. Although Ludicorp was integrated into Yahoo!'s Search and Marketplace Group, Ludicorp's assistance was sought throughout the large organization. They soon influenced decisions like the purchase of other community sites such as upcoming.org. The media took note, and *Business 2.0*, a magazine that specializes in reporting about tech companies, ran an article called "The Flickrization of Yahoo!" in December 2005.

Flickr's rise had only just begun. Just before the acquisition, Flickr's member base totaled just shy of 300,000, and by December 2005 that had escalated to about 2 million.

In June 2005, Ludicorp's staff moved their offices to Santa Clara in California, and found homes in close proximity to each other in San Francisco, a tribute to their close teamwork in and out of the office.

The Flickr community continues to grow, and features continue to be added in its drive toward a full public release. Its past is an amazing story of how creating and nurturing a community can actually create a compelling service. Today's Internet is all about community-driven projects, and Ludicorp should be commended for their incredible foresight.

In this book you'll learn what Flickr's amazing team created. Its community has embraced and extended a photo-sharing application, which now creates amazing art, and 21st-century cultural artifacts. From beautiful portraits to groups that encourage sharing a photograph of what's in your bag, the community is immersive. It's just waiting for you to add your personal touch.

DOS PESOS

Dos Pesos is Caterina Fake's dog (see Figure 1.3). Half Chihuahua, half Yorkshire Terrier, he was born in 2001. It might seem odd that I mention him, but he's become somewhat of a legend.

Other than constant mentions and photographs by Caterina on Flickr's weblog, Dos Pesos' image was the first photograph uploaded to Flickr. The only other images were test files, emblazoned with the green text, "TEST IMAGE."

Now Dos Pesos is essentially Flickr's mascot, even making an appearance on the back cover of a QOOP Flickr photo book (which you can learn about in Chapter 5).

In all honesty, this book wouldn't be complete without sharing a photograph of the wiry-haired holiness of Flickr.

Figure 1.3
Dos Pesos, Flickr's mascot, and Caterina's pet dog.

JOHN WATSON

John Watson is the brains behind fd's Flickr Toys.

How'd you hear about Flickr?

I can't remember. I joined on July 15, 2004. I'm sure I must have read about it somewhere. Thank goodness I did.

What do you like about Flickr?

More than anything else, I like the community aspects. I like the activity in the groups—there is always something going on. And it's not always photography related. I like that you can meet people from all over the world and have conversations via comments on particular photos. The photographs themselves can be seen as facilitators of community building. Each photo is like a landmark or a virtual space where people can meet and have a conversation. And I remember being delighted by the interface when I joined—mostly it just gets out of the way and lets me do what I want.

What's one of your favorite photos you've taken and shared in Flickr, and why?

It's hard to pick a favorite. This one (http://flickr.com/photos/john/8380839/) is right up there. This one too: http://flickr.com/photos/john/6766720/in/set-194936/. But for different reasons. My children and family are my favorite subjects (see Figure 1.4). I love presenting them in flattering or dramatic ways like the first one illustrates. But I also love photos that make me feel good, that evoke strong and happy memories.

What's one of your favorite photos from another Flickr user, and why?

There are so many it's impossible to choose. Each one of these is my favorite photo: http://flickr.com/photos/john/favorites/.

Figure 1.4
John Watson's daughter, caught in the wind.

What is your favorite group, and why?

Again, impossible to narrow down to just one. Utata (http://flickr.com/groups/utata), Nikon D70 (http://flickr.com/groups/d70), Photographing Children (http://flickr.com/groups/children/), and for similar reasons. They each represent a relatively small group of people who are active and involved and interesting to talk to. Participating in these groups feels a lot like Flickr was when it was smaller and more personal. You can get to know people in these groups. The equivalent of sitting down at a table with a few friends in the back room of an extremely crowded and noisy restaurant.

What is your favorite tag, and why?

fdsflickrtoys, of course. :-) I love seeing the things people produce, especially when the tools are used in ways I never imagined.

Why do you create your Flickr tools?

My original and overarching purpose is to create tools that help people do fun things with their photos, especially people who wouldn't be able to do so without them. For example, the Flickr Badge toy was created based on LarimdaME's (http://flickr.com/photos/larimdame/4967439/) original concept. Lots of people were expressing an interest in creating a badge like that but just didn't have the technical know-how or design skills to create their own. Photoshop and its ilk are powerful but intimidating tools. I think the Mosaic Maker was next, originally created to help people make mosaics for the Mosaic of Best Tiles (http://www.flickr.com/groups/top36faved/pool/) and other mosaic groups. All of the other tools were created to fill a similar need. These are things people want to do with their photos but need a little help. And it's very gratifying to know that these tools are making people happy.

What's your favorite tool you've created, and why?

You know, as silly as it is, I think it's got to be the badge maker. It really struck a chord with the community, it was the first big hit I had, and I know it has made a lot of people happy and continues to do so. I'm looking forward to when Flickr comes out of beta so I can release a new version of the badge maker without the beta designation. :-)

Any interesting stories about Flickr?

This may only be interesting to me, but I don't think it's a stretch to say that Flickr has changed my life in a non-trivial way. Photographs kept in a shoebox are wasted, in my opinion. Sharing them with the Flickr community has opened my eyes to a larger world, allowed me to meet a bunch of interesting people, and has helped me create opportunities outside of Flickr related to photography. I guess you could say I'm richr for Flickr.

Chapter 2
Getting Started

I have a fond memory of buying a secondhand Polaroid instant camera at a market, run each Sunday at my local shopping center's car park. I was 10 years old, and took great satisfaction seeing the results of my photographic endeavors develop in only minutes. The family's cocker spaniel puppy didn't have the same satisfaction; being poked and prodded into the correct pose must have been very tiring.

Somewhere in my shed, in the back, amongst the cobwebs, in a box, in an album, are the photos I kept from those amateur photo shoots. It's not that I believe they're of such a high standard that the world would want to see them, but someone somewhere might enjoy the retrospective style of the subjects; early eighties fashion is iconic after all. In fact, the people of the Flickr Polaroid group (www.flickr.com/groups/polaroid_/) would be just the crowd with whom to share the photographs.

Which is why we're both here. We want to share our photos with family, friends, like-minded puppy prodders, and complete strangers. Registering with Flickr and uploading a few digital photographs are only a few steps away. You'll have your first photo online quicker than I can run up the backyard, rumble through the boxes, and find the old Polaroid of my dog, Digger (see Figure 2.1).

Figure 2.1
I spent some time in my shed to dig out this Polaroid instant photo of my dog, Digger, in the early eighties.

Although using Flickr can get much more involved—with tags, groups, privacy, and numerous other interesting features—this chapter focuses simply on getting you signed up. Once you've taken these steps, you'll be able to explore the online Flickr world in a lot more detail.

Signing Up

To sign up to Flickr, you simply visit the Web site, www.flickr.com, in your Web browser and click the *Sign Up Now!* icon (see Figure 2.2). This will take you directly to a form to create your account. Flickr's login is integrated with Yahoo!, which bought Flickr in 2005. This means if you already have an account with Yahoo!, you already have access to Flickr. If this is the case, once you've clicked the icon, you only need to enter your Yahoo! ID and move on to choosing a *screen name* (see the section below).

If you don't have a Yahoo! ID, then creating one is like every other online service—you'll have to abandon your fear of providing personal details. Some people hesitate to provide personal details online because they believe the Internet isn't very secure. Although there are plenty of strange things that happen online, I'm certain that Yahoo!'s activity isn't underhanded, and there probably isn't any information they require that you haven't already provided to companies online or otherwise.

I've been providing my personal details online for more than 10 years, and you should know that as long as you are careful about whom you give your information to, it's just as safe as in the real world. In fact it's just the same as the real world; just make sure the company or entity with which you're sharing information is reputable. I'll vouch for Yahoo!'s credibility.

You'll see a section on the current Web page that provides a link to *Sign Up* if you don't already have a Yahoo! ID. Click the link, and your browser will take you to the form to create it (see Figure 2.3). Enter the required details including your first name, last name, preferred content (which is used to make Yahoo! more relevant to your locale), and gender.

Figure 2.2
Flickr's main Web page, before you sign up.

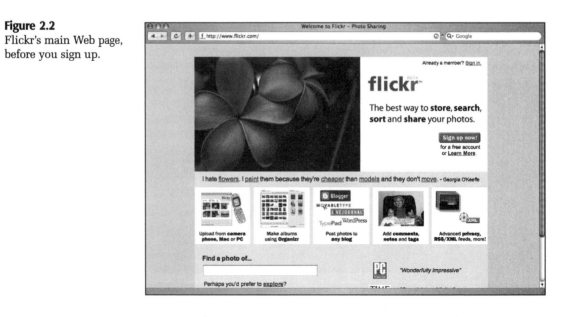

Figure 2.3
The "Create Your
Yahoo! ID" Web page.

The most difficult part of signing up is actually finding the right Yahoo! ID. After 10 years of operation, Yahoo! has already allocated all the standard names and nicknames, so you'll have to come up with something a little more obscure. For example, the username "Richard" was taken by 1996, and I ended up having to use "rich115." Fortunately, the sign-up process provides a little help, making suggestions if your chosen name is already taken—you simply provide a few preferred alternatives, and it'll mix them together to give you a few choices.

There are a few extra miscellaneous details that might seem a little tedious to complete. The Flickr form asks you for information such as your favorite pastime, birth date, and postal code, so that if you forget your password it can verify your identity and allow you access. If you like, you can also provide information about your work, like your industry, your title, and specialization—none of which is relevant to Flickr but is used with sections of Yahoo!

Once you've filled in the required fields marked with a red asterisk, you can verify your registration with a special image code. This stops hackers from using computers to automatically generate Yahoo! accounts, because the image is made to be readable only by humans. Having said that, I've sometimes struggled to read what it says.

Make sure that you also read the fine print, and if you're happy, click the *I Agree* button. You'll then be sent a confirmation e-mail, and you can continue on to use Flickr.

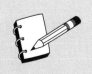

YAHOO! E-MAIL

When you fill in the Yahoo! ID form, you'll see a section that allows you to create a free Yahoo! e-mail address. If you select this, it will become the default location to which Flickr sends notifications (the first of which is a registration confirmation). You can either choose not to use Yahoo!'s e-mail, and provide an alternative at sign up, or, if you prefer, change the primary e-mail in your Yahoo! Account Information later.

CHAPTER 2

Your Screen Name

From here you'll need to fulfill the next difficult task: choosing a *screen name* (see Figure 2.4). Choose this wisely, because it should be a reflection of who you are in the community—picking "DevilDog" will result in a different reaction from friends, family, and strangers than the angelic "ButterflyWings." Fortunately, the crew at Flickr realized you might not get this right the first time, and they allow you to change it later.

Figure 2.4
Choosing a Flickr screen name.

FLICK OFF

Some Flickrites are a fickle bunch. In August 2005, several months after Yahoo!'s purchase of Flickr, the companies announced that they were merging their user accounts. It sounds harmless enough to me; why have two different ways of using Yahoo!'s services when the two services can have just one simple login?

Many Flickr users decided this was a hostile attempt by a major company to co-opt the freedom they enjoyed by using a small open company. In fact, some took it so personally that they created a Flickr group called Flick Off (www.flickr.com/groups/flick_off/). The group's creator even suggested he would quit Flickr 24 hours prior to the official merge of accounts in 2006.

To their credit, Flickr responded quickly on their Weblog (http://blog.flickr.com/flickrblog/2005/08/flickr_and_yaho.html), explaining that the merge of the two systems was to everyone's advantage: "It wastes a huge amount of effort and attention that could otherwise go into making new features, improving performance, and all the things we'd rather be doing than gumming around with this stuff."

Impressively, the Flick Off group still remains, and even includes Flickr co-founders as members. No attempt by "the company" has been made to suppress the protest. A move that, I think, demonstrates a great deal of openness and honesty.

ANOTHER REASON TO SIGN UP TO FLICKR

Flickr is fantastic as a backup for all of your photographs. Having a comprehensive collection of photos of my daughter from birth in Flickr means I can rest a lot easier. Fire or flood always played on my mind when I stored precious photos at home, but now with a backup on the other side of the planet I can rest easy. Given that I live in Australia, and Flickr resides in San Francisco, it'd take a major disaster to befall two continents; I'd have things other than photographs on my mind.

I wouldn't suggest that you rely solely on Flickr for peace of mind; we don't know where Flickr or Yahoo! will be in 10 years. It's not that I'm predicting their demise, but when CD or DVD technology is so cheap, it's worth saving your photos to disc.

Stewart Butterfield, a co-founder of Flickr, knows firsthand the pain in losing every photograph in his Flickr account. At 3:00 in the morning, while helping a user who'd requested his account deletion, Stewart accidentally erased his own membership. That included several hundred photographs—a depressing situation. He had to start his collection from scratch—the first image composed of text reading "Oops"—losing over a year's worth of photographs. He insists that it's impossible for a member to delete an account that easily (there is a delete option, but it requires confirmation), but it's still a valuable story to learn from.

I take backing up to the extreme. DVDs with photos of my daughter have found a home with several members of my family, like my mother and my in-laws. That way I have backups in many different locations. Your precautions don't need to be as extreme as mine, but it's worth taking the time to back up your photographs somewhere.

There are at least a couple of solutions you can use to back up your Flickr membership. We'll explore the service from Englaze in Chapter 5, and a free application called Flickr Backup in Chapter 10.

Your Flickr Identity

Once you've created your screen name, Flickr offers some pointers to get started. I'd suggest you set up a little bit of your profile, create a Flickr Web address, and a buddy icon. That way, when you start to upload photographs and explore the rest of Flickr, other people will know a little about you, and your photographs will be much easier to share.

Your Profile

When you begin to use Flickr in earnest, it's just like the real world—everyone wants to know a little more about you, not just your name. So it's a good idea to set up your profile to tell people who you are. Let's have a look at what it contains, and if you prefer you can come back and complete it in more detail, or change it completely, later (see Figure 2.5).

After you've signed up, you're presented with the option to *Create Your Flickr Profile*. If you were a little excited and raced ahead, that's fine as well. You can access your profile from the *Home* page by clicking on the *Your Account* link on top right-hand side, followed by the *Your Profile* link. Both methods take you to exactly the same place.

Figure 2.5
Editing your profile in
Flickr.

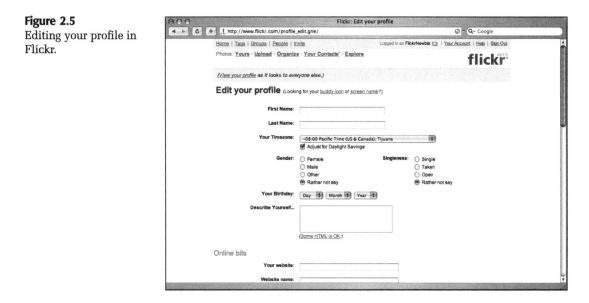

Profile Basics

The basic parts of your profile are straightforward, with all the things that you'd expect to see: first name, last name, gender, singleness (Flickr's cheeky way of saying marital status), and your birthday. You might be surprised to see that you can also specify your time zone. I'll explain later, but it comes in handy when you want to sort your photos by the date you upload them. It also has a little section to describe yourself in your own words, with even a little HTML (if you don't know what HTML is, don't worry, it won't matter).

The profile form is then split into a few other sections: Online bits, Offline bits, and Things You Like.

Online Bits

This section is great if you already have a presence on other places on the Internet. You might have a personal Web site, like a Weblog, or even a company Web page that you're very proud of. If not, just leave those sections blank. It also provides a place for you to advertise your instant message account if you have one or more with AIM, Yahoo!, MSN, or ICQ. After all, being a part of a community is all about communication.

Offline Bits

Offline Bits is the place to provide details about the real world; described as "meatspace" by many people in the virtual world. Currently they only show up in your profile, but they offer a bit more context for the people who might enjoy viewing your photo collection. You can list your occupation, hometown, city, country, and even the code for your local airport.

Things You Like

It's interesting to note the variety of detail that different Flickr members provide in their profile. The *Things You Like* section allows you to go completely overboard; if you like collecting belly button lint, then this is the place to brag about it. Simply list all your passions separated with commas. The wonderful repercussion is the ability to search for other like-minded people, which I'll cover later in the book.

If you're interested, you can also click on the *View Your Profile as It Looks to Everyone Else* link at the top of the profile page. That way you can get a firsthand view of what people perusing your photos will see. It's important; remember that first impressions count.

Choosing Your Flickr Web Address

When you're a fully fledged Flickrite, you'll want to start sharing your photos with people outside of the Flickr community. To do this, it is easier if you have a simple name for your Web address. If you don't choose one, the address for your photostream will look like a mess of letters and numbers (for example, www.flickr.com/photos/83644032@N00/). Flickr allows you to choose your own Web address, also known to nerds who like to show off their knowledge of acronyms as a Uniform Resource Locator (URL).

If you haven't created your own Flickr address, you can create one by selecting the *Your Account* link, followed by the *Your Own Flickr Web Page* link. Choose *Set Up Your URL*, and you'll be presented with a text box for you to fill in (see Figure 2.6).

Whatever you choose will result in a URL that starts with www.flickr.com/photos/ (and www.flickr.com/people/), and ends with your chosen text. If your first choice is already taken, you'll be prompted to try again. I've tried to create my own personal brand, so I use www.flickr.com/people/richardgiles/, but others are much more creative. Do some surfing through Flickr and you'll see some great examples.

Figure 2.6
Creating your Flickr address.

It's important to realize that whatever you select will be permanent; you won't get a chance to change it later. If you're happy with the preview, select the *OK, LOCK IT IN!* button, and prepare to share it with everyone you know.

Adding a Buddy Icon

As a default setting, all Flickr accounts are given a buddy icon that is bland—a grey square with two dots and a dash, which happens to look like an unsmiling face (see Figure 2.7). For an artist like you, that type of representation just won't work. So Flickr provides you with the ability to upload or build your own *buddy icon*.

Flickr's community doesn't mind poking fun at the bland icon. There is a group that specializes in photographing objects that look amazingly similar. Visit www.flickr.com/groups/defaulticon/ to look at the group's pool of photos.

While editing your profile, you'll see the link to the buddy icon right next to the heading *Edit Your Profile*. Another link is provided on the your main Flickr home page, which stays there until you've created your own icon. The icon builder provides a number of methods to change it.

You might like to create your own, and if that's the case you can just build an icon that is 48 pixels wide and 48 pixels high, and click the *Choose File* button to select it from your computer. Then you click the *UPLOAD* button and wait for the transfer to complete.

For those not as accomplished with creating tiny graphics, there are three other options available. You can select from an image you've already added to your Flickr account, grab one from your computer, or use one you found on the Internet.

If you've rushed ahead and have already uploaded a photo to Flickr, you can choose option one. You'll be presented with rows of your images to choose from. Select your desired photo to load it into the builder.

If you're following this book step-by-step, then you won't yet have any photographs in Flickr; that exciting moment will come later. So you might choose something on your computer. It doesn't have to be a photograph, just an image file (the supported file formats are JPEG, PNG, non-animated GIF, BMP, and TIFF).

An alternative is to use something you've seen on the Internet. As long as it is one of the file formats I mentioned above, and not a copyrighted image, you can provide the Web address (beginning with "http" or "www"), and Flickr will load it into the builder, ready for you to use.

Using any of these three methods loads the image into the icon builder. The icon builder is a neat tool that displays the image with a nice rectangle that you can maneuver and resize to frame the image correctly (just like the one shown in Figure 2.8). You can constrain this selection to a square or choose to distort the image to your own design. While you're moving the icon around and reshaping it, you'll see a preview of your icon in the browser right above the image your using. When you're happy with your design, click the *Make The Icon* button.

Figure 2.7
The bland default buddy icon—a grey little face.

Figure 2.8
Flickr's tool for creating
your buddy icon.

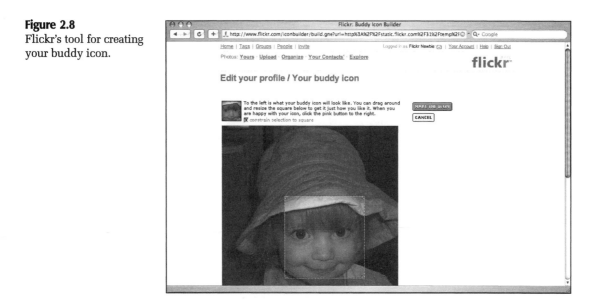

Many people have noted that Flickr's icon builder may not produce the clearest icon. In some cases if you resize an image to 48 pixels wide and 48 pixels high on your own computer, you'll find that the result is much clearer. However, the builder makes creating the icon simple.

Have some fun and play around with a few images, as long as it's one of the file types mentioned previously. You might use a photo or perhaps something a little different like a cartoon character—after all, it's also a reflection of your personality, just like your screen name.

If at any point you want to change your icon, simply click your mouse on your current creation at your *Flickr Home or Profile* page, and you'll be taken back to the icon builder to redo the process.

IMAGE FORMATS

With the amount of TLA (Three Letter Acronyms) used in the computer industry, it's easy to get lost. The trick is to not be intimidated by the jargon; it's only designed to make geeks feel important.

There are many different image file types, all with different file extensions: JPEG, PNG, GIF, BMP, and TIFF. All you need to know at this point is that they are all just different formats in which a computer stores pictures. Technically they are slightly different, with different sizes and qualities (Table 2.1 shows the estimated file sizes for TIFF and JPEG).

If you're not sure whether Flickr will accept an image file you've found, just give it a go. Flickr will soon tell you if you picked something that won't work. (That's how people become gurus—through trial and error.)

TABLE 2.1 DIGITAL CAMERA RESOLUTION AND ESTIMATED MAXIMUM FILE SIZE

Megapixels	File Size (TIFF)	File Size (JPEG)
2	6MB	900K
3	9MB	1.2MB
4	12MB	2MB
5	15MB	2.5MB
6	18MB	3MB

WHAT'S A MEGAPIXEL?

Although a megapixel sounds like a currency used in ancient Aztec cities ("How many megapixels for your cow, friend?"), it's actually a way of describing the quality of a photo taken by a digital camera.

A *pixel* is a single dot in a digital image—if you zoom in using photo-editing software, the square blobs you see are pixels. In fact, if you look close enough at a computer screen, you'll see the individual pixels as well.

A megapixel is a million pixels, and is often advertised as a digital camera feature. At the time of writing this book, a good quality digital camera has four to five megapixels. Some of the world's best digital cameras have 12 megapixels.

One ambitious group called The Gigapxl Project has created a camera that takes photos equivalent to 4,000 megapixels (4 gigapixels). This provides an amazing amount of detail in each photograph. One example is a photograph of the San Diego city skyline. Zooming in on the Marriott hotel reveals the silhouette of the inside of a room.

You can find more examples of their high-resolution photographs at the Gigapxl Project Website (www.gigapxl.org/).

It should also be noted that the higher the megapixels, the larger the file size of the photo. This will affect how many photos you can upload before reaching your limit. See Table 2.1 for a handy reference that shows the different file sizes created by cameras at their maximum resolution setting. Fortunately some of the upload tools allow you to resize before you upload, but if you're keen to keep the best quality in Flickr, a larger file size is the trade-off.

Free Account versus Pro Account

Flickr offers two types of accounts: free accounts and Pro Accounts. Following are details on the differences.

Free Account

Flickr's free account comes with the following restrictions:

▶ Each month you are limited to uploading 20 megabytes (MB) of photos, which is a little more than 20 photos from a 4.2 megapixel camera set at its highest resolution (see Table 2.1 for estimated photo sizes). In fact, the biggest image size allowed is 5MB, which is a pretty chunky image. Remember that this limit includes every image uploaded in a month, even if you delete them from your account later.

▶ A free account shows only the 200 most recent uploaded photographs—all your photos are there, you just don't get to see them until you upgrade to a Pro Account.

▶ Although you might upload an image that has a bigger resolution, the maximum size it will display is 1024 x 683, which Flickr labels as *Large*. The original size is still stored in Flickr, but it's just not made available in a free account. If you decide to upgrade your account to Pro at a later date, the original size becomes available.

▶ Later I'll talk about *photosets*. For now, it's good enough to know that they are a way of presenting a collection of photos that you might want to clump together. A free account provides you with a maximum of three photosets.

▶ You'll also notice small and very unobtrusive advertisements amongst people's photos. These ads appear only when you and the other person have a free account. Fortunately they are very subtle, and they are sometimes relevant to the photo you're viewing. For instance, looking at photos with the tag *Japan* might generate an advertisement for leasing an apartment in Tokyo.

▶ If you don't use the account for 90 days, Flickr reserves the right to delete it, along with all your stored photos. I've been told that this has never happened, but I wouldn't take the risk with my own photographs.

If you plan to use Flickr on a regular basis, and enjoy its community, it is worth investing a small amount of money to upgrade to a Pro Account. Having bought this book, I'm assuming that you're ready to make that investment, because you're serious about using the application.

Having said that, Flickr promises that there will always be a free account available.

Pro Account

A Pro Account provides some extra benefits that are must-haves if you plan to be a regular Flickr member.

▶ Instead of a 20MB upload limit, you get 2 gigabytes (GB) each month. That's a hundred times more than a free account, which means you can worry less about how many photos you want to load into Flickr, and focus more on taking as many as you can.

▶ For exactly the same reason, you get unlimited storage with the Pro Account. That's right, you can store as many photos as you can jam up your Internet connection. They're all stored there permanently, never deleted, waiting for our future descendants to laugh at our ridiculous fashion sense and cultural quirks.

▶ You also get an unlimited amount of photosets, so showing off your creativity isn't stifled by the limit of just three collections.

▶ Your photos are available in their original high-quality resolution. The only limit is that the file size must be under 10MB, which would only be an issue for people with professional digital cameras.

▶ If you spent some time using your free account, then you may have noticed some of the advertisements. When you upgrade to the Pro Account, these ads disappear.

IF YOUR PRO ACCOUNT EXPIRES

If your Pro Account expires, no photographs are deleted. However, because your account lapses back to a free account, you can view only the last 200 uploaded photos, and only three of your sets.

Since you're here to really delve into using Flickr, it's worthwhile investing in the Pro Account. The Flickrites who run the service make sure that's as easy as signing up—if you haven't yet upgraded, they'll remind you every time you're at your Flickr *Home* page.

If you click on the *Upgrade* link, you can select from a one- or two-year account—costing $24.95 or $47.99 (US dollars). You can pay by Visa, MasterCard, American Express, Discover, or PayPal, or, if paying online makes you nervous, you can send your payment via draft or international money order. The online form will request your credit card details and billing address (if you're not using an existing PayPal account), and can be processed immediately, or within a few days, depending on what method you use.

PAYPAL

When you pay for your account, you might notice that Flickr uses another online service called PayPal. There's no need to be nervous, it's a very reputable company owned by the people who run the eBay online auction Web site.

Now that you've completed your Flickr identity, you're ready to go. You can have a bit of fun uploading some of your photos before you get into exploring the community. After all, you're here to show off your amazing photographic abilities, right?

Chapter 3
Uploading Photographs

Flickr is all about sharing photos, and you can't share them unless you first upload them to your Flickr account. Fortunately there are many different ways for you to upload Aunty Monica's birthday party snapshots, creative portraits of the kid's appendicitis scar, and the dogs practicing karate (no, really, they do practice karate: www.flickr.com/photos/sontheimer/22864970/).

If you run Windows, OS X, or even Linux as your computer's operating system, you'll find some applications that can turn your Flickr photostream into a flood. This chapter explores a few of the tools that are available. First we'll tackle a simple method, which isn't very flexible, and then we'll explore some alternatives.

You might prefer to choose one method and stick to it, or you might find features that work for you on different occasions. For instance, part of Flickr's beauty is the ability to use it anywhere you have an Internet connection and a Web browser. However, if you've just taken 101 shots at your daughter's school play, or returned from a Caribbean cruise, you'll want to upload a batch of photographs at the same time.

PHOTOSTREAM

Flickrites are constantly talking about *photostreams*. Your photostream is simply all the photos that you've uploaded for people to view. Different people might see different photostreams, depending on your privacy settings (see Chapter 6 for details on privacy).

TAGS

Although I'll discuss them in more detail in future chapters, it's worth noting that tags play a major role in Flickr's organization. Essentially, tags are keywords that can be used to describe the content of a photograph. For instance, the tags "dog," "puppy," and "animal" might be used to describe a photograph of a puppy. We'll delve into their importance soon, but you'll notice their inclusion in all the tools in this chapter.

Upload Tools

Flickr provides everything you need to upload and manage your photographs. However, some members who are passionate about the service have created a range of other tools to help. It might be worthwhile using Flickr's upload form to test the waters since it's simple to use, but then try a few alternatives. These include the Flickr Uploadr, 1001, iPhoto plug-in, the Windows XP Explorer, and an address for uploading by e-mail. You'll find many other upload tools, but these are the most popular.

Upload Form

By far the simplest method to upload, and the one that doesn't require any preparation, is the Web form that Flickr provides on the Web site. The link to the tool is available on your *Home* page, labeled as both *Upload* and *Upload Photos*.

From the form (see Figure 3.1) you can select up to six images, as longs as they are one of the standard file types (see "Image Formats" in Chapter 2). You'll also see a place to add *tags* and choose your *privacy settings*; I'll get into those later in the book. For now, just choose a photo or two from your computer and click *UPLOAD*.

As the photo is transmitted, you'll see an animated screen telling you what's happening (see Figure 3.2). Leave this Web page open until it's done. The length of time it takes to upload depends on the file size of the image you're uploading and the speed of your Internet connection; it should take a lot less time over a broadband connection compared with a dial-up connection. Open another browser window if you'd like to carry on working.

Figure 3.1
Flickr's upload form allows you to upload six images at a time.

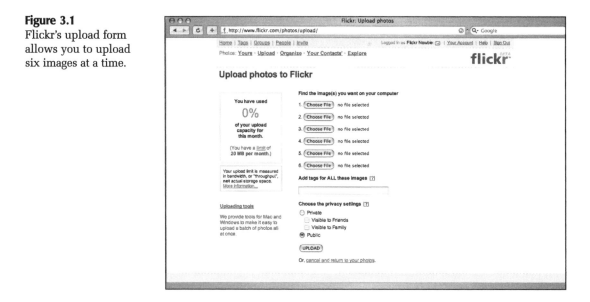

Figure 3.2
Waiting as a photograph
is uploaded with the
Flickr upload form.

Uploading... ●

Please leave this window open while the upload process completes. Meanwhile,
feel free to open a new browser window and continue using Flickr.

When a lot of people are uploading photos all at once, **you may have to wait a
little while** before the photos you are currently uploading appear on Flickr.

If you're watching closely, you'll also see a brief message stating that Flickr is resizing your
photograph. Don't panic; it keeps a copy of the original and also stores it in several different
sizes for convenience; it's automatic, so you don't have to worry. You'll have a thumbnail, small,
medium, and large format.

Once it's completed it will be obvious; you'll be presented with another page to add more detail
to your photo. You can either play with these fields now and *Save* the result, or wait until I
cover the details in the next chapter. You can even skip ahead if you're eager.

On occasion you might upload an image that isn't quite right; some of your photos might be on
their side and need rotating. Don't worry, Flickr provides everything you need to correct this. I'll
get to that in plenty of time.

Once you've tested the tool with a few photos, you can view the results using the link labeled
Yours. You'll see everything you uploaded in your *Photostream.*

MEMORY
When playing with large computer images, you might find that your computer
has to work very hard and slows down. In most cases it's all to do with your
computer's memory. By this I mean its Random Access Memory, or RAM, not
its hard drive. If this becomes frustrating, there are a few solutions: patience,
use smaller images, or buy some more computer memory.

Flickr Uploadr

There are occasions when using the Flickr upload form is the best way to send photos to your
account, like when you're on holiday at an Internet café, or using someone else's computer—but
it's a bit inflexible. Fortunately there are several other ways to do the job.

While you were using the form, you might have noticed a link called *Uploading Tools*, which
also appears on your *Home* page. From there you'll find a list of tools that offer a variety of ways
to get photos from your computer up to Flickr. The first one, *Flickr Uploadr*, is provided by the
Flickr team and offers some great features.

Flickr Uploadr is available for Windows and OS X. Although they look very different (see the
Windows version in Figure 3.3, and compare it with Figure 3.6), the functionality is very
similar. The Windows version also offers a couple of extra tricks, like adding a "Send To Flickr"
option to your right-click menu, and you can rotate your photos before you upload them. These
options are not yet available in the OS X version.

Figure 3.3
Flickr Uploadr for
Windows XP.

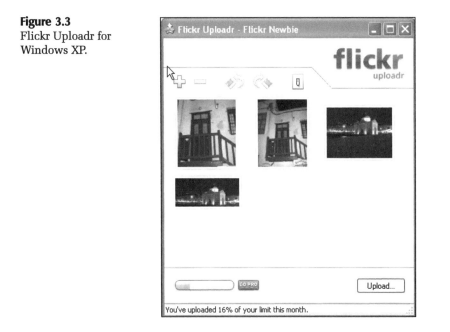

When you launch Flickr Uploadr for the first time, you will be requested to authorize the application (see Figure 3.4). This is a clever security feature to make sure that no one else can read, write, or delete photos in your account. It does this by launching your Web browser for you to log in to Flickr (if you're not logged in already). Once that's done you can return to the Uploadr to finish setting it up. When you launch Uploadr in the future, it will automatically check your credentials, and at any time you can go back to the authorization settings to revoke the application privileges.

From here on it's simple to add a photograph to the Uploadr; you can drag and drop a photo from Windows Explorer or the Mac Finder, or select Upload > Add Photos for the Mac, or click the + icon for Windows.

In the interest of bandwidth, Uploadr will ask whether you want to resize the photograph when it is larger than 800 pixels wide (see Figure 3.5). When it comes to my own photographs, I prefer to keep them the original size on Flickr. That way if I need to edit a photo later, I've got the highest quality image possible. However, if you're using the free account, you might want to conserve some bandwidth, because large images will eat into that very quickly. The prompt explains which size works best for different purposes. However, if you're like me, you can select *Don't Resize* and *Don't Ask Me Again.*

Figure 3.4
The dialog box
requesting that you
authorize the Flickr
Uploadr on OS X.

Flickr Uploadr requires your authorization before it can upload photos to Flickr

Authorizing is a simple process which takes place in your web browser. When you're finished, return to this window to complete authorization and begin using Uploadr.

Quit Authorize

Figure 3.5
Flickr Uploadr will prompt you to resize large images.

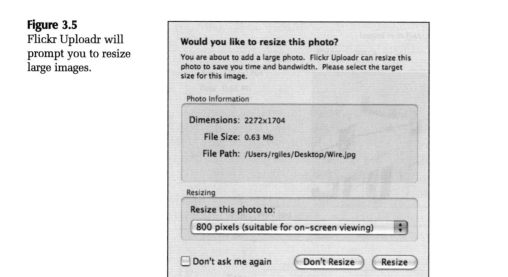

Just like the Flickr upload form, you'll see the *Tags* and *Privacy* fields, with the addition of *Title* and *Description* in OS X and *Create Set* in Windows. I'll explain all this in future chapters; for now just fill in the basics.

The distinct advantage of using the Flickr Uploadr is the ability to upload more than just six photos at a time. I dumped over 300 images that I had laying around on my laptop into the application. However, when dealing with large batches of photographs, be prepared for long upload times, and many hours spent creating titles, descriptions, and tags. When the photographs share a commonality, you can use the Uploadr's batch features as a quick measure. However, you may want to add individual details, and that'll take some time.

Uploadr also informs you of your bandwidth usage for the month, and if it thinks you're going to exceed that limit with your latest batch, it will highlight the numbers of photos and overall size in red (see Figure 3.6). You'll find it easy to push this to the limit with a free account, but 2GB in the Pro Account will give you plenty of room to spare.

Figure 3.6
Flickr Uploadr with a bunch of photos added. Notice the red-colored photo quantity count—a warning that I'm about to exceed the month's size limit.

Once all the photographs are uploaded, you'll be prompted to visit your Flickr account to make any changes to the batch. At this point it's useful to spend a short time adding any extra tags or changing titles or descriptions. That way you don't have to remember to update anything later.

1001

If you're an Apple Mac user, then you're in luck; Flickr has plenty of applications built for OS X, one of which is 1001, created by Adriaan Tijsseling (see the sidebar on the next spread). It doesn't just upload your photographs to Flickr, but integrates with it to provide a few other uses. You can download 1001 at http://1001.kung-foo.tv/.

When you first launch 1001, it will request that you authorize it with Flickr, just like the other uploading tools. Clicking the blue link, as shown in Figure 3.7, will launch your Web browser and take you directly to the authentication page.

Once you've authenticated you'll see why 1001 is unique. Rather than focusing on its upload feature, you'll be thrust into its photostream viewer—the default settings displaying any recent uploads to Flickr by everyone in the community (see Figure 3.8). It's very voyeuristic, offering you an automatic way to view photos that people are uploading around the world, all in real time.

Figure 3.7
1001's authentication request.

Figure 3.8
Recent streams in 1001.

Alternatively, you might want to change some of the *Preferences* settings (see Figure 3.9) to display only photostreams that you've chosen. For example, it's a great way to automatically see what your friends and family are sharing, or you might have a favorite Flickr group or tag you want to monitor. With this in mind, 1001 lets you display photostreams based on contacts, groups, and tags, with the ability to show multiple streams at the same time. It will check periodically with Flickr for updated photos within these streams and displays them on your desktop in an attractive little pop-up window like the one in Figure 3.10.

Once it's grabbed some images, it will store them locally in a cache. That way you can manually cycle through the stream, view a larger version, add it to your *Favorites*, set it as your desktop wallpaper, and even blog about it (see Weblogs in Chapter 9).

1001 also bundles in a screensaver that will display images from your selected photostreams. It includes similar functions accessible with keystrokes: press **f** to add the current image to favorites, **r** to refresh, **s** to save the current image to your desktop, and the arrow keys to skip or rotate.

Figure 3.9
1001's preferences.

Figure 3.10
1001's pop-up
photostream viewer.

When you're done perusing other people's photographs, you can upload your own using 1001. Drag and drop the photo onto 1001's Dock icon or the application itself, or use the menu by selecting Image > Upload. It's similar to the Flickr Uploadr but adds extra functionality like the ability to rotate photos, convert to JPEG, and add to *Groups* before you upload to Flickr (see Figure 3.11).

1001 is a handy uploader, and it's very community focused. Where other applications only allow you to share your photographs, Tijsseling's application involves you in the Flickr community—that's what makes it unique.

Figure 3.11
Uploading to Flickr using 1001.

ADRIAAN TIJSSELING

Adriaan Tijsseling wrote an application called 1001.

Why did you name your application "1001"?

Years ago I was at a friend's place and she had this French book with the title *1001 Images,* which was about how pictures say more than words and stuff like that. The title kind of stuck and since Flickr is a huge medium for sharing pictures, it seemed fitting to name my app "1001."

Why'd you write it?

Flickr is one of the few Web services that also implemented a very rich Application Programming Interface (API) [the way Flickr communicates with other computer programs]. How could I not use that API? I wanted to see the stream of images flowing through Flickr in real time on my desktop, and with Flickr's API it was fun to do.

What is the aim of the software?

It has three purposes. One, uploading images to Flickr, complete with tagging, scaling, rotating, and assigning to sets and/or groups. Two, see what everyone is uploading to Flickr. You can create custom photostreams for contacts, groups or tags, let 1001 check for new images, and then just see each image float by. Three, blogging about your favorite images. Click an image, choose *Blog This,* and your favorite blogging app will be launched to create a new blog entry.

How'd you hear about Flickr?

It was demo'd at E-Tech 2004, but I didn't pay much attention at the time. They were mostly demo'ing the online chat feature, which I wasn't so hot about. A while later I started looking into the photo sharing and that I surely liked.

What do you like about Flickr?

The photo sharing and the tagging. I don't have to keep a photolog or moblog. I put the pictures on Flickr, then tag and share them. Sharing is great; you get to see what cool pictures others made and what other pictures there are for some of your tags.

What's one of your favorite photos you've taken and shared in Flickr, and why?

www.flickr.com/photos/1001/20423255/

I'm originally from the Netherlands, but I've been moving around a lot the last 10 years. Flickr's a great way to show the family back home pictures of my family—in particular, my little daughter. She's got great facial expressions and this one sure got a lot of attention (see Figure 3.12).

What's one of your favorite photos from another Flickr user, and why?

My favorite photo by another user is actually private, so I cannot show it. It's from a very good friend from my time in the U.S. and it shows him with his daughters. It's a very good photo and really typifies him, so that easily became a favorite. I should ask him to make the photo public.

What's your favorite group, and why?

www.flickr.com/groups/gokurousama/

This group was started by a friend of mine. I live in Japan and the service here is incredible. The pictures in this group honor the workers providing great service and has many good portrait shots.

What's your favorite tag, and why?

Either http://flickr.com/photos/tags/japan/clusters/ or http://flickr.com/photos/tags/flower/clusters/

Some of the most stunning images are tagged with these. Check them out and see if I'm right.

Figure 3.12
Adrieaan Tijsseling's daughter, Kee—his favorite photograph on Flickr.

continued

Do you have any interesting stories about Flickr?

Flickr's probably the only way I found out my friends back home are still gossiping about my so-called gaming thumb (http://flickr.com/photos/vondelskater/4688455/). I have three close friends back home, and we would always spend a few hours on the PlayStation. My thumb would get sore and I always blamed it for my poor performance. Obviously, no one wanted to believe me. I had blisters on my thumb!

Are there any hidden features in 1001?

Probably the best feature of 1001 is one that isn't so obvious to users. When uploading photos, tagging can become tedious, but in 1001 you don't need the mouse to check or enter tags. With the tags list active, just type the first few characters of the tag you want to check. 1001 scrolls to it and selects it. Press the enter key to check it. If there is no tag, 1001 automatically creates one and all you have to do is finish the tag. I use it all the time. See http://blog.kung-foo.tv/archives/001269.php.

iPhoto Plug-In

While we're on the subject of Apple applications, Mac fans will be aware of iPhoto (see Figure 3.13). Before OS X 10.4, the application came bundled with an Apple computer, but now it's an extra item that you can buy with the iLife package. It's a great tool, allowing you to store, edit, and share your photographs from your desktop—in many respects it's similar to Flickr. However, it doesn't have the many community aspects that Flickr provides.

Fraser Speirs (see the sidebar), a fan of the two applications, created a plug-in for iPhoto. It provides similar features to other uploading tools, but it sits neatly inside the iPhoto application, creating a symbiotic relationship between it and Flickr. Speirs provides the FlickrExport plug-in through his company, Connected Flow, for free (http://connectedflow.com/flickrexport/).

Installation is straightforward. Follow the prompts, and when it's complete you won't notice that anything has changed. It's not until you delve into the iPhoto menu that you'll notice the difference.

Figure 3.13
Apple's iPhoto
application.

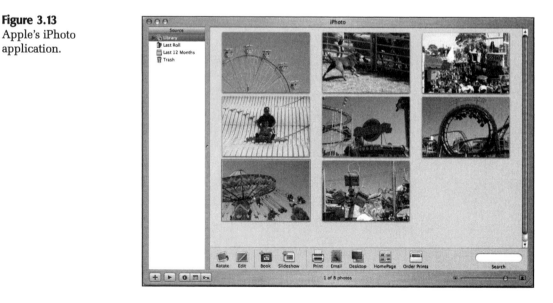

In iPhoto, select Share > Export for the *Export Photos* options. You'll see a range of tabs that include *File*, *Flickr*, *Web Page*, and *QuickTime*. Select *Flickr* and you'll be presented with a window like the one in Figure 3.14 requiring you to authorize the application for use with your Flickr account. Click the *Authorize* button and your Web browser will pop up and prompt you to log in to your Flickr account (if you're not already logged in).

From here you'll notice similar options to all the other tools (see Figure 3.15): bandwidth meter, title, tags, and privacy settings. However, in some instances it's a little more comprehensive. I haven't covered it yet (that's to come in Chapter 4), but you'll notice the plug-in allows you to create a *photoset* and apply it to all the photos you want to upload. It also has a neat search tool that allows you to find photos by title or comments if you've already added some of those details in iPhoto itself.

Once you've selected the photos you want to export and have added the details, click on the *Export* button and iPhoto will begin the upload. If you selected the checkbox labeled *Open Flickr When Export Complete*, when it's done your browser will take you to a list of the photos you've uploaded, and will display text boxes for you to change or add the *Title*, *Description*, and *Tags*. If you didn't select the checkbox, the Export tool will disappear and you can continue to use iPhoto.

Figure 3.14
The iPhoto FlickrExport
authorization.

Figure 3.15
The iPhoto FlickrExport
window.

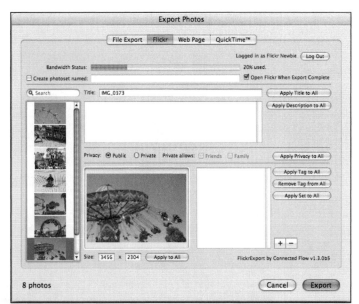

FRASER SPEIRS

Fraser Speirs wrote an application to extend Flickr's functionality to Apple's iPhoto application.

Why'd you write the iPhoto Flickr plug-in?

Simple answer is "because I wanted it for me." I had used the Gallery PHP image hosting program previously, and there was an iPhoto plug-in for that. When I moved to Flickr, I missed that tight integration and figured there was a gap in the market.

What is the aim of the software?

Really just to make people's lives easier. To get out of the way and help people communicate with their friends on Flickr.

What are the plans for the application in the future, if any?

There's been recent pressure to make FlickrExport work in conjunction with Flickr's new Yahoo-merged authentication API. That's been the main focus, but there are some features that users ask for, such as better set management.

One thing I'm trying to avoid is going overboard with features though—there's only so much one can and should do inside an iPhoto plug-in. :-)

How'd you hear about Flickr?

I really can't remember! Probably through someone's blog.

What do you like about Flickr?

The first thing that attracted me to it was the notes on photos feature. What I like about it now is that it's an almost infinite resource of photos that I can dip into and get ideas that enhance and inspire my own photography.

It's also a great source of Creative Commons–licensed photos that you can use for whatever reason.

What's one of your favorite photos you've taken and shared in Flickr, and why?

www.flickr.com/photos/fraserspeirs/15483027

An archway café in Bologna that I captured during a work conference this year (see Figure 3.16). I was consciously trying to ape the style of Cartier-Bresson and I felt that, for the first time, I got a fraction of the way there.

Figure 3.16
Fraser Speirs's favorite photo, an archway café in Bologna.

What's one of your favorite photos from another Flickr user, and why?

www.flickr.com/photos/x180/20404240/

By fellow Mac hacker James Duncan Davidson. I think the reasons are quite obvious! Also, it's Portland—a city I love.

What's your favorite group, and why?

I'm a new owner of a Canon EOS350D, so I'm enjoying being a part of the Canon DSLR group. The Macintosh group is also great.

What's your favorite tag, and why?

"Flight." I love aircraft photography!

Windows XP Explorer

If you use Windows XP, you might prefer not to introduce any extra applications. These days, computer operating systems come with a range of comprehensive tools that provide some great functionality. In some respects the uploader tools we've explored already repeat some of the functions you might already use in other applications. That's where the Windows XP Explorer Wizard will come in handy.

Essentially the Wizard allows you to use Windows Explorer, the application you can use to look at files on your computer, as a tool to upload to Flickr. You can download it directly from www.flickr.com/tools/wizard.reg.

When you download and run the file, a dialog box will appear like the one shown in Figure 3.17. This message is informing you that some changes are being made to the Windows Registry. Making such changes aren't for the faint of heart—we're just lucky the crew at Flickr knows what it's doing.

The install process will also request authentication from Flickr. Unlike most other applications, this will result in a unique key being generated. To grant access to your account you need to copy the key and paste it into the Wizard. From here on in, the application will be able to read and write to your account, enabling it to see all your photos, upload new photos, and add, edit, or delete titles, descriptions, tags, etc.

Once it's installed you can upload photos by finding them in Windows Explorer and selecting the *Publish This File to the Web* in the *File and Folder Tasks* that you'll find in the left-hand pane of the window (just like in Figure 3.18). From there it's similar to other Windows wizards. Follow the prompts: select the photographs you want published, choose Flickr as the location you want them published, authorize the application with the special code, complete the tags and privacy settings, resize if required, and your images will be uploaded to Flickr.

Figure 3.17
A message similar to this will appear when you run the wizard.reg file.

Registry Editor

Information in C:\DOCUME~1\JODIEE~1\LOCALS~1\TEMPOR~1\Content.IE5\TF7BUJEL\WIZARD~1.REG has been successfully entered into the registry.

OK

CHAPTER 3

Figure 3.18
Windows XP Explorer.

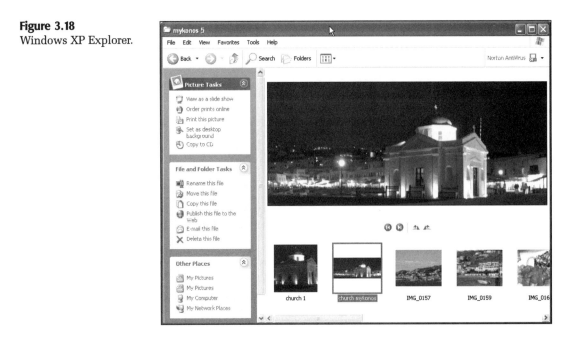

Uploading by E-Mail

Every so often you're not going to have access to your own computer or a Web browser. It might not be a common occurrence, but Flickr provides yet another avenue for you to upload photographs to your account: by e-mail.

You're probably racking your brain, wondering when on earth you'll want to upload photos by e-mail. Some people have found that Flickr's upload tools do not work in certain situations, like from behind a computer network firewall, or when your boss insists everything on the Internet is evil and you should be working anyway. I've also found it handy to e-mail my photos from my camera phone, which I'll explain in Chapter 9—it's a simple way of sending images while on the go.

To e-mail photos you'll need an address. Each Flickr member is allocated a random individual e-mail address; the combination stops people accidentally e-mailing photos to the incorrect account. It might be fun for a short time having other people's photos delivered incorrectly to your photostream, but eventually the enjoyment will wear a bit thin.

To find your personal e-mail address, select the *Your Account* link at the top right of your *Home* page. You'll then find the *Uploading by Email* link that will take you to the page like the one shown in Figure 3.19.

Memorize the address or, better still, click on the *Add This Address to Your Address Book* link to have it sent to you via the e-mail address that was selected when you created your Yahoo ID. When you receive the e-mail, it's a great idea to save it to your address book—that way you don't have to create some strange mnemonic.

When you upload photos by e-mail, use the subject line to give your photo a title, and the body of the e-mail to give it a description. The blank textbox you see in Figure 3.19 is where you add tags that will automatically be added when you use e-mail to upload.

Figure 3.19
Flickr provides you with a unique e-mail address to send your photographs to your account.

Adding some extra flags to your e-mail also allows for specific privacy settings for the individual photograph. You'll explore privacy in more detail in Chapter 6. In the meantime, here is a list of the e-mail flags, assuming your Flickr e-mail is new3ie@photos.flickr.com

▶ Make the photo visible to only your friends: new3ie+friends@photos.flickr.com

▶ Make the photo visible to only your family: new3ie+family@photos.flickr.com

▶ Make the photo visible to only your friends and family:
new3ie+ff@photos.flickr.com

▶ Make the photo visible to only you: new3ie+private@photos.flickr.com

Adding tags is also simple. As well as the default tags you set in the *Upload By Email* settings, you can add a line to the body of the mail that includes the word "tag:" followed by a list of tags.

If you ever get sick of the e-mail address, or you're afraid it's become public knowledge, you can reset it by returning to the *Uploading by Email* section and clicking the RESET button.

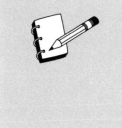

REPLACING A PHOTO

Any photo can be replaced. This allows you to upload a new photo in replacement of an existing one in Flickr. It might sound trivial when you can delete and upload the new version, but replacing keeps all the details intact, like the title, description, tags, comments, notes, and the number of views.

Choose the *Replace* link in the *Additional Information* on a photograph's page. A browse box appears for you to choose the replacement from your computer, and then you can upload.

CHAPTER 3

FLICKR AND LINUX

Currently Linux is mostly the domain of advanced computer users. However, the Linux platform is spreading out and novice users can be found here and there using it as their primary computer operating system. With that in mind, and with a community of people developing applications for the rogue platform, it didn't take me long to find several uploaders that can be used on Linux.

FlickrUploadr is a simple tool similar to the official one available for Windows and Mac (http://micampe.it/things/flickruploadr/).

Flickr Kipi Plugin was created by Vardhman Jain and is available as a plug-in for Digi Kam (http://research.iiit.ac.in/~vardhman/flickrexport/).

jUploadr uses a programming language called Java so it can run on Windows, Mac, and Linux (http://juploadr.sourceforge.net/).

Of course, you can always use the Flickr upload form or e-mail, as these are both platform independent.

Chapter 4
Organizing Photos

Now that you've uploaded some photos into your account, it's time to discover part of Flickr's power. I've mentioned that there is more to Flickr than just storing photos, and so far we've only scratched the surface of Flickr's abilities. In this chapter I'll start to show you just how clever Flickr can be.

In the last three decades we've seen some interesting advances in camera technology. Kodak took the first digital still photograph in 1975. The digital camera was powered by 16 AA batteries, and weighed over eight pounds (four kilograms). It recorded a black-and-white photograph at .01 megapixels to a tape cassette, not the tiny memory sticks we use today.

However, this hasn't extended to how we catalog photos. Photography has never been easier. Think about camera phones and digital cameras: They allow society to take billions of shots each year. In 2004, amateur photographers in the United States alone took 28 billion photos. I personally can take over a hundred photos in a weekend outing with my wife and daughter without my finger blistering up. But how do I extend these advances to my photo album?

As recently as the nineties my friends wrote descriptions on the back of photographic prints; how else would they remember the date the snapshot was taken, or the name of the strange mustached aunt? I found these scribblings just as important when receiving photos from relatives around the world.

Once the photos had been processed at the lab and labeled on the back, they were arranged neatly in an album in some artistic order; beautiful in its synchronicity until the glue that held the photos in place wore off and all the photos fell out the bottom.

This is why computers are invaluable: There is no need for sticky substances, you can label photos with any number of details, and searching is a breeze.

With so many photos, it's difficult to quickly find those memories we're searching for. That's why it is important to provide detail for each photograph you take. Just like labeling the back of a print, you can add extra data in Flickr that helps catalog your collection.

CORY DOCTOROW

Cory Doctorow is a published science fiction author, with titles like *Down and Out in the Magic Kingdom* and *Someone Comes to Town, Someone Leaves Town*. He is co-editor of the popular Web site Boing Boing, and works for the Electronic Freedom Foundation as their European Affairs Coordinator.

How'd you hear about Flickr?

I was an advisor to the company that invented it, and I suggested some of the initial ideas that germinated into Flickr to Stewart Butterfield, the founder, over breakfast in the Mission one morning.

What do you like about Flickr?

Practically everything. It's playful, easy, moderately priced, feature rich but not overwhelming. I like that it's (much, much) faster to use and search than iPhoto is on my own damned Powerbook, so I keep copies of my photos there to search.

What's one of your favorite photos from another Flickr user, and why?

http://flickr.com/photos/jjlook/15925365/

I love this heavily processed pic of a typical Toronto retail strip. I grew up in Toronto and miss it a lot.

Any interesting stories you have about Flickr?

The woman who took a picture of the guy who flashed her on the NYC subway, Flickred it, and then the *NY Post* picked it up and they ID'd the guy and arrested him.

Being a futurist, where do you see Flickr going?

I'd love to see Flickr make some sense of 12-second video clips taken with little hand-cams and phones!

Title, Description, and Tags

The most logical place to start organizing your Flickr photos is with their *titles*, *descriptions*, and *tags*. All the upload tools I discussed in Chapter 3 provide the ability to add these details. In fact, you can edit each of these whenever you're viewing your own photostream.

Title

On your *Home* page, select the link labeled *Your Photos* and you'll be presented with up to your last 10 uploaded photos. Unless you changed the title when uploading, you'll notice each photo uses the name of the file. Your camera gives each photo file a new name, similar to IMG_256 as seen in Figure 4.1.

These types of titles aren't that helpful; they don't offer the right amount of detail. Click the mouse cursor on the title and it'll change into a text box for you to edit and *SAVE* or *CANCEL*, just like in Figure 4.2. Don't forget to save, or you'll lose the change.

Naming conventions vary throughout Flickrdom. Some people will choose the artistic route and be creative; others will use something more descriptive. Others don't bother to make any changes, so you'll see a cacophony of camera naming conventions. It's a personal choice. I find I'm always in a hurry to upload a batch of photos, and my titles usually end up fairly bland, but occasionally I create something creative or humorous.

Figure 4.1
A photostream without any changes to the title and description.

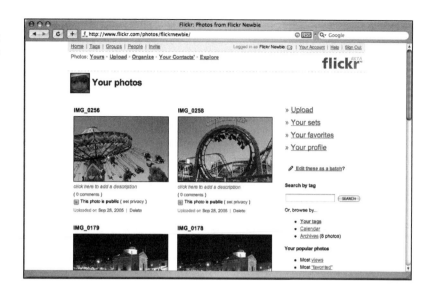

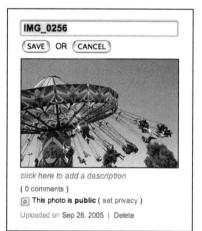

Figure 4.2
The dialog box that appears when you click on the title of the photo.

For a great collection of titles, check out the Entitled group (see Chapter 6 for details on Groups). Flickr member fubuki created it suggesting, "We've all run across photos with clever and outstanding titles that made us grin and laugh. Entitled is a sort of Hall of Fame for the great Flickr stream titles and descriptions of your friends. Let's give props to our creative compatriots—next time you find one of their gems, invite 'em over to share it."

Description

The *description* is a slightly different beast. While surfing Flickr photostreams, I found that a lot of people don't provide a description. I suppose most people use the images to tell the story. However, in some instances descriptions can add to the pleasure of looking at an image. I've lost count of the number of times I've seen some scenery in Flickr with no way of knowing its location. How am I meant to plan my next vacation?

Just like you change a photo's title, you can change the description. Click the cursor on the text *Click Here to Add a Description* (as seen in Figure 4.2), and a large text box will appear like the one in Figure 4.3 for you to add your notes.

You can edit a title and description wherever you see one of your photos, so even when you drill down to the individual photo, you'll have the opportunity.

There doesn't seem to be any size limit imposed on these two fields, so go for your life. In some instances you'll have only a few words to describe your photos, and on other occasions you'll tell a long tale.

If you know some Hyper Text Markup Language (HTML), then you can use a little in your description. This includes the ability to add a Web page link by using the HTML tag "a" and an image using the HTML tag "img." You can also vary the text by adding bold ("b"), block quote ("blockquote"), emphasis ("em"), italics ("i"), strong ("strong"), and underline ("u"). Of course, if I've confused you, you can simply use text.

Tags

I save all my energy for Flickr's *tags*. If you want bang for your buck, then tagging your photos will produce the easiest method for searching, and hours of fun when we explore the community in later chapters.

Tags are keywords that help categorize a photo. It can describe the type of image, like portrait, landscape, or black and white. Or it can sum up the contents of the photo, describing objects like dog, cat, aunt, flower, or me. It can even describe a feeling. Some of the fun applications we'll explore later in the book require other obscure tags. The point is that you'll find a variety of uses for them.

Tags aren't new; they're simple a way to add extra data to your photo collection. Their beauty starts with your creativity. Titles and descriptions seem so bland when presented with the opportunity to add any keywords to your photographs that take your fancy.

Figure 4.3
The dialog box that appears when you click on the description of the photo.

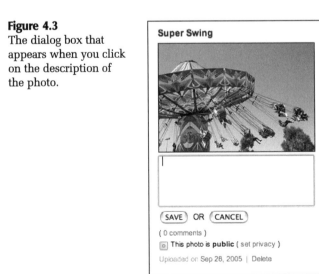

Tagging

If you don't use your upload tool's tag feature, you can tag by drilling down into your photostream. At any point within Flickr you just need to click on the image that you want to edit, and Flickr will displays that photos page. In the *Tags* list on the right, click *Add a Tag* and enter one or more keywords into the text box shown in Figure 4.4.

Each word you enter into the text box will appear as a separate tag. Generally, if you want to use two or more words together as a single phrase, you remove the spaces or enclose the words in double quotes. You'll also see a prompt to *Choose from your tags*. This presents a list of your most popular keywords; based on the amount of times you've used them in the past.

Every photo that is tagged has a list on the right-hand side of the page detailing every tag it has allocated. You can click on any tag and it will produce a new Web page with your photos that you've tagged with the same keyword. If you change your mind, you can also select the *[x]* from the list to remove the tag from that photo.

It's great fun seeing your tag collection amass over time. In a year of earnest Flickring I've collected over 500 different tags, from "honeymoon" to "winniethepooh," and "backlottour" to "renovations." They say a lot about how my life has changed in the last three years.

Depending on another member's privacy settings (we'll explore yours in Chapter 6) you might also have the option to add tags to their photographs. In that respect, adding extra information to a photograph can be a communal activity. Your friends, family, or any Flickrite may want to add another useful keyword.

Browsing Tags

Once you've added tags, you can browse and search photos by specific keywords. There are a number of ways to browse. Flickr provides a popular list, a list of all your tags, and a search with multiple keywords.

On your *Home* page, select *Your Photos* to jump to your photostream, find the list labeled *Or, Browse By* on the right, and select the blue *Your Tags* link. You'll be presented with an alphabetic list of your most popular tags, similar to mine shown in Figure 4.5.

You'll notice that some of the tag names have a larger font size, which depicts how often you have used them. In my case 2005, 2003, mia, and honeymoon rank the highest. If you click any of the tags, you end up in a photostream of every photo using that specific keyword. Sigmund Freud would have had a field day with a list like this.

Figure 4.4
Tagging a photo.

Tags

[] (ADD)
Choose from your tags

Separate each tag with a space:
cameraphone urban moblog. Or to join 2
words together in one tag, use double
quotes: *"daily commute"*.

Figure 4.5
My popular tags. Their size is based on how frequently I've used them.

2001 2002 **2003** 2004 **2005** 7610 acapulco adventurersclub aeroplane airport al **alyssa** ann apple art aruba **aspen** **australia** baby **backlottour** backtothefuture barrels batesmotel bath beach bird birth **birthday** blue bluejackets bootleg boots brian bridge britishcolumbia **bryce** burswood bus cabosanlucas **cake** **cameraphone** **canada** cap carousel castle **cat** catchmeifyoucan **china** **christmas** colin costarica **cruise** **disneyworld** dog donna dvd **easter** **eastperth** eating elephant **florida** food friends grandma great grumman hat **holiday** hollywood **home** **honeymoon** horse hotel **house** icehockey infinity island **jodie** jurassicpark **kahuna** kennedyspace **kensington** **kilee** kings kodaktheatre lorilee **losangeles** mac **magickingdom** mexico mgm **mia** misssandalford mothersday **mum** nanaimo nasa **newyearseve** **night** **nokia** palace **park** **party** perpermintgrove **perth** pleasureisland podcast **pool** **present** presents psycho **rapids** reid **renovations** **richard** richarddale royalshow samantha **sandalford** sha shack siena sign sleep slide southperth spa staples summer **sunset** swanriver swing terri tiger **tva** **tyler** **unitedstates** universalstudio **universalstudios** vancouver venicebeach victoria **vip** wall water **wedding** wildernesslodge wildlife zali **zoo**

An alternative is the traditional list view. Select the *All Your Tags* link at the top of the popular list, and Flickr will provide an alphabetic list split into the columns: name, link, quantity, edit, and delete (similar to Figure 4.6).

This view is more functional. If you'd like to edit your tags, then this is a great location to tackle the task. Select the *Edit* link, and you can change or add to an individual tag. This means that every photo currently using that tag will be altered when you save a change or addition. That's great news when you realize that on several photos you've spelt a word incorrectly, or you need to add an extra keyword.

To change more than a tag, click on the blue keyword (the tag link). The tags page will load and you can select *Edit These as a Batch*. That way you can change or add to the *Title*, *Description*, and *Tags*, for every photo on a single page. This is much easier than editing them one by one.

The traditional list also provides the ability to *Delete* each tag within the whole collection. At any point, if you need to delete a batch of tags—to destroy the evidence—then the delete option in the column will blow away an entire tag, removing it from every photo with which it is associated.

If you prefer, you can narrow down the list to the top 150 tags by simply selecting the option at the top.

Figure 4.6
The start of the list for
all my tags.

The Untagged

Flickr is also clever enough to provide a link to all the photos that haven't been tagged. In the *Did You Know?* section on the right of the popular or traditional list, you're told how many photographs don't have a tag. If you've tagged every photo, you won't see this option, but for any untagged photos you can batch edit them.

Searching Multiple Tags

To find photos that have a match for several tags—perhaps because you have a bunch of photos that have related keywords—you can select the *Searching Through Multiple Tags* link on the right-hand side of your popular or top tags page. A page similar to Figure 4.7 provides the ability to find photographs with all the keywords, or one of the keywords. It's similar to the search feature that we'll explore next, but is handy when you can't remember the name of a tag. It offers you a great pick list for sorting. It initially loads the top 10 tags, but offers the ability to show all of your tags.

Later in the book we'll explore other repercussions of tagging, but at the very least it's a worthwhile exercise to make sorting and searching your own photographs much easier. My recommendation is to try to add as much detail as possible to the photos as you upload them. Uploading small batches and adding the data on a regular basis means you only need to commit a small amount of time at any given moment. Waiting to add detail at a later date is just begging for hard labor in front of a keyboard.

Figure 4.7
A tag search to find any or all tags checked in a pick list.

STRIATIC

Striatic is a member of Flickr's community who has been deeply involved since Ludicorp's Game Neverending. Given his fantastic range of photographs, helpful group commentary, and his bowler hat, he's become a minor celebrity in the community.

How'd you hear about Flickr?

I was on the GNE beta. GNE was a whimsical Web-based graphical MOO-type MMOG that Ludicorp was working on before they decided that they wanted to make some money. One rare day when I wasn't hanging around the GNE chat, my GNE friends yeoz, loli, and capodistria all left IMs for me, urgently telling me to go to dev.flickr.com/ and log in as user "horse" and password "rodeo." I thought to myself something along the lines of "What's a flickr?" and logged in to a skinned version of GNE where instead of sharing cartoon foodstuffs, we'd share photos.

What do you like about Flickr?

The thing I like most about Flickr is the pink *r*. Some say it is magenta, but we all know it is pink. The thing I like second most about Flickr is the incredible range of different people that use it. The range in age, photographic experience, socio-economic background, and geographic location is pretty extreme for an online community. Flickr users are more aligned by a kind of artistic and cultural curiosity than any other factor. That and the fact that we've all bought digital cameras and want a place to dump our snaps.

What's one of your favorite photos you've taken and shared in Flickr, and why?

www.flickr.com/photos/striatic/3406872/

In the subway, and somewhere above me college street is having an identity crisis (see Figure 4.8).

I'm ghostly, and wandering, and every bit the part of the flaneur. It might seem the very height of pretense, but I believe very deeply and very honestly that texture and subtlety are often overwhelmed by blasts of color and intense composition. Sometimes you have to strip things back to their minimal, elemental nature in order to come to an understanding. I like subtleties cast plain, like the subtle shift of uneven titles fracturing the reflection.

As for Flickr, you can easily become overwhelmed in the chase for views and comments and your own personal slice of the explore page.

One of the things I like about this photo is that the response wasn't immense, but some of my favorite people on Flickr took time out to comment. For me, that's the most important thing.

Figure 4.8
A self portrait of Striatic
in Flickr.

What's one of your favorite photos from another Flickr user, and why?

www.flickr.com/photos/underbunny/34279/

In May 2004, Flickr was on the edge of transforming from a Flash-based chat forum primarily for "'snagged" Web shots to a community-based photo-blogging platform. Underbunny was one of the first to prove to me that Flickr was going to be more than a just a place to gab in a browser window, and she did so with peerless poetic eloquence. The hands of an old woman as she lies in her casket—the photo is as carefully composed as the hands are. Though the woman remains entirely anonymous, her wrinkled hands speak to each of her 102 years of life.

What's your favorite group, and why?

flickr.com/groups/circle

"squared circle" was a group that I started up right after Flickr introduced the group photo pools and slideshows. You upload a photo of circular form cropped to a square aspect ratio and add it to the pool. Since this general shape aligns with the ones preceding and following it, an interesting 'morphing' slideshow emerges. It can change how you look at the world for a day or two, noticing all of the circular shapes that surround you. More than that, some talented people have come in and really done interesting things with the group. An excellent programmer and Flickr user, jbum, has done marvelous things like a bot that works with the Flickr API to automatically weed all of the unsquare photos from our pool. Variants on this bot have helped out many other groups since then. He also created generative posters and we did a creative-commons licensing campaign so that he could make prints and sell them back to people at cost. Another user, courtneyp, took orders on lapel buttons based on "squircles" and shipped them all over. The group has served as a unique testing ground for the API, group organization, and promotion. It is about a year old now and has been a lot of fun.

continued

What's your favorite tag, and why?

I like the sketch tag because it can serve as a breath of fresh air after looking at a large volume of photos—so visually different and expressive in a very different way than the rest of Flickr. Like an after-dinner mint.

Any interesting stories about Flickr?

Over the summer of 2005, I went on a trip around North America by train and car and plane and boat, meeting and traveling and staying with Flickr members all along the way. I attended meet-ups in New York, Philadelphia, Washington DC, Durham, Atlanta, Houston, Austin, Phoenix, Los Angeles, San Luis Obispo, San Francisco, Seattle, Vancouver, and Edmonton. One interesting thing of the many interesting things that happened on the trip was learning that people's personalities come across rather well on Flickr. My friend zen (both his Flickr and real name) mentioned that back in the early AOL days he attended meet-ups where very gregarious online personalities would come off as wallflowers in person. After attending the Atlanta meet-up he told me that the Flickr people seemed much closer to their online personas. Maybe that's because when you post and comment on Flickr you are doing so within a social network ... so the same group sees a continuity between two individual photos posted, statements made, and aspects revealed over time. Stories ... there was the time in chat where everyone mimicked the high-contrast black and whitishness of my icon: flickr.com/photos/striatic/9380/ or a bunch of us santa-i-fying our icons over Christmas: flickr.com/photos/striatic/2514796/in/dateposted/ or the fellow who did an oil painting of my user icon and gave it to me: flickr.com/photos/dilly/9160537/in/pool-striaticart/ or my mother's first comment of my photostream, appropriately and embarrassingly regarding the revelation that I had a black sock floating about my apartment: flickr.com/photos/striatic/694948/. I bought a set of buttons from spacing.ca, each button having the tile pattern from a Toronto subway station. The photo was tagged "toronto," and was found through that tag by a contributor to boingboing.net. They blogged it, which led to the spacing.ca people finding my photo and then linking to my photo from their order page because they had neglected to make up an image of the entire set: flickr.com/photos/striatic/4497496/. The great Flickr lightwriting contest, where a number of us raced to be the first to dot the *i* of "Flickr" in liquidlight: flickr.com/photos/striatic/2010229/. My friend Rupauk and I photographing a plane leaving a contrail across the Toronto sky, then discovering that a photographer in Toronto in another neighborhood took a photo of that same contrail within a minute of mine: flickr.com/photos/striatic/4897135/.

Search

Having rigorously tagged every photo in minute detail, you can now explore one of its many benefits: search.

In your photostream you'll find a search box. You can type in a tag to search your collection; however, it won't search for multiple tags, but only a single tag at a time. Clicking the *SEARCH* button will return a page with the resulting photographs shown as thumbnails, and several of its details like title, description, privacy, date, and time (see Figure 4.9). If your search result is greater than 15 photos, it'll split them across multiple pages.

When a single tag isn't enough to find a desired batch of photos, the results page offers you an alternative. You can add the *title* and *description* to the search request by marking the check box on a new search field (seen in Figure 4.11). That way your request will be matched against the other details of your collection. This comes in handy for tags that produce dozens of results, and you need to narrow down the selection.

Figure 4.9
Searching tags.

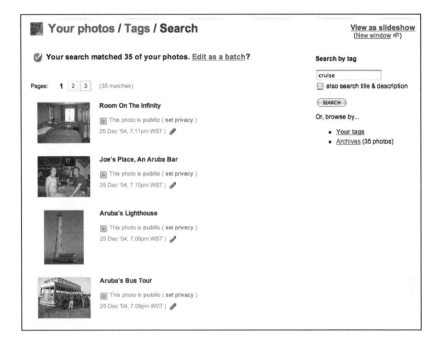

Also on the results page, is a pencil icon; clicking it allows you to edit individual photos. It's exactly the same as editing in other circumstances. The results page also gives you an option to *Edit as a Batch*. This is very handy if you have photographs with the same tag. Every photo found with your search will load into a single page for you to edit the *Title*, *Description*, and *Tags*.

In the *Edit a Batch* section, there is also *Batch Operations*, so instead of changing individual photo tags and privacy settings, you can do it quickly with a single operation. If you like, you can use it to delete every photo the search result generated.

Rotate or Delete a Photo

Two features that will occasionally come in handy, but sit out on a limb of their own, are rotating or deleting. You can find these tools along with a bunch of others when you pick one of your individual photos. Along the top of the image you'll see a toolbar like the one in Figure 4.10.

It's completely trivial, but I've noticed that when my wife takes photographs in a portrait orientation, she holds a camera on its side the opposite way to me. I know this because I'll often have to manually rotate an image 90 degrees one way for my wife and the other for myself. Fortunately, software like the Windows Uploadr and 1001 allow you to do it quickly at the time you upload the photographs—iPhoto even does it automatically—but you can also do this on the Flickr Web site.

Figure 4.10
Flickr's photo toolbar.

ADD NOTE SEND TO GROUP ADD TO SET BLOG THIS ALL SIZES ROTATE DELETE

On the right-hand side of the toolbar you'll see the word *ROTATE*. Click the icon and a dialog box will appear over the top of your photograph with an option to rotate clockwise or counterclockwise (see Figure 4.11). You can select it more than once to rotate the photo 180 degrees—if you're inclined to take photos upside down. Click *OK* when you've achieved the right angle, and all the stored sizes (see the "All Sizes" sidebar) of the photograph will be rotated.

You might find that for a few minutes all the images aren't quiet complete. Be patient, check them when you return later, and you'll find that all is well. It sometimes takes a few moments for Flickr's background computer processes to get everything right.

Flickr can also automatically rotate photographs when they are being uploaded. Some cameras add an orientation detail to a photograph's file using a section of its EXIF data (see the EXIF section in this chapter). When Flickr detects this field in the file it can correct the orientation with which it displays the image without your intervention. To turn this option on, visit *Your Account* and select the *Auto-Magically Rotate* link. Check the box provided and *SAVE* the option.

This may not work every time. A camera determines its orientation with a special sensor. However, under some circumstances, like when you take a photograph facing the floor, it might incorrectly "guess" and add the orientation data anyway. This isn't a disaster, as you can always correct the orientation using the above method.

I find that I rarely need to delete my photographs. With the great privacy features, which I'll explain in Chapter 6, I only need to delete an image when it's a duplicate. Otherwise, with unlimited storage, I can just make it private so only I can see the image. There really isn't any other instance that I can think of that would call for deleting a photograph from Flickr altogether. However, that's just me, and the option is available for any reason you find.

Figure 4.11
The option to rotate a photograph clockwise or counterclockwise.

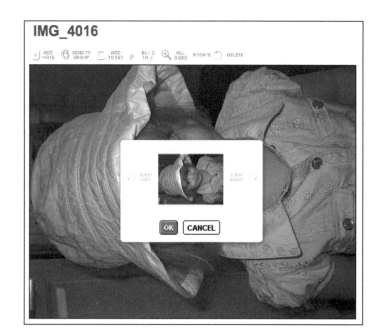

On the toolbar is the Delete tool (Figure 4.10). When you make your selection, you'll be asked to confirm the action; it's permanent, so you'll want to be sure. Any of the extra data like comments or the inclusion in groups and favorites will be lost along with the photograph. You can't reclaim the bandwidth either, so if you're using a free account it's better to avoid uploading unwanted photographs.

ALL SIZES

I mentioned in Chapter 2 that Flickr automatically creates different sizes of your photos. Throughout this chapter, as we explore more of Flickr, you'll see that it uses these different sizes constantly. If you like, you can access these sizes yourself from any photo's toolbar.

Clicking the *All Sizes* icon will take you to the large size, with an option to view other sizes. Each has its own set pixel height and width: Square (75 x 75), Thumbnail (75 x 100), Small (180 x 240), Medium (375 x 500), Large (768 x 1024), and the Original, which depends on your camera's resolution.

At the top of the image you can click on the *Download* link to retrieve the size to keep or use on your computer. Right-click on the link and select "Save Target As" for Windows, and control-click and select "Download Linked File" on a Mac.

At the bottom of each image you will find a Web address that you can e-mail to people for them to view the image on their browser, or some HTML that could come in handy if you have your own Web page (see Chapter 9 for more details) or want to add an image to a Flickr group thread (see Chapter 6).

Notes

Have you ever been addicted to Post-it notes? I worked with a colleague who bordered on lunacy with the little yellow stickies; before long the damn things covered the office. I can see the same thing happening with Flickr's Notes. For examples, see the Flickr noteart group, which has taken the feature's use to the sublime.

On the toolbar you have the option to add a note to a photograph. It might seem a little over the top when you consider the number of ways to add detail to a photo, until you realize that each way has its own advantage. Notes enable you to add the detail right on top of the image. That way if you want to highlight a section or point to an item, you can be very specific about where you place your sticky note.

Click on the toolbar's *NOTE* icon, and up will pop a shapeable rectangle and a text box, like the one in Figure 4.12. Using your cursor, you can drag the rectangle around the photo, pull the corners to reshape, and then add the desired text. Once you've saved it, moving the cursor away from the image will hide the note. When the cursor hovers over the photo you'll see the outline of the note box, and holding the cursor over it will reveal the text. This provides both the note feature and an uninterrupted view of the original photo; a clever way of making sure a photo is uncluttered even when it includes plenty of notes.

Figure 4.12
Adding a note to a
Flickr photograph.

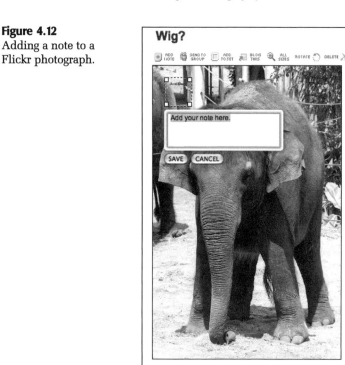

Notes can also contain Hypertext Markup Language (HTML) links. To point to another location on the Internet within the note, use simple HTML to add the functionality. I've used it to point to other photographs in my Flickr photostream.

Flickr member lunaryuna used notes to describe her children in a wonderful photograph (Figure 4.13) that goes beyond a physical representation and provides a few notes on their character.

Figure 4.13
The completed note on
lunaryuna's photo, as it
appears when the
cursor is over the
rectangle for Natasha.

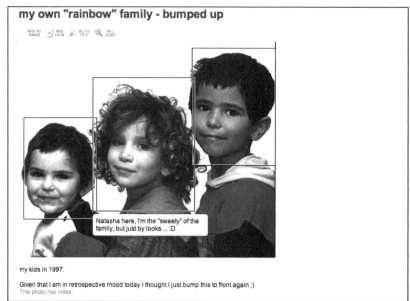

POST-IT NOTE ELVIS

A quick search in Flickr for the keyword "postitnote" results in a great image shared by ih8gates.

Over the Memorial Day weekend in 2005, two enterprising employees of Capstrat, a strategic communications firm, decided to decorate a conference room. Rather than paint a wall, an idea well below the creative muscle of a strategic communicator, they decided to create an Elvis mosaic—with only a collection of Post-it notes.

Choosing Aquatic and Sunbrite from 3M's color palette—who'd have thought they would have their own palette for the notepads—they set about using 10 unique colors, 10 hours, and 2,646 individual notes to construct a psychedelic portrait.

A co-worker, Scott Reston, decided to share the mosaic online; he took a few photographs and posted them to Flickr (see Figure 4.14). Within days the images were viewed several thousand times, and became a hit with webloggers and the media worldwide.

Figure 4.14
Post-it note Elvis designed by Charles Mangin and Todd Coats and shared in ih8gates' photostream.

Organizr

Organizr is a Flickr tool that provides a quicker and easier user interface for organizing your photo collection. It does this from inside a browser window; so you don't have to download a separate application.

You can start Organizr by clicking the *Organize* link on any Flickr page. When it launches (see Figure 4.15), it provides a guide for the three main ways to begin to use its features: load all your photos, select a date range, or search with keywords.

Figure 4.15
You can launch
Organizr by clicking the
Organize link on any
Flickr page.

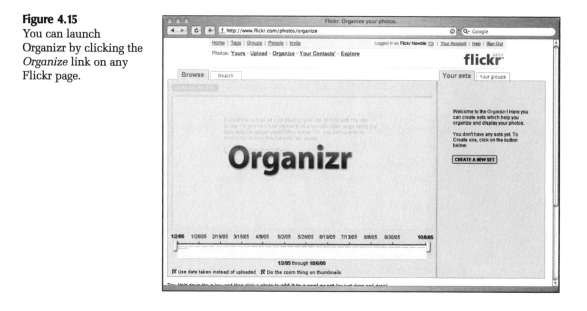

DHTML, FLASH, AND AJAX

Flickr does some very clever tricks in its Web page. If you've surfed the Net for some time, you might notice that Flickr's tools incorporate some funky animations, and operate quickly and smoothly.

Flickr's team of talented programmers achieves this behind the scenes. They use a collection of technologies that sound more like detergents: DHTML, Flash, and AJAX.

In fact, Flickr's team found the AJAX term so amusing that they coined their own version: scrumjax. It then leapt from in-joke to a collection of photographs, and even a T-shirt. View the resulting pool of photos by searching for the tag "scrumjax" in Flickr.

However, members don't need to worry themselves with the technology. The crew behind Flickr aims to make using the tool as simple and pleasant as possible, no matter what the acronyms are.

Load All Your Photos

We'll start by loading all your photographs. At this point you might not have many, or you're a full-blown Flickr addict and you've loaded several year's worth of images into Flickr. I completely understand; I spent the Christmas break of 2004 loading in hundreds of photographs from previous years.

Depending on the number you've added, the tool will load them in to one or multiple windows, displaying a bunch at a time. It presents them as small images, so you can see which ones you'd like to organize, just like Figure 4.16.

Figure 4.16
Tiny images of the
photos loaded into
Organizr.

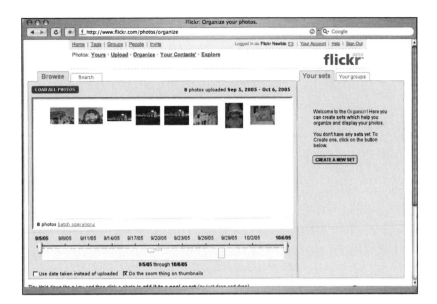

Date Range

Along the bottom of Organizr's photo window, you'll notice a date range (see Figure 4.16). You can toggle this range between the dates your photos were uploaded and the dates they were taken by selecting the check box. Each slice of dates with photos shows up as a bar in the date range—the more photos the larger the bar.

You can see the number of photos contained within a slice by hovering your cursor over the top; clicking on it loads the images from that slice into the Organizr. Alternatively you can drag the two sliders at either end of the date range left or right. That way you can make your own selection of the start and end date for the photos loaded. As you drag the slider, you'll see the value of the range at the bottom of the window.

Search

Search within the Organizr is similar to the photostream search that you explored earlier. The difference is that this search skips straight to searching *Title*, *Description*, and *Tags*. It also loads every photo it finds into the tool for you to edit.

The search window (see Figure 4.17) gives you a selection of your most often and most recently used tags. If you want, you can search for photos that contain multiple tags from your list by selecting the "Search for all checked tags" option. You can then scroll down and select any tags you'd like to include in your search. That way you can search all the checked tags, displaying only the photos that include every one of those selected. Alternatively, if you select the checkbox labeled "Search for any checked tags," the result will produce photos that contain one or more of the selected tags, but not necessarily every one.

Figure 4.17
Organizr's search window provides the ability to search title, description, and tags.

Editing

From the Organizr, select an image and it will present you with a window to edit the details of the photograph (see Figure 4.18). It's all the standard items: *Title*, *Description*, and *Tags* (I'll discuss privacy settings in detail in Chapter 6). If you've already added details to the selection, those will be loaded in as well. That way you can make changes or additions if required.

You can move back and forth within the loaded photostream by selecting the *PREV* or *NEXT* buttons. You can also select to go to the next photo when you save by checking the box cleverly marked *Go to the Next Photo When I Save*. That way you can quickly organize your photos without having to manually load each one.

Figure 4.18
Loading an image into the Organizr allows you to edit its details.

Editing the Date

Organizr also allows you to edit dates. This is handy for several reasons. I have a few photographs from the eighties and nineties that I took with a standard film-based camera. I scanned them in to my computer, but the dates weren't captured within the image, which only occurs with modern digital cameras. However, that's not an issue when Flickr allows you to add dates manually. While viewing an individual photograph in the Organizr, select *Edit Dates* for the editable fields.

I also found this feature handy when I loaded a few hundred photos my wife and I took on our honeymoon. While on the trip, we visited a Walgreens store to have the photos burned to CD. That way we freed up the camera's memory for more photos. Unfortunately, all the photos lost their details, such as the dates they were taken. I needed to manually add these after uploading to Flickr.

If you're not certain of the exact date, Flickr lets you add the month and year, and even provides a flexible option: *Some Time In*. I used this option with the photographs that I scanned because I wasn't sure when they were taken. I could only take a rough guess at the year.

If you need to edit a large batch of dates, then by creating a set (explored shortly) you can batch edit all of them at once. In the Organizr, load the set in the right-hand tab and select the *Batch Edit Dates* option. It provides fields to change the date taken and date uploaded. The first photograph in the set is given the exact date and time you specify, and each progressive photo is incremented a second until every one is redone.

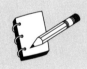

SCANNING PHOTOS

In high school, back in 1987, I was granted special access to the library's computer system. It was an Apple Macintosh, and impressively had a computer scanner—something I'd never seen previously.

I played with a few photographs of Sting, my favorite singer at the time, and the Wildcats, my state's basketball team. The images were all converted to grainy black-and-white pixels on the computer.

Today's scanners can achieve some amazing resolutions. They make a great tool for converting your old photo prints to digital files on your computer. With that in mind, you can convert all your old albums to a trendy Flickr collection.

In some instances you might have some old family photographs, and rather than fret about losing them to age, you can scan and preserve the images in bits and bytes.

When my mom asked me about some old photos from the early twentieth century, my first suggestion was scanning them into her computer.

Just remember my tip about backing up your collection in Chapter 2.

If you're interested in other people's endeavors with a scanner, search for the "scanned" tag, and the groups called "scanned objects—images using a scanner," and "As we were—70's & 80's memories."

Sets

So far Organizr is similar to anything you can achieve in your photostream; it's just a lot quicker and easier to use. However, there is something called *sets* that makes it really powerful.

Your attention has probably been attracted to the *CREATE A NEW SET* button in Organizr. Even if you haven't been tempted to click it already, let me explain its use. Sets are a fantastic way to group your photographs. You create a set to highlight a collection that might have a common theme, story, or feeling. It might be your holiday, wedding, honeymoon, party, favorites, color, or every meal at lunch. Once it's created you can put in any of your photographs, and it will present them as a collection. A single photo can even belong to multiple sets.

Perhaps this is getting confusing: What's the difference between groups and sets? Well, a group is composed of a collection of people that you can add photographs to (which we'll explore in Chapter 6). Sets are collections of photographs only. Think of a group as a club, one you can join to show off your photographs and interact with other members. Sets are more like pin-up boards to show off a selection of your photographs.

Comments can be added to entire sets. Like commenting on an individual photograph, anyone with permission can add commentary. Follow the *Add a Comment* link for a familiar text box. Once a comment has been added to a set, you'll notice that a speech bubble appears on the set's icon in the creator's photostream. Clicking the speech bubble links straight to the comments, rather than the set's photographs.

Creating a Set

The only way to create a set is in Organizr (see Figure 4.19). You simply click the *CREATE A NEW SET* button in the left pane of the Organizr window, and add a title and description that represent the set. You then need to select the photos you want to add before you can save it.

Figure 4.19
Creating a set in Organizr.

Adding to a Set

It's at this point that the Organizr becomes really important. If you have a large collection of photographs, it could be a long process to find the photos you want to add. By using the date range or search function of the Organizr, you can quickly find the batch of photos you want to add. This is made easier the more accurate your photo tagging.

When you find a photo in Organizr that you want to add, you can drag and drop the image into the set, or click the thumbnail while holding down the *a* key on your keyboard. You can pick your way through your photostream a photo at a time, adding each to a set. Fortunately, if you try to add a photo that is already a member of the set, Flickr will let you know without adding it.

If you're not happy with a particular photo in the set, there's a little image of a trash can that you drag the undesirable to. This doesn't remove the photograph from Flickr; it just removes it from the set.

Deleting a Set

You can delete an entire set if you no longer need it. Select the set in Organizr and it provides the *Delete This Set* option. Click the text and a dialog box will ask you to verify the decision. However, this action will not delete all the photographs; it will remove them and erase the set from your account.

Batch

An alternative to adding a single photo at a time is the *batch* function. If you narrow down your search, by using tags, and if necessary by combining them with the date range, you can often find all the photos you want to add. When you click the *Batch Operations* link at the bottom of the photo window, you're presented with some options: add to a new set, add to a current set, change permissions, add tags, delete, and cancel (see Figure 4.20). Whichever of these options you choose, the action will be carried out on every photo loaded into the Organizr.

Figure 4.20
Organizr's batch
function to add to a Set.

Once you've created a set and added the photographs, you have more batch options. You can edit the dates, permissions, and tags of the photos contained in the set, as well as reorder them by the date taken or the date uploaded, or you can reverse the order.

Flickr automatically picks a photo to represent the set and will display it on your photostream page. However, you can be specific and choose your own by dragging the photo in Organizr and dropping it into the section that looks like a stack of photos.

It's important to remember to save the changes you make to the set, or they'll be lost.

Once a photo is added to a set, its individual photo page will sport the set's photostream (see Figure 4.21). This way you can sail up and down the photos, or jump straight to the set. Your sets also appear on the same page as your normal photostream, sporting the photo that was allocated to represent it. Once you're inside the set it also allows you to arrange it by dates taken or uploaded, and contains an edit link for you to make changes to the photos as a batch. There is also a *Make Stuff* option, which I'll discuss in Chapter 5.

Figure 4.21
A set's photostream icon, found in an individual photo's page.

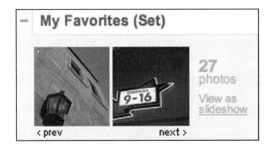

SLIDESHOW

We're all used to slideshows. In fact it conjures feelings of arduous torture camped in front of a projector, watching several hundred photos of a friend's overseas trip. It's been proven time and again that there are several hundred ways of photographing scenery from a moving car (join Flickr's "Boring boring boring" group to enjoy more).

Flickr has its own slideshow feature. From any individual photo's page there is the option to start one for a photostream, set, or group. In each of the boxes that represent the collections, found on the right-hand side of a page, you can start a slideshow by selecting the *View as Slideshow* link.

Every slideshow starts with a default setting of a 5-second interval, but you can change this. If you move the cursor to the top of the slideshow's window, you can change it from 1 to 10 seconds. The same toolbar allows you to skip backward and forward, or pause the show.

If you move the cursor to the bottom of the slideshow window, a group of photographs loaded into the slideshow will appear as thumbnails. Selecting any one of them makes the slideshow jump straight to that image.

If you select the photo that's currently playing, the slideshow will pause and display some of its details: title, description, uploaded by, buddy icon, location, creative-commons status, and the ability to add it to your favorites. You can resume the show, or click a link to open the chosen photograph or member in a new window.

You can also start a slideshow from individual sets, the Organizr, and a tag's search result.

Archives

We've already explored how we can search your photos using title, description, tags, and even the date range. Your Flickr archive lets you explore your collection further by using dates. In your photostream page, there is the *Archives* link in the *Browse By* section.

Date Taken and Posted

Flickr can automatically add the date a photo was taken and uploaded (see the "Details" section toward the end of this chapter to discover how). This allows your archive to be the date of the photo or the date it was uploaded. Once you're at the Archives page you're presented with both lists, similar to Figure 4.22.

These two lists are handy for different reasons. When I first discovered my Flickr addiction, over the Christmas break of 2004, I uploaded several hundred photos—in fact 419, as you can see in my Archives page—and it's handy to know that I can quickly access that batch. Some of the photos I uploaded at that time were from my honeymoon in 2003 (if you look at Figure 4.22, can you guess it was in March?), so an alternative is to explore the date taken list.

If you're like me, and you've uploaded some images that didn't have an exact date, the Archives page also lists the photos from the *Taken Some Time In* category.

Figure 4.22
The Archives' list of dates.

Your photos / Archives

This is a complete archive of all your photos.

By date taken

1999 • December (1)

2000 • October (2)

2001 • December (19)

2002 • January (10)
• August (4)
• September (5)
• October (2)
• November (2)

2003 • February (53)
• March (163)
• April (7)
• May (11)
• June (1)
• July (4)
• October (25)
• November (8)
• December (14)

2004 • January (11)
• February (3)
• March (2)
• April (3)
• May (1)
• June (1)
• July (4)

By date posted

2004 • February (1)
• September (2)
• October (2)
• December (419)

2005 • January (170)
• February (19)
• March (43)
• April (11)
• May (18)
• June (6)
• July (2)
• September (95)
• October (78)

Calendar View

If you prefer to see the archives in a calendar view, like the ones you hang on your wall, then you can select the year or month in either list. Selecting the year generates a calendar view as shown in Figure 4.23, similar to a desk calendar, with rows and columns, and the days highlighted in blue if it holds a photo. Clicking on a blue date will present all the photos taken on that day as thumbnails. If you have enough photos it'll split them across several pages.

Flickr's multiple date views allow you to get a quick snapshot of years, months, and days. It's a great way to reminisce about the past or quickly find photos when you're not certain of the date you took them. You can also access it directly from your photostream page.

Figure 4.23
The Archives' calendar view, similar to a desk calendar.

Detail or List View

When you're in the calendar view, there are two other *view* options: *Detail* or *List*.

▶ The *Detail* view is similar to your photostream page. It provides small versions of the photos for the date you've selected. The page allows you to modify the title and description, and drill down to further detail.

▶ The *List* view shows you the square version of the photos, and is a quick snapshot without the detail.

All these views give you the option to drill down into month or day, and shuffle up and down the date range.

Details

It isn't just average family photographers who have added notation to their photographs. It's been a standard practice for years in many industries, like publishing.

EXIF

In 1996, the Japanese Electronics and Information Technology Industries Association (JEITA) created a way for digital still cameras to record some extra detail within an image file at the time of exposure. Known as Exchangeable Image File Format (EXIF), it can record a large collection of information—much more than an average user could ever want or need.

The current standard allows fields like image width, image height, flash setting, compression scheme, pixel composition, orientation, date and time, equipment, title, and a bunch of very technical details.

There are at least two reasons why this might be of interest. First, Flickr uses the EXIF details to capture the date and time of the photograph. That way you can utilize your archives without having to add it manually. Second, some of the information can be valuable if you want to improve your photography skills.

THE CORRECT DATE AND TIME

Note that the technology that cameras use does not enable mind reading. At this time they cannot automatically add the correct date and time unless you first set it. So, if you'd like your photographs labeled correctly, it's up to you to consult the camera's manual, and set the date and time yourself. While you're at it, the video recorder probably needs adjusting too.

Using many of today's digital cameras, you have a range of settings. Whether you use a point-and-shoot or a digital SLR, you can adjust many of the settings. When reviewing your photos, you might be happy with one but not with another. With EXIF data you can compare the details: exposure, aperture, focal length, and ISO speed. This might give you the tip you need next time you're out taking photos.

In the *Additional Information* on a particular photo's page there is a link to More Properties. This is where you'll find the EXIF data that's stored within the photograph, similar to Figure 4.24.

Figure 4.24
An example of a photo's EXIF data.

More detail about Wakeboard

Camera:	Canon EOS 350D Digital
Exposure:	0.001 sec (1/1600)
Aperture:	f/8
Focal Length:	200 mm

ISO Speed:	400
Exposure Bias:	0/2 EV
Flash:	Flash did not fire
Orientation:	Normal
X-Resolution:	72 dpi
Y-Resolution:	72 dpi
Software:	QuickTime 7.0.2
Date and Time:	2005:10:08 13:37:54
Host Computer:	Mac OS X 10.4.2
YCbCr Positioning:	Centered
Exposure Program:	Action
Date and Time (Original):	2005:10:08 11:08:32
Date and Time (Digitized):	2005:10:08 11:08:32
Shutter Speed:	697556/65536
Metering Mode:	Pattern
Color Space:	sRGB
Focal Plane X-Resolution:	3954.233 dpi
Focal Plane Y-Resolution:	3958.763 dpi
Compression:	JPEG

Taken on
October 8, 2005 at 11.08am WST

Posted to Flickr
October 8, 2005 at 1.54pm WST

Edit the photo dates

What is EXIF data?

Almost all new digital cameras save JPEG (jpg) files with EXIF (Exchangeable Image File) data. Camera settings and scene information are recorded by the camera into the image file. Examples of stored information are shutter speed, date and time, focal length, exposure compensation, metering pattern and if a flash was used.

Source: Digicamhelp.

Your privacy

If you like, you can prevent the link to your EXIF data from displaying on the photo page. Set this in your privacy options.

PHOTOGRAPHY 101

There are many great books about photography. This book is all about Flickr, so I don't have the leisure of including everything you need to know to improve your photography skills. However, there are some quick bits of information that will make reading the EXIF data in your photos more informative.

Exposure: The basic definition of exposure is the amount of light that is allowed into a camera. This is achieved by the length of time the shutter is open, commonly called exposure, and the aperture.

Aperture: The size of the opening in the camera's lens is called the aperture. The greater the aperture the more light is allowed through. To ensure that nothing in the world is simple, this is measured with something called *f-numbers* or *f-stops*. The smaller the number, the bigger the size of the opening, and the greater the amount of light that is let through the lens.

Focal length: When an image is in focus, the distance between the digital camera's sensor and the center of the lens is measured in millimeters and is called the focal length. It's interesting to note that the wider the lens, the shorter the focal length, and the greater the field of view. A telephoto lens has the opposite effect. It's also handy to know that at a focal length of 50mm, a camera will capture the same field of view as the human eye. Decreasing the focal length will capture more of the scene, and increasing the focal length will capture less.

ISO speed: A hangover from film-based cameras is a setting known as the ISO. This is essentially the sensitivity to light; the higher the number the greater the sensitivity. So a high ISO speed requires less light to generate an image but is also a lot grainier. With advances in camera technology, the images are progressively becoming less grainy, but it's helpful to know when taking photos indoors, at night, or of action.

IPTC

If you already use a digital photo organizer on your computer, you might have heard about IPTC, an acronym for International Press Telecommunications Council. It might sound a little strange that such an organization has anything to do with Flickr, but it makes sense when you delve into a little bit of history.

In the late seventies the IPTC created a standard for transmitting text messages to newspapers, news agencies, and other recipients. It made sense to follow a standard, as is the case when large numbers of people need to access the same information. Since they were influential, having a large membership, the standard was generally accepted.

In the nineties, IPTC collaborated with the Newspaper Association of America (NAA) to develop a standard for "a globally applicable model for all kinds of data," including digital images. It included information such as caption, keywords, credit, copyright, date created, city, province, state, country, byline, headline, and source.

Adobe Systems Incorporated, a computer software maker that specializes in solutions to create, manage, and deliver digital content, adopted part of the IPTC-NAA standard with its Photoshop product. It adds the data right into the image file, so that when it is moved around, the data is still intact. Since then, a number of software products have included the feature, and it has become a common way for many to add additional detail to their photos.

It's for this reason that the crew at Flickr added a feature that reads the IPTC data from a photograph when it is uploaded. That way, some of the fields that you might normally need to add manually simply take the information from the file.

There are many applications that you can use on your computer to add IPTC details. These include Adobe Photoshop, FotoStation, GraphicConverter, IMatch, MediaGrid, and iView MediaPro.

If the right IPTC fields (see the IPTC sidebar) are available in a photograph you're uploading, Flickr will use the IPTC information based on some simple rules:

- ▶ IPTC **keywords** will be added as tags.
- ▶ IPTC **headline** will be used as the title if there is no title specified.
- ▶ IPTC **caption** will be used as the description if there is no description provided.
- ▶ IPTC **created date** will be used as the photo's date if there is no EXIF date available.
- ▶ IPTC city, **province**, **state**, and **country** will be added as tags.

Chapter 5
Do More with Your Photos

I remember the excitement of picking up a batch of printed photos from a local photo-finishing store. Twenty years ago you'd drop off a roll of film and wait several hours or even a day before you could return to pick up the finished product. I'd barely leave the store before opening the envelope and shuffling through my snapshots. I'm not sure if the wait heightened the excitement, but I remember the relief when stores began offering a one-hour service.

In my opinion, the advent of the digital camera means that physical photo prints are close to redundant, but there are a few occasions where a print still matters, like hanging something on the wall. After owning a digital camera for several months, I decided to print several of my snapshots. I wanted to frame several of them to mount at my home's entry. I wanted a collage of events and friends, which to this day is still an unfinished project.

The salesman at the photo-finishing store did a great job convincing my wife and me of the value of quality prints; he'd obviously honed his sales spiel. His rationale was the longevity of prints versus computer hard drives or compact discs. Quality prints should last over a hundred years, he explained, but hard drives fail after several, and there are debates as to the length of the life of CDs and DVDs.

We bought a membership to their print club, guaranteeing 50-cent prints and 100 "free" photos. Five years later, we still have yet to use all 100.

When Flickr launched its public beta, it did not include photo finishing. Its focus was on establishing the ability to build communities, not only sharing photographs with family and friends, but with the world. Other photo sites offered photo-finishing services, like Ofoto (now Kodak EasyShare Gallery), Shutterfly, and Snapfish who used photo sharing as a loss leader to make money from finishing.

FlickrCentral group discussions about printing from Flickr date back to 2004. Some members discovered other printing services and offered advice. However, Flickr listens to its community, and in March 2005 they announced plans to develop photo finishing for its members.

Several months later, Stewart Butterfield announced the introduction on the FlickrBlog. "Over the last year, we've been asked 15,381 times, 'How about printing? When are we going to get printing!?' Today we are happy to answer: 'Today!' You can order prints to be delivered by mail, or pick them up at your local Target store for one-hour printing, even."

At the same time they began piloting several services with other businesses: QOOP for photo books and posters, Englaze for backups to CD or DVD, and real U.S. postage stamps via Zazzle. In this chapter we'll explore the first additional services that have sprung up around Flickr, and how you can send your own and others' photographs for professional printing.

With this service I'll have my home's entry filled with photos in no time.

PRINTING RESOLUTION

I can remember, when I was young, sitting close to my parent's television and staring at the little colored dots that composed the moving picture; no wonder I now use contact lenses. When viewed from a distance the little dots blur into a single large image and fool your eyes into believing the television's image is real.

This same principle applies to digital photographs. Each image is composed of small dots, known as *pixels*, with varying shades of color. In Chapter 2 I explained the meaning of a camera's megapixel count, and the higher the number, the better quality the image that a camera can produce.

Figure 5.1 shows a section of a photograph. Zoomed right into that section you can see the individual pixels.

Pixel count is even more important when printing. The greater the pixel count per printed area, the better quality the print.

An image's pixel count is measured in dots per inch (DPI). This represents the number of printer dots per linear inch. If you measured out one inch on a print and then counted the individual dots created by the printer along that line, you'd have the DPI.

When put into that context, it's obvious that a photo printed at 10 DPI is much grainer than a photo at 300 DPI.

So, what is an ideal DPI for printing? Most printers suggest a DPI over 300, which then has a repercussion on the size of the print.

For instance, if you've taken a photo at 2048 × 1536 pixels (a 3.2-megapixel camera's highest resolution), and then divide each number by 300, you'll find that it can print a photo at 6.83 by 5.12 inches at 300 DPI.

My Canon EOS 350D can take photographs up to 3456 × 2304 in resolution. So I can print each image at up to 11.52 by 7.68 inches at 300 DPI.

QOOP, which prints a range of products from Flickr, suggests the following:

> "An optimal target number should be equal to or larger than 300 DPI. Minimal resolution that we recommend is a number larger than 200 DPI. For resolutions that are smaller than 200 DPI, we recommend choosing a layout with multiple images on a page for best results."

Fortunately, Flickr's printing service calculates what it believes are the best print options for your photographs. It uses the photo's resolution and displays a warning when it thinks the quality won't be achieved: "Due to low image resolution, this photo will appear blurry and grainy if printed."

Following each service's guidelines means you'll receive a high-quality print. That way, no matter how closely I stare at an image, I won't see the dots; they're just too tiny to make out.

Figure 5.1
If you zoom in on a digital photographs, you can see the individual pixels.

Printing Preferences

To start using Flickr's printing options, you first need to set your *Printing Preferences*. Select the *Your Account* link at the top right of a page. Among other options, there are two printing preferences: *Allow Printing* and *Set/Change Your Location for Printing*.

Not only can you print your own photographs, but you can allow others to do so as well. The option is very similar to your photographs' privacy but is activated globally for all of your photographs. Select the *Allow Printing* link and a drop-down list is presented (see Figure 5.2). You can select any one of the options: Only You; You and your family; You and your friends; You, your family and friends; You and any of your contacts; or Any Flickr member.

The benefits of allowing others to print your photographs vary. Friends and relatives can select your photographs to print. This comes in handy when you live apart, or if you're too frugal to pay for prints for your own family—they can pay for their own, after all. Alternatively, you might be open to sharing your work with anyone, allowing complete strangers to print and frame your photography. Just be careful which photographs you make public.

There are a number of ways to print your photographs, but to use Flickr's own service you need to specify your location. As of this writing, Flickr only provides the ability for members who hold current credit card accounts with a billing address in the United States. They plan to add additional countries as they find partners that service different regions.

Regardless of your location, Flickr suggests you set your region. That way when they add your area, they can keep you up to date. Select the *Set/Change Your Location for Printing* link and answer the question, "Are you in the U.S.?" (see Figure 5.3).

If you select the *NO* button, you can choose which country you currently reside in. Flickr collects this data so that it can prioritize which countries it will focus on for the service. They also highlight other services that offer printing outside the U.S., which we'll explore later in the chapter.

Figure 5.2
Selecting who can print from your Flickr photostream.

CHAPTER 5

Figure 5.3
When you click on the *Set/Change Your Location for Printing* link, Flickr asks if you're a U.S. resident. Prints are available only for U.S. Flickr members at the moment.

If you move to a new country, you can return to *Your Account* and change the setting.

Selecting the *Yes* button updates your Flickr account so that your photo toolbar now has an *ORDER PRINTS* icon, and an icon of a shopping cart appears next to the mail icon at the top of most pages. Now you can get on with the business of printing your collection.

Ordering Prints

Once your account has the printing option activated, each of your photographs has the *ORDER PRINTS* icon added to the toolbar (see Figure 5.4), and each of your sets has a *Make Stuff* option. This makes selecting images to add to your shopping cart quick and simple. Select the icon, or the *Make Stuff* option, and a drop-down list is provided.

If you've chosen an individual photograph, the drop-down list provides a list of print sizes and quantities. The *Make Stuff* option provides a list of different options. To order prints, simply select *Order Prints*.

Print Size and Quantity

In the *ORDER PRINTS* drop-down list, Flickr determines the resolution of your photograph and provides a list of recommended sizes. If the resolution is too low, which may mean the quality of the photograph is compromised (see the previous "Printing Resolution" sidebar), it provides the option of ordering prints but in a separate *Not Recommended* list.

In a set's *Order Prints* menu it doesn't recommend sizes, but you can turn on the display of all the photograph's resolutions. That way you can determine the best print size yourself.

The most common photograph print size today is 6 × 4 inches; walk in to any photo-finishing store and ask for a roll of film to be developed, and they'll produce prints at these dimensions. However, you might want a photo for your wallet, purse, frame, or poster, so Flickr offers plenty of choices. Select the *More Options* link for a greater list of sizes.

Figure 5.4
Flickr's ORDER
PRINTS icon and
drop-down print size
and quantity list.

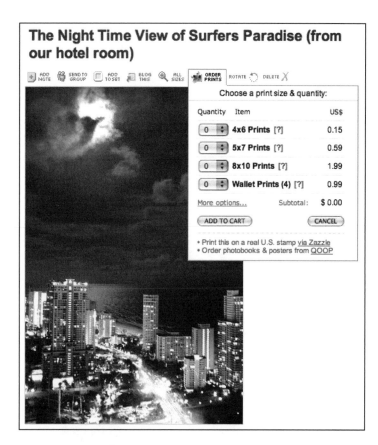

Table 5.1 provides a list of these options, and the minimum photograph resolution that it uses to make recommendations.

TABLE 5.1 PHOTO PRINTING AND MINIMUM RESOLUTION

Print Size	Minimum Resolution
Wallet Prints (× 4) 2.5" × 3.5"	525 × 375
4" × 6"	900 × 600
5" × 7"	1050 × 750
8" × 10"	1500 × 1200
20" × 30"	1600 × 1200
5" × 5" square	750 × 750
4" × D (digital aspect)	900 × 600
5" × D (digital aspect)	1050 × 750
8" × D (digital aspect)	1500 × 1200

Although Flickr determines its recommendations automatically when in an individual photo's page, you might like to check the resolution of your image. Any computer photo-editing software will provide this information, and Flickr captures the details from the EXIF data that we explored in Chapter 4. On the photograph's Flickr page, choose the More Properties link found under *Additional Information*. It lists the *Image Width* and *Image Length* pixel counts.

Click the ? symbol beside any of the print sizes, and it will remind you of the minimum suggested resolution.

Once you've decided on print sizes and quantities at an individual photo's page, you can select the desired number from the drop-down list and the subtotal value in the menu will update. To proceed, click the *ADD TO CART* button.

Flickr will offer the option to continue browsing photographs, or to proceed to the cart (see Figure 5.5). Select the *CONTINUE BROWSING* button and the menu disappears for you to continue using Flickr. The items you've selected will stay in your shopping cart for you to return to later by selecting the cart icon. Alternatively, select the *PROCEED TO CART* button to check your order.

Figure 5.5
Once you've requested specific prints, you may continue browsing or proceed to your shopping cart.

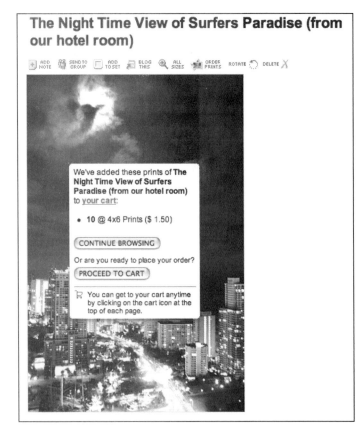

MAXIMUM PRINT QUANTITY
Although the Order Prints menu only provides for up to 10 prints of each size, when you move on to the cart, you can increase that number.

DIGITAL ASPECT

Traditional 35mm cameras (those old analogue cameras that use rolls of film) were made to take photographs with a size ratio of 2 × 3. If you print the whole image, the width will measure 150 percent more than the height. Or, phrased a different way, the image will fit exactly onto a 4" × 6" print.

Most compact digital cameras don't use a 2 × 3 aspect ratio; they capture images in a 3 × 4 aspect ratio. So to fit an image onto 4" × 6" print, a percentage of the image has to be cropped (see Figure 5.6).

However, Flickr also offers digital aspect print sizes. That way a photograph doesn't require cropping; the whole image is printed.

Check your camera's resolution, because some cameras, like digital SLRs, maintain a 2 × 3 aspect ratio.

Figure 5.6
A photograph taken with a compact digital camera at a 3 × 4 aspect ratio, and the transparent border showing the cropping required to reduce the photo to 2 × 3.

CHAPTER 5

Cart

Your cart is always available. Select the shopping cart icon at the top right of most pages, and your unpurchased items will be listed.

In your shopping cart page (see Figure 5.7) you can select the delivery method, update quantities, remove unwanted selections, add other sizes, and review the pricing—a comprehensive way to make changes or confirm your selections.

Target

Flickr offers two methods to receive your prints: You can visit a local Target store or have the prints mailed.

For speedy gratification, your prints can be developed at a local Target store. With 1,300 stores in 47 states, if you're a resident of the United States it's likely that you live nearby at least one store. All year round you can select a store and pay a visit to pick up your prints within hours (or the next business day, if ordered after 5 P.M.).

To find the location of a nearby Target store, and to select it as your method of delivery, follow the *Select a Target Store for Pickup* link. A pop-up window then prompts you to select a state and city (see Figure 5.8), or return to the shopping cart by choosing the mail delivery method.

Figure 5.7
Flickr's shopping cart.

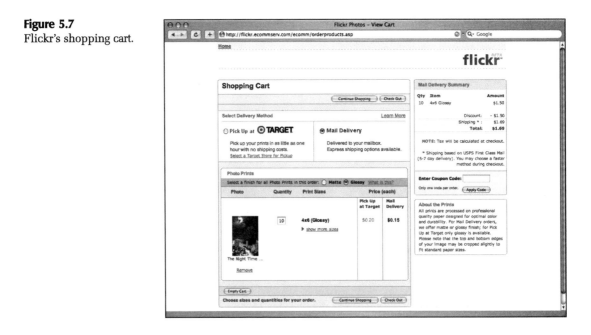

BULK ORDERS
If you plan to order more than 100 prints from Target, you may have to wait up to 24 hours for the prints to be ready.

Figure 5.8
Choose a state and city
to determine your local
Target store.

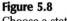

Select your state, and the city drop-down list will be populated with cities. Once you've selected one, the window will refresh with a list of nearby Target stores, each with details including address, phone number, hours, and processing time (see Figure 5.9).

Yahoo! even provides a map so that you can find the exact location before jumping into your car to pick up your prints (see Figure 5.10).

Figure 5.9
A list of local Target
stores in Los Angeles
for print pickup.

CHAPTER 5

Figure 5.10
A Yahoo! map for
Target's Commerce store
at 5600 Whittier
Boulevard in Los
Angeles.

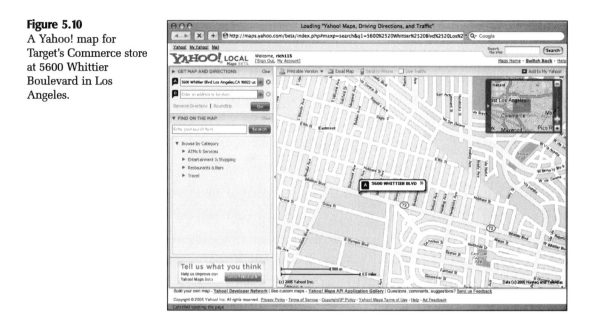

Mail Delivery

If there is no rush to lay your hands on your prints, you can opt for delivery. Flickr ships your order anywhere in the U.S. via economy, express, second business day, or overnight shipping. The actual cost of the prints is less compared to picking them up at Target, but there is a delivery charge that varies depending on the speed.

MATTE OR GLOSSY?

When selecting mail delivery, there are two options available for the finish of photos: matte or glossy. The choice is mostly personal preference; some people prefer a shiny, or glossy, finish to the photos, and others prefer a dull, or matte, finish. It depends on the paper used for printing.

At present, if you pick up the photos from Target, only a glossy finish is available.

Pickup

Selecting the Target pickup option, and clicking the *Check Out* button leads to a new form (see Figure 5.11). Specify several details of the person picking up the order: first name, last name, daytime phone number, and e-mail address (used to provide an e-mail confirmation). This means you can specify someone else to pick up your order, which turns out to be a great way of shipping photos across the country to friends and family.

No shipping or billing details are required for pickup. Orders are paid for at the chosen Target store when they are picked up.

Select the *Continue* button to review the order.

Figure 5.11
The form for providing details for Target pickup.

Shipping

Selecting the delivery option, and clicking the *Check Out* button leads to a new form to specify your shipping address (see Figure 5.12). There is also the option to save the address for future use, which will then be presented the next time you place an order. The address doesn't have to be your own, because you might choose to ship photos directly to friends or family.

There is also a section to choose the shipping method. Each option provides a price and an estimated date of arrival.

Select the *Continue* button to proceed to the billing form.

Figure 5.12
The form for providing shipping details.

CHAPTER 5

Billing

The billing form (see Figure 5.13), for the delivery option only, allows the use of the shipping address as a billing address, or provides a new form for a different location. Credit card details must then be provided for the payment.

Review

Both pickup and delivery options provide a review of your orders. Of course, they differ in the details displayed, providing shipping or pickup details depending on the selected option (Figure 5.14 shows the review for a pickup order).

This page allows you to make changes to the pickup or delivery details and, if everything is correct, send the order.

Confirmation

Once you've selected the *Send Order* button, the pickup or delivery process is under way. Flickr provides all the details, once again, for you to print or review (see Figure 5.15). An e-mail is also sent to the e-mail address that you provided in the pickup or billing forms. The message displays similar confirmation details.

Now it's just a matter of picking up your order from Target, or waiting for the mail.

Figure 5.13
The delivery billing form.

Figure 5.14
The review of a pickup
order.

Figure 5.15
The confirmation page.

QOOP

QOOP (www.qoop.com) might sound like a strange name for a printing service, but it made a little more sense when I discovered that the founders of the company were the entrepreneurs responsible for, among other things, the Snowchuck—a toy designed to aid the creation and hurling of snowballs.

QOOP (the name of the company as well as its printing service) seems to be a departure from their other inventions, like the Snowchuck or Flowboard (a skateboard with 14 wheels allowing tricks similar to surfing or snowboarding)—instead focusing on printing. They offer the ability to turn digital content into products, from books to shirts, and provide their services to a variety of online services like Flickr, Buzznet, and JellyBarn.

Capitalizing on their investment in printing equipment, QOOP also offers high-quality digital document prints at QOOPPrint (www.qoopprint.com), corporate print platform tools at PrintRocket (www.printrocket.com), and weblog printing at Blogprinting (www.blogprinting.com/).

The QOOP team has also received accolades for the quality of their customer service: quick feedback, refunds where required, and some great press about how quickly they implemented a request for a photo book that's all thumbnails in the magazine *Business 2.0* (by Michael Copeland and Om Malik, in the October 26, 2005, issue).

Flickr photographs can all be printed on QOOP books, posters, calendars, postcards, shirts, mugs, and mini-books by following the *QOOP* link in the *ORDER PRINTS* drop-down menu. With printing enabled in your Flickr account, you'll find the icon on any of your photos' toolbars. The link connects you to QOOP's Flickr photo printing page (see Figure 5.16).

From the QOOP page, select the *START PRINTING NOW BUTTON* to begin the process. The first time it's started, QOOP requests "read authorization" from Flickr so it can access all of your public and private photographs. Then it provides a list of print options: photo books, posters, and calendars, with plans for post cards, shirts, mugs, and mini-books (see Figure 5.17).

Figure 5.16
QOOP's Flickr member page.

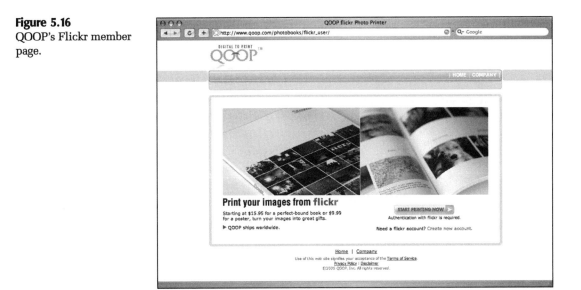

CHAPTER 5

QOOP'S INTERNATIONAL SHIPPING

QOOP launched with worldwide shipping. When you're ready to purchase a product, it provides two delivery options when checking out: International First-Class Mail or DHL Worldwide Priority Express. First Class is the cheapest, but is slower to deliver, taking four to six weeks, with no guarantees. DHL usually only takes a few days.

Figure 5.17
QOOP's print options.

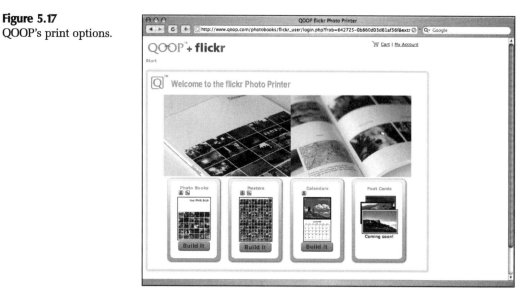

Creating a QOOP Account

QOOP allows new users to create an account upfront, or later while in the process of creating an order. If you're anxious to start your creation, skip ahead and come back when you need to open an account; otherwise, let's look at the process.

From the QOOP Flickr print page, select the *My Account* link at the top right. The resulting page offers two options: Return Customer Sign In, or New Customer. Select the *CREATE NEW ACCOUNT* button if it's your first visit.

QOOP is like any other online service, and its *Create Account* page requires personal details, billing details, and shipping details, and it also has its own terms of service that require acceptance. These details include:

▶ Personal Details: Include basic details like name, e-mail address, and password.

▶ Billing Details: Provide your address, but make sure it is the same as your billing address for your credit card.

▶ Shipping Details: You can use the same details as your billing address, or shipping can go to another location and person; great for sending presents direct to friends or relatives.

▶ Terms of Service: Similar to the legalese that any business uses, but you should read it to ensure that you agree and are willing to abide by the details.

You can also select to receive the QOOP newsletter to learn about new products and services as they become available—a great idea for those people interested in printing their photographs on a regular basis.

Once all the required fields are completed, select the *CONTINUE* button for a message from QOOP. Click *CONTINUE* again to progress to the *My Account* page, where you can modify your details. You'll also receive an e-mail with similar details.

The next time you visit QOOP you can simply log in to your account.

Photo Book

Lets move on to why we're really here. QOOP's most popular service is their photo book. From one of your photo pages on Flickr, select the *QOOP* link from the drop-down *ORDER PRINTS* menu. Your browser will be directed to QOOP's Flickr photo printer page (see Figure 5.16). Click the *START PRINTING NOW* button, and select the *Build It* button below the Photo Books option. You may need to log in to QOOP if your session is not yet active.

QOOP's Photo Book is a collection of your photographs, printed on high-quality paper, and bound in book format. It's perfect as a gift or for setting on your coffee table, depending on what photographs you use. (I wouldn't want to leave photographs from my daughter's birth sitting on a coffee table; it might put my guests off their tea.)

QOOP's quality is of a high standard; you'd have to work hard to match the quality level with your home printer and stapler. All the images are printed at 600 DPI (see the "Printing Resolution" sidebar earlier in the chapter) on 100-pound ultra-gloss paper for perfect-bound books, and on 80-pound digital color paper for saddle-stitch books.

I printed a collection of photographs from my daughter's first two years in a QOOP photo book. My wife, Kilee, proudly showed it to friends and family, and in every case people asked how they could make a similar book for themselves.

PAPER QUALITY

When you delve into the intricacies of paper, it gets a little complicated: size, grade, caliper, and opacity. Fortunately, QOOP looks after the details.

However, it's interesting to note that *basis weight* signifies the weight, in pounds, of 500 sheets (known as a ream). Although the grade of paper has an effect on the basis weight, the major contributor is *caliper*, or the thickness of a sheet of paper expressed in thousandths of an inch.

Multipurpose paper that you'll often find around an office for printing or copying has a basis weight of about 20 pounds. So you can tell that QOOP's photo book paper, at 80 or 100 pounds, is nice and thick, and great for a quality book of your photographs.

Select Photos to Print

Once the *Build It* button is selected, QOOP accesses your Flickr account and loads details from your account (see Figure 5.18). It determines how many photos you have, what sets you've created, and the date ranges for every photo. It then provides three options for selecting photographs: All Photos, Your Sets, or By Date.

- ▶ **All Photos** provides a list of every photo, split into groups of one hundred, so you can select pages or individual images.

- ▶ **Your Sets** provides the ability to select one or more sets, and individual images within each. QOOP recommends this method for creating a book or poster, because Flickr's Organizr is simple and comprehensive for creating groups of photographs.

- ▶ **By Date** provides a list of your photographs grouped by the month they were uploaded. You can select an entire month or individual photographs from each.

Figure 5.18
QOOP's Flickr photo
selection options.

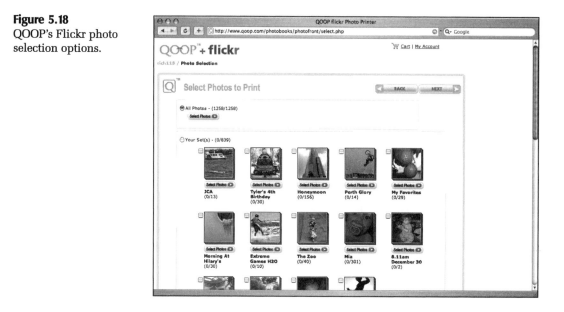

Select one of the options, and click the check boxes to determine which photos will appear in your book. Click the *Select Photos* button if you'd rather refine the photos in sets or dates. Once you've made your choice, click *NEXT* to design the type and layout.

Options

What would a book be without a title, a little bit of layout, binding, and the name happily printed across the spine?

QOOP provides a few options for customization, including title, book size, binding type, and page layout (see Figure 5.19). Each of the choices means an individual style for your book.

Figure 5.19
QOOP's options include
title, size, binding, and
layout.

- ▶ **Cover Title:** The cover can be untitled, you can use your name, or you can provide a main title and subtitle. If you've chosen to use one, it appears at the top right of the cover. Just make sure that it is less than 25 characters or it could be truncated. Your name or main title is also used on the spine if your book is a minimum of 90 pages and is perfect bound. If it's neither, it can't physically fit on the side.
- ▶ **Book Size:** Choose between 8" × 10" and 8.5" × 11".
- ▶ **Binding Type:** Choose between perfect bound and saddle stitch (see the "Binding" sidebar).
- ▶ **Page Layout:** QOOP offers a comprehensive set of layout options. Choose 1, 2, 4, 6, or 20 photos per page. You can add a title, description, page numbering, single or double sided, and logos. It's also worth noting that this will affect the size, price, and, in some cases, the binding type. Image descriptions (printed below the image) are not available in the 20 per page option. Also be careful of the length of titles and descriptions, as they could be truncated if you make them too long.

BINDING

I've often wished I could bind my work in a professional manner. In most cases the best I can do is staple the top left corner. It's never of the highest quality.

QOOP provides a professional look: either saddle stitch or perfect bound. What's the difference?

A *saddle stitch* staples the book twice at the center of the spine. It gets its name from the process used, opening the book to its center page and sitting on a "saddle" while being stapled.

Perfect binding a book gives it a little more of a professional look. The book you're reading is perfect bound: the cover is wrapped around the inner pages and everything is professionally glued together.

There are limits to the size of both QOOP binding techniques. Saddle-stitched books must be between 12 and 84 pages, and perfect-bound books between 28 and 732 pages. If your selection falls below the minimum, blank pages are added to the finished product.

Perfect binding also offers the possibility of a title printed on the spine. However, the book must have a minimum of 90 pages for the text to fit.

CHAPTER 5

Because QOOP prints at 600 DPI, a very high quality, the resolution of your photographs is important. Just like other printers, they recommend high resolutions. They suggest that Flickr's non-Pro members who wish to use the service use no less than the 4 photos per page layout option, because they only have access to the large version of their images (1024 × 768), not the original size. This restricts the quality when printing in larger sizes such as two or one per page.

Once you have the format of your book just right, click the NEXT button to move on to a preview.

Preview

Just before you preview your new photo book, QOOP selects a bunch of photographs to display on the cover. How many it uses, and their size, depends on the number of photos you've chosen. If you're unhappy with its selection, you can select to re-randomize for a new look.

Once QOOP has loaded your photographs and determined the cover's dimensions, it displays a page with the cover, book details, and a preview browser to view the pages (see Figure 5.20). Any of the pages, including the cover, can be selected by clicking your mouse on the image, and it will display a larger preview (see Figure 5.21). However, it offers the warning, "Previews are approximate; actual text wrapping and photo placement may vary slightly in your finished book."

The book details include Flickr member name, cover title, spine title, book length, and the price. If you're unhappy with any of the details you can always select the *BACK* button to return to the *Options* page to make changes. Otherwise, select *CHECKOUT* to continue with your purchase.

Cart Contents

Prior to providing your credit card details, QOOP shows you your shopping cart (see Figure 5.22). This provides an opportunity to make sure you are happy with your selection, update the quantity, and return to the QOOP shop to add another product to the cart.

Delivery Information

When you created your QOOP account, you provided your shipping details. These are displayed on the *Delivery Information* page, but can be changed if you require a different location. It also provides the delivery options: DHL Next Day, DHL Ground, International First Class, or DHL Worldwide Priority Express, depending on your location.

The items first require printing, which can take three to five business days before the order is shipped. Once on its way, your order can be with you a day to a week later. For international orders, the delivery time depends on your location, and can be several days or as many as six weeks, again depending on the address.

Figure 5.20
A preview of QOOP's photo book.

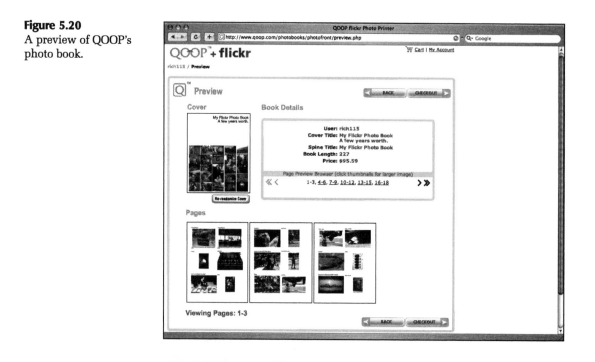

Figure 5.21
A preview of a page from QOOP's photo book.

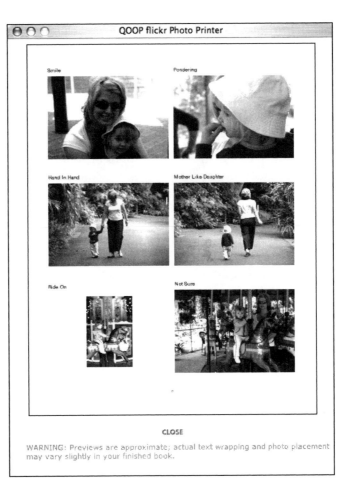

Figure 5.22
Contents of a QOOP cart.

Payment Information and Order Confirmation

QOOP accepts a range of popular credit cards. It's a simple process of providing the correct details and submitting for payment. The credit card is not charged until your order is shipped.

Click *CONTINUE* to submit the details, and a confirmation is provided. You'll also receive an e-mail with all the details confirming your order.

Checking the Status of an Order

At anytime you can return to QOOP to check the status of your order. Select the *My Account* link at the top right of a QOOP page and it displays previous orders. Click on the *VIEW* button and it will display your order, as well as *Status History & Comments*.

Poster

Creating other QOOP products is similar to building a QOOP photo book. The service allows you to select individual photographs, your entire collection, sets, or groups by the date uploaded.

The QOOP poster is a 13.5" × 19" print of a selection of photographs. Depending on the number of photographs you choose, the image size varies; the more you have, the smaller the photograph on the poster. It may also crop some images, and ignore some, because it creates a uniform grid. Including all the images may require blank spaces, which QOOP won't produce. QOOP suggests that you use sets of images with the same orientation and aspect ratio, or at the least ensure that the primary subject is in the center of the photograph for best results.

Once you've chosen your photographs, the design options are provided. Choose to display the images in order (latest Flickr addition first), randomly, add a poster title, or select to include the QOOP and Flickr logo. Select *NEXT* to decide if you'd like to generate a preview.

Depending on the number of photographs you've chosen, QOOP may take a long time to generate a preview. Fortunately there are three preview options: no preview, while you wait, and e-mail when ready.

> ▶ **No Preview:** Choosing this option means you're willing to trust QOOP, and it will proceed straight to the *What's In Your Cart* page.

> ▶ **While You Wait:** This option requires you to keep your browser open, and generates an image as you wait. I selected just over 1,300 photographs, and it took over 15 minutes to generate a preview, whereas 29 photographs took less than a minute. Your mileage may vary, depending on how busy the QOOP service is at the time.

> ▶ **Email When Ready:** For large groups of selected photographs, the third option is appealing. A notification is sent to your e-mail address when the preview is ready, doing all the work in the background, and doesn't require an open browser window. When the preview has been generated, QOOP e-mails you a new URL for you to see the preview (see Figure 5.23) and continue the checkout process.

The rest of the poster-ordering process is the same as when ordering a photo book.

Figure 5.23
A preview of a QOOP
poster.

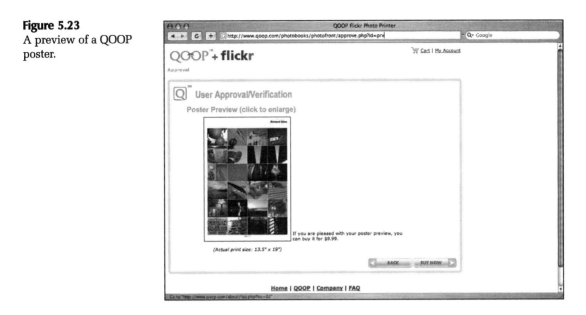

Calendar

QOOP provides a monthly wall-mountable calendar, bound with a coil. It prints an image and associated month, with a cover image of your selection. The whole build process is customizable, ensuring that you choose the images for each month.

Each page is 8.5" × 11", which is a large print. So QOOP provides a warning if it determines that the photographs you supply are not a high enough resolution. They suggest an image resolution of 3,360 pixels wide, but won't complain until the photograph drops below a width of 2,240 pixels. Landscape images work best in this instance, because the photograph's width is always greater than its height. Portrait images will be cropped to fit the page, and this means a lower resolution than the original image.

QOOP will print calendars with the lower resolutions; you just have to be prepared for a grainy photograph.

As with the other QOOP products, you can choose from individual photographs, your entire collection, sets, or groups by the date uploaded. Select the photographs and click the *NEXT* button.

Options

A calendar is very different from a simple photo book or poster. There are several other options that need to be specified (see Figure 5.24).

▶ **Style:** There are three styles available: Full Bleed, Framed—White, and Framed—Black. Full bleed is a printing term that means the image is printed right to the edge of the paper, and there is no border. For the full-bleed option, QOOP prints at 8.7" × 11.2" and trims to a final size of 8.5" × 11". The framed option creates a border, either white or black.

CHAPTER 5

> ▶ **Title:** You can build a calendar with or without a title. A title can be aligned at the bottom or top, and at the left, right, or center.

> ▶ **Image Cropping:** This option is not available for the full-bleed style. Cropping provides a more uniform calendar, but some of the image will be lost. No cropping maintains the original photograph's aspect ratio, but each month's image may vary in size.

> ▶ **Holidays:** At present, QOOP will add U.S., European, and Canadian holidays. You can choose not to include any if the calendar is intended for another region.

Select the *NEXT* button to decide which of your photographs best suits the months of the year.

Image Placement

A beach scene wouldn't be quite right when associated with the month of December, unless you're an Aussie like me. So QOOP allows full-rein in allocating images to the calendar's pages. A simple drag-and-drop tool is loaded into your Web browser (see Figure 5.25).

If you'd rather not place the images, or you already have the correct order, then select the *Auto Flow Images* button and QOOP will add the photographs to the calendar in their sequential order. You can always reshuffle them by dragging images to a different month, and the images will swap places.

Click the *NEXT* button to view a preview.

Preview

The preview page displays a mockup of the final calendar (see Figure 5.26). It shows the cover and each month. Clicking each of the images produces a larger version so you can check that the result is what you desire.

Figure 5.24
QOOP's calendar options.

Figure 5.25
Placing images into
QOOP's calendar.

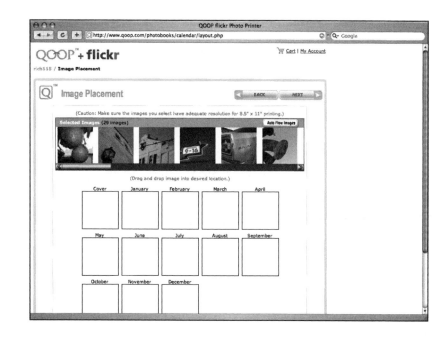

Figure 5.26
QOOP's calendar
preview, with warning
messages.

The calendar's title, holidays, and price are displayed, as well as the note explaining that a hole
will be punched through the bottom of the calendar, half an inch from the edge.

If your photographs are below the minimum resolution (2,240 pixels wide), the preview will
display a warning message. Each page that contains a low-resolution image will be highlighted
in red and marked with three asterisks.

The rest of the calendar-ordering process is the same as ordering a photo book.

QOOP AND IMAGE ERRORS

It's possible that photographs in Flickr have errors. If that's the case, QOOP cannot print them. Errors may occur for a variety of reasons, such as a corrupt file.

If so, QOOP will e-mail you a message during the printing process. You can then exclude the images or fix the errors by replacing the photograph in Flickr and rebuilding the QOOP product.

SIMON PHIPPS

Simon Phipps is Chief Open Source Officer at Sun Microsystems, and a good friend of mine. On his trip to my home town in 2004, we discussed Flickr, and a calendar he'd created from some of his own photographs.

How'd you hear about Flickr?

I was introduced to Flickr by my friend, social software researcher Elizabeth Lane Lawley, who knew Caterina and Stewart from an earlier project. But pretty soon after it launched, it was hard to move in the world of social software development without references to it. I earned a "beta pro" account by signing up friends within a week or so, and bought a real account almost at once when they became available.

What do you like about Flickr?

Plenty. I adore the clueful [a reference to the *Cluetrain Manifesto* mentioned in Chapter 1] informality that the site oozes—always professional, yet never stuffy or officious. I like the use of AJAX on the pages, which makes it feel more like a photo application than a Web site. I like the way that the porn that has inevitably gravitated to the site has not been able to dominate or even, really, become visible to the casual visitor. I like being able to insert photos freely in my blog, www.webmink.net. I really like the way they have embraced Creative Commons licensing. I love their open attitude to their APIs, which has allowed my favorite plug-in for iPhoto on OS X to be written by an otherwise unrelated community member (Flickr Uploadr). And I especially like the way that unexpected and creative uses of photographs keep getting discovered by the eclectic community.

What's one of your favorite photos you've taken and shared in Flickr, and why?

Just one? Tricky. As your book is printing monochrome photos, I'd have to say the photo of an osprey soaring over the Everglades that I took in a rainstorm one summer (see Figure 5.27). We'd endured roasting sun and homicidal mosquitoes to go on a boat tour, and we'd cruised several rivers in a vain search for anything much other than mangroves. As we were crossing a large lake, it went from bad to worse and a small but intense thunderstorm sprang up—at least it kept the mosquitoes off for a while. I saw the osprey flying away from us and risked a few shots to try to capture the bleakness and the bird in the same frame. The photos actually came out monochrome even though they were taken in color! This was the best of the bunch and, after a little leveling, it captured exactly the mood of the scene— becoming what my favorite photographer Galen Rowell called "an icon of the experience."

What's one of your favorite photos from another Flickr user, and why?

I've been adding people to my "Contacts" list for ages now and have a large list of people I follow. I especially enjoy the wonderful flower photos Chrissie [actually Chrissie2003] posts almost every day. The prolific Special also posts great photos regularly.

What's one of your favorite groups, and why?

I'm a member of a load of groups, so that's a hard question too. I am a fan of "Squared Circle," which offers even the beginner a useful exercise in re-visualising scenes. Anyone can look for circles in the world around them and photograph them clearly. It took a flash of genius to collect them into a group, and the animations produced by the group remain fascinating.

What's one of your favorite tags, and why?

The only tag I actually keep an eye on is the "OpenSolaris Enthusiast" tag, which members of the OpenSolaris community use when they post photographs from user group meetings and social events. Watching that one keeps me in touch with what's going on 'round the world.

Figure 5.27
Simon Phipps's photograph of an osprey in the stormy Everglades.

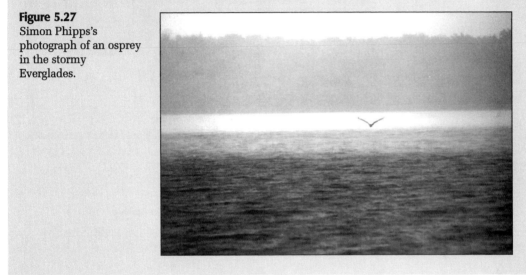

CHAPTER 5

ZazzleStamps

For my wedding my mother-in-law arranged for postage stamps emblazoned with an image of my wife and me. Postal workers around the globe must have had a good laugh at the couple in the photo. However, it was a very kind gesture, and a great idea for any special occasion.

If you're a resident of the U.S., your mug shot, or any other image of your choosing, can wing its way around the earth on U.S. postage. Zazzle has integrated its customized postage stamp service with Flickr, which you can access from any of your photo's pages.

Zazzle (www.zazzle.com) is a lot more than a stamp maker. Their service has a similar ethos to Flickr, providing any Internet user with the tools to publish their art. However, Zazzle takes the extra step, providing the tools to publish on hardware like stamps, mugs, and T-shirts, and they can even make a dime from it (see Figure 5.28). We'll explore its other collections later in the chapter. For now, let's stick to stamps (pun intended).

Like several of the other printing services, you can reach Zazzle through a photograph's toolbar. Select the *ORDER PRINTS* icon for the drop-down menu, and you'll find a link to Zazzle (see Figure 5.29). Selecting it takes you, and your currently selected photo, to the ZazzleStamps design tool.

Figure 5.28
Zazzle allows you to customize a range of products.

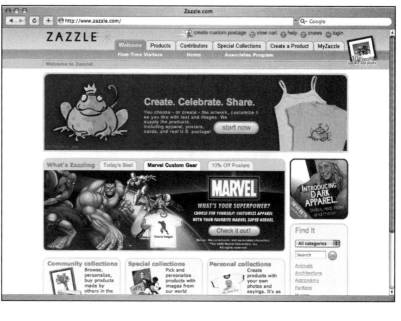

Figure 5.29
The Flickr photograph Order Prints menu.

The design tool displays a preview of a stamp. It's your creation—your photograph added to a U.S. Postal Service stamp. It's really that simple, and if you're happy with the design, you can add it straight to your cart. However, Zazzle allows you to customize the layout.

The left window pane shows the actual design. There are icons at the bottom left of the window that toggle between different design views: workspace overlay, product view, and design view. The bottom-right icons provide a larger preview and revert the design to its original state.

Stamp Info

By default, the ZazzleStamps tool opens with the Stamp Info tab selected (see Figure 5.30). This window shows pricing information and allows changes to the postage rate. The U.S. Postal Service bases postage rates on weight, and Zazzle provides the option to create different denomination stamps: postcard, 1 oz, 1 oz unusual shape, 2 oz, 3 oz, 4 oz, and Priority Mail up to 16 oz. Selecting the ? icon next to the postage rate menu provides a list confirming the rates for each.

Customize It

Not every photograph works well as a stamp, so it may require customization. Select the *Customize It* tab (see Figure 5.31) for several options to modify the stamp, including: orientation, background color, border color, clear side, add text, and change the image.

- ▶ **Orientation:** Choose between a horizontal or vertical stamp.

- ▶ **Background Color:** Choose the color behind the photograph. This only changes the color within the image border, not the entire stamp. If you're familiar with hexadecimal color codes (hex #; see the "Hexadecimal Color Codes" sidebar), you can specify one of the 16,777,216 combinations. That provides plenty of colors to choose from.

- ▶ **Border Color:** Choose from the same number of border colors with the provided colors, or the hexadecimal codes. Border thickness is also adjustable, from 0 to .15%.

- ▶ **Clear Side:** Delete every element other than the actual U.S. Postal Service stamp.

- ▶ **Add Text:** Add your own slogan or statement to the stamp.

CHAPTER 5

Figure 5.30
The ZazzleStamps design tool.

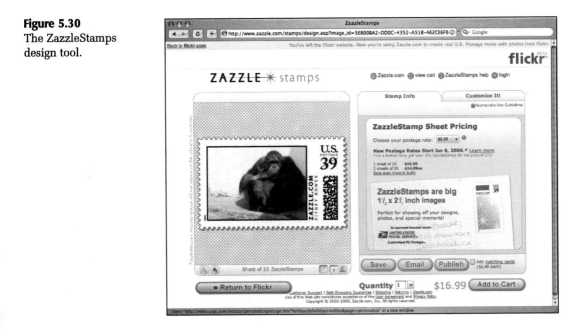

▶ **Upload New Image:** If you'd rather change or add another image, the tab allows uploading a new image. Rather than deleting the original photograph, it simply loads the new image over the top, so if you move the images around, you can add one or more photographs. Blend them into a completely original design.

▶ **Add from My Images:** Zazzle stores all your previous photographs. If you upload, or use Flickr to create a stamp, Zazzle stores the photographs. It saves uploading images that you've used previously. You can add any of these images to the current stamp.

Each design element, such as image and text, has its own settings. You can remove an element completely by selecting the × icon in its window, or you can adjust its settings. Image elements provide the option to move, resize, autosize, rotate, and center. Text elements have options to change the text alignment, size, color, and style from a selection of over 250 fonts.

Figure 5.31
ZazzleStamps design tool's Customize It tab.

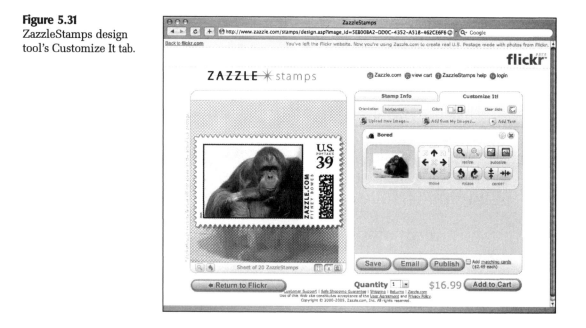

HEXADECIMAL COLOR CODES

Despite conventional wisdom, the traditional base 10 numeral system is not alone. In fact, mathematics has a great variety.

In computing, one such system is hexadecimal. Instead of a base of ten, it uses a base of 16: counting from 1 to F. It's commonly used with computers because it's easier to map to binary.

So a hexadecimal color code consists of six digits, which represent the three basic colors: red, green, and blue. The number #000000 results in black, #FF0000 in red, #00FF00 in green, #0000FF in blue, and #FFFFFF results in white. Everything in between creates shades of the three primary colors. Because of the number of combinations, this provides a possible 16,777,216 shades of color.

You can play with the color code, or many computer software packages can convert or provide the hex numbers. Alternatively, search the Web for a complete table.

Save

At any stage the stamp can be saved. When you return to the Zazzle Web site, select the *My Zazzle* tab from their home page, and choose *In-Progress Designs*. Every product you've saved is stored in your account, and you can continue to edit or delete.

E-Mail

Are you proud of your creation? E-mail the design to a friend or family member.

Click the *Email* button when in the ZazzleStamp tool and a new window will prompt you for details (see Figure 5.32). Enter the recipient's name and e-mail address, as well as your own, and click the *Send It* button. When the e-mail is received, it will contain a preview of your stamp, and allows the reader to visit Zazzle to customize the stamp further or create his or her own. Imagine that—a community-built postage stamp.

Publish

Zazzle isn't only a private tool. I mentioned it was similar to Flickr, because you can publish your creations for others to see and buy. Click the *Publish* button to start the process.

Publication of your very first Zazzle product requires the creation of a gallery. Just like in real life, you need a location to show off your wares. Zazzle follows a process, collecting details such as the gallery description, categories, payee, and payment information. It's then just a matter of naming and captioning the stamp for display.

Figure 5.32
E-mail your Zazzle creation.

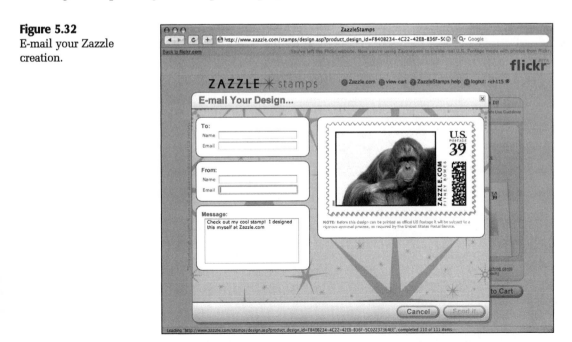

Once you've submitted your work, it goes into a holding pen. Zazzle must first confirm that your work meets the acceptable content requirements for U.S. postage stamps. The list of unacceptable items isn't surprising—it restricts the use of art that is obscene, pornographic, vulgar, sexually suggestive, violent, profane, deceptive, abusive, and so on.

What is most compelling about Zazzle's publication policy is that you earn money when anyone buys your product. Every time someone purchases your work, you receive a royalty. That's not a one-off fee; it's every time a purchase is made. Not only that, if someone customizes your stamp further, you still earn a royalty when the modified stamp is sold.

Zazzle's license is nonexclusive, which means that when you publish your work, you can still use it elsewhere. You own the rights.

Add to Cart

If you've created a stamp for yourself, wanting postal workers worldwide to see your creation, then click the *Add to Cart* button. If you need more than a single sheet of 20 stamps, you can select up to 200. Change the quantity before you head to your shopping cart.

The first time you purchase you're required to create a Zazzle account, if you don't have one already. Follow the process and provide your details, including login details, address, shipping, and payment method. You can then place your order.

Zazzle Collections

Zazzle is worth exploring. Like Flickr, it has its own community, and a mass of artistic collections. Visit the *Products* tab from the Zazzle home page and you can browse apparel, posters and prints, cards, and custom postage. Find anything you like and you can place an order, with a royalty going to the artist.

The special collections category doesn't restrict Zazzle to amateurs; it contains work by Disney, Neopets, Star Wars, and even Marvel comics. If you're interested in personalizing a superhero, you can add names, numbers, and phrases to posters or T-shirts.

ZAZZLE TAGS
Zazzle even added the ability to tag your work. Similar to Flickr, you can add keywords to your work.

PhotoShow DVD

Printing isn't the only way to productize your Flickr photographs. Another Flickr partner, Simple Star, offers a slideshow for your TV that plays on any DVD player.

Simple Star is a software company that has created a name for itself by producing easy-to-use slideshow creation tools. It offers a stand-alone software package that you can purchase for a Windows computer, or you can create a slideshow online with your Flickr photographs by using the PhotoShow DVD service.

The PhotoShow DVD produces a slideshow and is sent to you via mail on DVD. A Flickr set's photographs are played one at a time to music that you select. Each image transitions in a variety of different ways—for example: stars, circles, slides, and fades. The final product is packaged with a case and a picture DVD with an image from your collection, picked by a Simple Star product specialist.

To create a PhotoShow DVD, select a set that you'd like as a slideshow. In the set's page you'll find a *Make Stuff* drop-down menu, with *PhotoShow DVD* as an option. When you select it, your browser will redirect to the PhotoShow Flickr page (see Figure 5.33). Click the *Start Here* button to continue, and Flickr will request that you authorize PhotoShow DVD with read permissions to allow access to all your private photographs. Allow it, and you can begin creating the DVD in the Web-based customization tool.

The PhotoShow DVD customization tool is simple (see Figure 5.34). Choose a PhotoShow style: Simple Slideshow (No Music), Music Video—Pop, Music Video—Jazz, Photo Documentary, Christmas, or Party. Each has its own music (or lack of), type of transitions, and in some cases borders. As you select a new style a preview restarts.

Next up, add the title, creator's name, and the names of the show's stars. This determines the text for the title intro and outro, and the DVD case will also carry the title and creator's name. The title and creator are also printed onto the DVD itself (printed directly onto the DVD surface, not stuck on with a sticker).

Lastly, choose the packaging style from classic, fun, or album, and the quantity of discs required.

Select the *Order Now* button and you'll move to the shopping cart, where you can change quantities and provide your address and payment option.

Figure 5.33
The PhotoShow DVD
Flickr page.

Figure 5.34
The PhotoShow DVD customization tool.

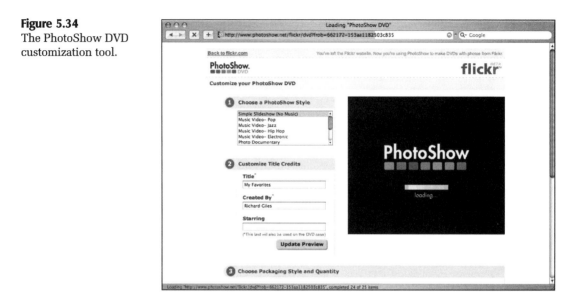

The final PhotoShow DVD contains three playback modes:

▶ **Play Movie:** Displays the slideshow in the same way it is played online.

▶ **Play Looped:** Displays the slideshow continuously, looping back to the start when it is finished. This is great for background images for parties or business events like tradeshows.

▶ **Slide Show:** Displays each photograph one at a time. No transition effects are used, and you must manually skip and replay photos with your remote.

Englaze

I mentioned that one way to protect the longevity of your photographs is by printing them. I've also mentioned the importance of backups. Remember the story of Stewart Butterfield deleting every one of his photographs from Flickr? The poor guy had to start his collection from scratch, losing every one of his old photographs.

That's why the Englaze service is so compelling. It allows you to back up every one of your Flickr photographs, in their original high-resolution version, to a CD or DVD that they will send to you in the mail. Not only that, but it maintains some of the other details from Flickr, like date, description, title, and tags (comments aren't available). All valuable data that you have spent hours creating.

If you'd prefer a more creative form of presenting your collection, Englaze also offers a slideshow DVD called Photoplay.

To use Englaze, point your Web browser to www.flickr.com/do/more/ and click on the Englaze logo, or head straight to www.englaze.com/flickr/. The resulting page (see Figure 5.35) provides the option to use archive or Photoplay. Select the service you'd like to use by clicking on either *Get Started* link. (Both require read permissions from Flickr, and will request authorization.)

Figure 5.35
Englaze's Flickr page.

LONGEVITY OF CD AND DVD MEDIA

I mentioned at the beginning of the chapter the great sales pitch that the photo-processing salesperson used to convince me to print my digital photographs. He alluded to a debate about the longevity of CD and DVD media.

Over the last few years the press has had a field day with an alleged issue called CD or DVD rot. Essentially the story is that some, if not all, CDs and DVDs are susceptible to rotting. The substance used in the disc itself disintegrates over only a few years to leave a CD or DVD useless, with all the data unable to be read.

My first version of the movie *The Matrix* mysteriously stopped working overnight. Who knows if it was DVD rot, or some other mysterious force. It certainly looked like it was still in good condition.

The reality is that CD and DVD media isn't as indestructible as it might appear. No doubt you've suffered from a disc skipping because of a few scratches. Well, there are a number of forces that mean CD and DVD media have a limited life. They may last for over 100 years if manufactured and handled correctly. On the other hand, a cheap disc left out in heat and unprotected from scratches could last less than a few months. Care must be taken if you plan to keep your valuable collection safe.

For instance, Englaze use quality media. They use Taiyo-Yuden CD and DVD media, who give a "100 Year Durability Data Integrity Guarantee." However, Englaze does not offer any guarantee or warranty. As they put it, "The reason we have this disclaimer is that disc quality is beyond our control. We do our best to use a reputable disc manufacturer, but we have no control over the production or quality processes of the manufacturer."

My ethos about backups is that I make regular updates to my archive. I'll only rely on a CD or DVD lasting a few years. I make it a rule to re-backup valuable data every so often. I also use several methods: Flickr and DVDs. It's no guarantee, but it increases the chances of my precious photos lasting.

Archiving

Select the *Create Your Backup Now* link and the Englaze archive application will launch within your Web browser (see Figure 5.36). From here it is simple: add a title, an optional subtitle, and select a cover image.

Figure 5.36
The Web-based Englaze archive application, used to create a backup CD or DVD of your Flickr photostream.

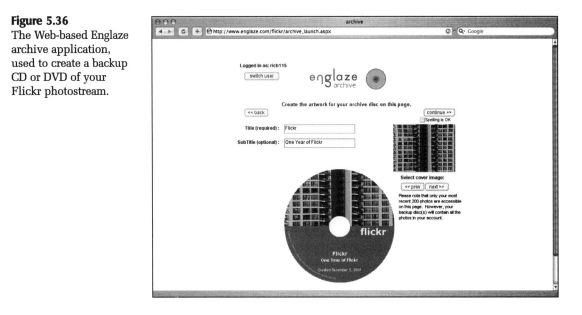

The cover image centers on the CD or DVD, so in some cases, because it crops the image to fit in a semicircle, some photographs don't work. Englaze allows you to cycle through the last 200 photos in your photostream, checking how it appears in the browser.

Once you're happy with the details, select the check box to confirm you've checked the spelling. Nobody wants a DVD showing up on the doorstep with an embarrassing spelling mistake. Then click the *Next* button to provide billing, shipping, and payment details. For the latter, you can specify the type of media and the shipping method. It then displays the total price.

The Englaze archive starts with a set price. When you've selected to back up more than the threshold, the price increases per batch. This price varies depending on which media you choose, CD or DVD.

The finished product is a computer-readable disk. It contains folders with your original photographs split up depending on your sets. There is a folder for the originals with no associated set, and one folder for each set. There is then a selection of HTML files that you can open in your Web browser that lists each photo, with its title, description, tags, and the date it was taken.

It's worth noting that the EXIF data is also preserved in each of the original photographs, so you can use it to re-catalog if necessary.

Photoplay

Englaze Photoplay is similar to Simple Star's PhotoShow DVD. You can select a bunch of photographs to produce a slide show that is viewable on a TV.

Once you've authorized the Englaze Photoplay application with Flickr, it allows you to select all your photographs, or a particular set, for a slideshow. However, if your photostream or selected set exceeds 450 photographs, it won't allow the DVD's creation. After all, there are space limitations on DVD media.

After you've selected a set, a preview of the slideshow is shown on the Web page, with the total running time for the collection (see Figure 5.37). You can tweak some of the other details, like the duration each photograph is shown, or pick the background music from the Englaze collection, including classical, country, jazz, mystery, and sports.

Clicking the *Next* button provides a form for the title, subtitle, optional date, and cover image (see Figure 5.38). You can select an image from the set's photographs, which it centers on the actual DVD media, and it also adds the details from the form. It automatically creates a preview before you move on to the billing, shipping, and payment details.

Figure 5.37
The Web-based Englaze Photoplay application, used to create a slideshow DVD.

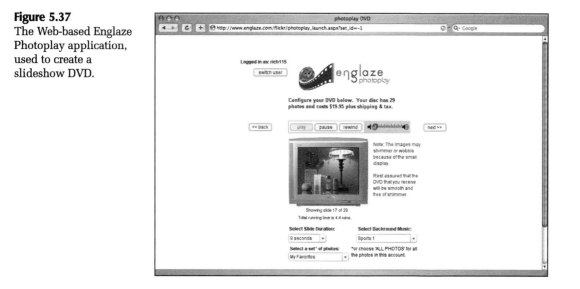

Figure 5.38
Choose a cover image for the Englaze Photoplay DVD from the selected set.

In the years to come we'll rely less on printing. With the advent of new digital frames, like the eStarling Flickr-enabled photo frame from PF Digital Inc. (see Figure 5.39), who will need to print anything? Simply connect a photo frame to your home network, and it'll automatically download photographs to display.

Still, just as computers haven't replaced books, there is a certain amount of pleasure associated with touching a photo print. It'll be difficult to replace them as personalized gifts, and a lot cheaper than filling a wall with small plasma displays. My entryway doesn't need to be that high-tech.

Figure 5.39
The eStarling photo frame that automatically connects wirelessly to Flickr through your home network.

BRYAN CAMPBELL

Bryan Campbell is a co-host on the Flickrcast podcast (see Chapter 8).

How'd you hear about Flickr?

I had heard Flickr mentioned on an old episode of the *Screen Savers*, which was a technology show on Tech TV, a television network that no longer exists. I was very interested in Flickr as a service, but at that point in time I only had a Largan LMini 350. The LMini is a digital camera that I had purchased in 1999; I had no desire to share photos taken with 350,000 pixels (that's less than half a megapixel!). Much later I bought a nice Nikon Coolpix 5200 digital camera, and my friend Jason (co-host of the Flickrcast) sent me one of his two free premium accounts so that I could really take advantage of what Flickr had to offer.

What do you like about Flickr?

There are many things I like about Flickr, but the very best part of Flickr is its community. For the most part, you will notice a peaceful co-existence between amateur and professional photographers alike, or anyone in between. I also love how easy Flickr is to actually use. Some similar Web sites, which I won't name, often make it difficult to find a specific type of image. Flickr has made some huge improvements since I've joined. I'm always excited to see what they will add next.

What made you start the Flickrcast?

In the beginning, I was working on two podcasts, and I lost interest in one of them and eventually decided to quit due to a very obsessive co-host. Now that I was only recording one podcast, it just wasn't enough for me. I wanted to do a podcast that had potential to help people. Well, Jason and I actually talked about doing a podcast together for months, and more specifically I wanted to do one based on Flickr, because at the time there was no podcast about Flickr, and I thought it would be an interesting challenge and might spark some much-needed creativity in my life.

What do you hope to accomplish with Flickrcast?

When I started the Flickrcast, my goal was to help the Flickr community come together even further. Also, I figured that the Flickrcast would simply be a fun thing to do.

What's one of your favorite photos you've taken and shared in Flickr, and why?

It seems that I'm never happy with my photos, not even the ones I post on Flickr (which is a very small percentage of the pictures I take). I do have a few favorites though. One of them is of a sleepy sea lion (see Figure 5.40). I took this picture with my parents' 5-megapixel easy-share digital camera (Kodak CX7525) when we went on vacation to Florida.

www.flickr.com/photos/animefx/23684547/in/set-1011153/

You'll notice I have it placed incorrectly in my Nikon Coolpix 5200 set. My other photo I was extremely pleased with was taken with my current digital camera, the Casio EX-S500. I was going to a wiener roast at my father's pond, and I arrived just as the sun was starting to go down and captured an excellent sunset with silhouettes of grasses and weeds in the foreground.

www.flickr.com/photos/animefx/55251952/

What's one of your favorite photos from another Flickr user, and why?

I've always had a weakness for beautiful women. There is one in particular that Mario EA took, which I would consider my favorite: www.flickr.com/photos/fotosmontt/46822957/. The composition and lighting in this picture are perfect!

Figure 5.4
Bryon Cambell's favorite Flickr picture from his own collection—a sleepy sea lion.

What's one of your favorite groups, and why?

I really enjoy the comiclife group located at www.flickr.com/groups/51492142@N00/. Neil Gorman of the foolish humans podcast sent us an e-mail with information on this group so that we could talk about it in a future podcast. What can I say, I was instantly hooked. Basically, it's a group dedicated to images edited with a computer program called Comic Life (see Chapter 7). Comic Life allows you to take an image and turn it into something you would see in a comic book such as speech balloons, crazy fonts, and color filters to make something look hand-drawn. I also enjoy a group called Tokyo Images, because I think Japan is beautiful.

What's one of your favorite tags, and why?

Stars. I'm not talking about celebrities either, I'm talking astrophotography. Ever since I was a young boy I've been astonished by the mysteries of our universe. Sometimes it's hard to comprehend that we can take pictures of light that originated millions of light years from earth.

Chapter 6
You and Your Friends

In Chapter 4 you discovered how Flickr makes organizing your photo collection easier. In reality this is the power of computing. However, a computer alone doesn't make sharing your photos easy. In fact, storing them on a PC makes sharing more difficult than grabbing a photo album from your bookshelf at a family gathering or dinner party.

Flickr's printing option goes a small way toward helping you share your photos. As I discussed in Chapter 5, printing them and sending them to friends and family worldwide helps share your memories. However, it costs money, and takes time and effort.

That's why storing them on the World Wide Web is so compelling. It solves this problem. It's becoming commonplace in first-world countries for most households to connect to the Internet. In the later half of 2005, almost 60 percent of the U.S. population were active Internet users. So it makes for an incredibly efficient method of sharing almost anything, especially images.

Flickr utilizes the power of the Internet to make sharing just as easy as organizing. In this chapter we'll look at steps involved in sharing your photographs with people you know.

Invitations

Many people like to lead a different life online; it's a place to escape and become a different personality in chat rooms and in virtual games. This is a little more difficult to do in Flickr, because you're exposing your world by sharing photographs. It's not impossible (see the sidebar "Flickr's Underbelly"), but that's not the aim of Flickr. In most cases its intended purpose is to share images of your real world, and a great place to start is with close friends and family.

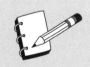

FLICKR'S UNDERBELLY

As with the real world, there is the shadier side of Flickr. Flickr's Terms of Service forbid "Content that is unlawful, harmful, threatening, abusive, harassing, tortious, defamatory, vulgar, obscene, libelous, invasive of another's privacy, hateful, or racially, ethnically or otherwise objectionable," but there are people that subvert the rules.

There have even been cases of virtual flashings (relabeled flashr). Some Flickr members have received Flickr mail informing them that they are a certain member's newest contact. Intrigued by the gesture, they've followed the link to see who sent the mail, only to be greeted with indecent exposure.

You can report violations at Yahoo!'s abuse page, or Flickr's help page provides a form at www.flickr.com/help/website/#7.

Inviting

Along the top of every page in Flickr is the *Invite* link. Select it to jump straight to the form, as seen in Figure 6.1.

You don't have to use the form. You can always just point people to the Flickr home page, and buy them a copy of this book. However, using the form means that they'll automatically become one of your contacts. They'll instantly see the value when they can view some of your amazing photographs.

Contact, Friend, or Family Invitation

The form is very simple. It requires your friend or family member's e-mail address and name. It uses these details to complete a form that you'll see dynamically populated on the right as you type. You then have the option to select two check boxes: *This person is a friend*, or *This person is family*. We'll explore the finer details of this selection later in the section on *Contacts*, but the general gist is that this will have repercussions on which photos you can share with them.

You can choose to send up to three invitations at a single time. Just complete the number of addresses and names that you desire.

Customizing Your Invitation

Flickr provides a standard invitation. It's not fancy, and in a conversational way explains to the contact your desire to share your photographs. "I want to share my photos with you on a cool site called Flickr. If you're bored with my photos you can explore photos from around the world too!"

Figure 6.1
Flickr's invite form.

Send an invite to join Flickr

We'll send each person you list below an email with a link to Flickr. If they are not interested, they can safely ignore the invitation.

See past invites on your invite history page.

First, enter your friends' info

1 Email Address

Name (required)

☐ This person is a friend.
☐ This person is family.

2 Email Address

Name (required)

☐ This person is a friend.
☐ This person is family.

3 Email Address

Name (required)

☐ This person is a friend.
☐ This person is family.

Then, customize your invitation and send it

To:

From: flickrnewbie@yahoo.com.au

Subject: [Flickr] Flickr Newbie has invited you to join!

Hi,

I want to share my photos with you on a cool site called Flickr. If you're bored with my photos you can explore photos from around the world too!

Signing up is free, and takes less than a minute. Just click here:

http://flickr.com/welcome/example/

See you on Flickr!

Flickr Newbie

p.s. If you are not interested, just ignore this email. Flickr won't bug you again and there's nothing special you have to do.

(SEND)

You'll probably want to change it, and make it a little more personal. You might even provide a link to one of your photographs, or a Flickr set, as a way to illustrate your amazing artwork.

When you've finished, click the *SEND* button and the e-mail will be on its way.

The recipient will receive the message addressed from your primary e-mail address that you chose at signup (changeable in the *Your Account* section of Flickr). It will contain the text and a special link. If your recipients follow this link, they'll see a personalized Flickr message welcoming them, and displaying some recent photos from your account, similar to Figure 6.2. If they choose to sign in, they'll follow the same steps that you did in Chapter 2.

Potential contacts have no way to reject your invitation. Instead, they're just told to ignore it if they aren't interested.

If you invite someone who already has an account, you'll be notified that they already use Flickr. It recognizes them by their e-mail address. Flickr will automatically add them as a contact in your account, and an e-mail will be sent inviting them to view your photos, just like in Figure 6.3.

Invite History

Most of the people whom I've invited to Flickr don't upload photographs. I can tell by checking my invite history, which is linked from the Invite page, that they don't have any in their photostream. Perhaps they just enjoy looking at mine. The page also lists every contact that's accepted my invitation, and those invitations sent but not accepted.

Accepted invitations provide a few details about your contacts: a link to their Flickr account, their e-mail address, their contact status for your photographs (friend, family, contact), the length of Flickr membership, and how many photos they've added, if any. For those contacts who haven't accepted your invitation, it still shows a few details: their e-mail address, when you last sent an invitation, the status you allocated them for your photographs (friend, family, contact), and a link to re-send the invitation.

Figure 6.2
The welcome screen
when you invite
someone new to Flickr.

Figure 6.3
If you invite people who already have Flickr accounts, they'll receive a message like this.

FlickrMail

From: FlickrHQ

Subject: Flickr Newbie says: Come see my photos!

Flickr Newbie would like to share some photos with you!

Click here to view their photos:
http://www.flickr.com/photos/flickrnewbie/

[DELETE]

Or, return to your inbox.

MARK FRAUENFELDER

Mark Frauenfelder is a writer, illustrator, and co-founder of the popular Web site Boing Boing, a self-proclaimed directory of wonderful things.

How'd you hear about Flickr?

Flickr is one of those things that slowly seeped into my consciousness, like eBay or Amazon. I heard about it, poked around, heard more about it, checked it out a little more, then took the plunge and started using it.

What do you like about Flickr?

It's a great way to share photos with my family and friends. That's 70 percent of why I use it. Another 20 percent is the way I use it as an art reference for my illustrations. The other 10 percent are the way it backs up photos and allows me to share photos with Boing Boing readers.

Has Boing Boing been affected by Flickr in any way?

Sure—I am constantly posting other people's neat Flickr galleries.

What's one of your favorite photos you've taken and shared in Flickr, and why?

The photos I took of grocery store signs in Hawaii are something I like to share with other illustrators and designers (see Figure 6.4). They used a wacky 1950s font that was just delightful.

What's your favorite group, and why?

The retrokid photo pool, which has vintage children's book illustrations. I love that kind of art.

What's your favorite tag, and why?

I love hot peppers (found under the peppers tag) and all those photos get me very excited.

Figure 6.4
Mark Frauenfelder's photo of a retro grocery store sign in Hawaii.

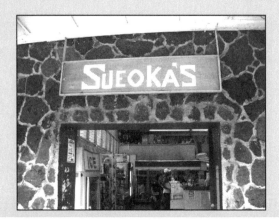

Your Contacts

Contacts aren't just isolated to those people you've invited to Flickr; you can add anyone who is already a member to your list. This broadens the social life you'll experience through Flickr. Whomever you add will appear in your contacts list, and you'll have easier access to their public photographs.

Your contacts list is available from your *Home* page. Follow the *People* link to a list of contact icons, which are categorized under the headings Friends & Family, Family, Friends, and Contacts. If you hover your cursor over an icon for a few seconds, a dialog box will appear (see Figure 6.5), offering you the option to change the contacts settings. You can redefine their status or remove them from your list altogether.

Be aware any of your contacts will have access to your different privacy settings, depending on the type of contact you make them.

Contacts

Contacts is the generic term for the people you add to your list but don't allocate to the *Friends* or *Family* categories. That way they can't view all private photos, but you've added the person to your list. If you're active in Flickr you'll find that this category comes in handy.

I'm active in online communities. For me it's a new way of networking for business and pleasure. I've met some amazing people: photographers, programmers, writers, musicians, locals, and internationals. Keeping an eye on their photostream is one way of staying in touch.

When you start to try some of the activities in Chapter 7, you might have a lot of people adding you to their contact lists. You don't have to reciprocate; it just depends how active you wish to be in meeting new people in Flickr. For extraoverts, more people adding you to their contact lists usually means more traffic to your photographs.

Friends and Family

Creating *Friends* and *Family* contacts enables you to share private photos without the world seeing. While uploading some photographs in Chapter 3, I briefly mentioned the privacy settings. You can adjust these when you upload or adjust them later if you change your mind via the *change* link next to the privacy description in your photostream. You can also select the photo in the Organizr for individual photographs or the batch options for multiple changes.

Figure 6.5
Do you want to change
a contacts setting?

Checking the *Public* setting means anyone can view an image. *Private* restricts the photo completely, and only you can see it. Selecting *Visible to Friends* or *Visible to Family*, or both, enforces privacy to people only in those contacts.

It's also worth noting that *Friends* cannot see photos restricted to just your *Family*, and vice versa. That way your mother can't view any moments of drunk and disorderly behavior with your mates. If you want someone to have access to both private categories, you can allocate them to both types of contacts.

It's also possible to restrict who can add *Comments*, *Notes*, and *Tags* to a photograph (see Figure 6.6). From the same *change* link below an image, there are *More Options*. Depending on who can see the photo, you'll be able to select Only You, Your Friends and/or Family, Your Contacts, and Any Flickr User, for these features. Flickr recommends that you use *Any Flickr User* for *Comments*, and *Your Contacts* for *Notes* and *Tags*. It will come down to a personal choice, and may depend on the content of the photograph.

The Organizr, discussed in Chapter 4, allows you to batch edit these settings if you need to adjust a bunch of photographs at once.

Default Photo Privacy

Flickr assumes that you want the world to see your photos. As you've just seen, there might be instances for which this is not the case. If you prefer you can start with the opposite intention, keeping your photos private unless you decide otherwise.

Figure 6.6
Privacy and control for a selected photograph.

Privacy and control for A Shrug

You can control how people can interact with your photos in Flickr. Choose who can see it, who can make comments, who can add notes, and who can add tags.

(You can also set a default level of privacy for every photo you upload into Flickr. Change your default here.)

Who can see this photo?

◉ Private
 ☑ Visible to Friends
 ☑ Visible to Family
○ Public

▼ More Options

Who can comment?

○ Only You
◉ Your Friends and/or Family
○ Your Contacts
○ Any Flickr User (Recommended)

Who can add notes & tags?

○ Only You
◉ Your Friends and/or Family
○ Your Contacts (Recommended)
○ Any Flickr User

(SAVE SETTINGS)

Or, return to the A Shrug page.

Within *Your Account* is a *Default Photo Privacy* category (see Figure 6.7). You can set all the privacy defaults, as you require, so that when any photograph is uploaded without specific settings, it will use these automatically. Pick the settings you think are likely for the majority of your photographs; this will minimize the changes you need to make to the settings for individual photographs.

Who Counts You as a Contact

In the *People* page, whose link is found at the top of most pages, is a *Who Counts You as a Contact?* link.

As people add you to their contact list, you'll receive an e-mail like the one in Figure 6.8. The message says there is no need to add this person to your own contacts unless you want to. The mail provides a link to their *Profile, Contacts* list, and photos. That way you can see if you know them, or peruse their shared photos.

Every time you are added to someone else's list, their buddy icon will be added to this *Who Counts You as a Contact* page. It's nice to know you're appreciated, right?

Searching for People

Also in the *People* page you can *Search for People*. If you think you know someone who uses Flickr, you can search for him or her with the search tool. Type their name, Flickr nickname, or e-mail address into the search box and click the *SEARCH* icon. I've found it useful when I've wondered if an old friend or new acquaintance uses Flickr.

In a lot of instances their name or nickname will generate a large number of results. It could help to narrow the search down. You can do this with the advanced search, which is offered at the bottom of a standard search's results or in the *Your Contacts* page.

Figure 6.7
The default photo privacy settings page in your account.

Privacy for photos you upload

Your Account /

Any time you publish a photo in Flickr, it will inherit the default level of privacy you set here. This setting applies to photos you upload by email as well.

You can change this setting at the time of upload, or for each photo individually afterwards if you wish (unless you're sending a photo by email).

Note: If you add a photo to a group pool, that group's members will be able to view and add notes/comments/tags to that photo, regardless of the privacy settings.

Who can see your photos?
- Private
 - Visible to Friends
 - Visible to Family
- Public

Who can comment?
- Only You
- Your Friends and/or Family
- Your Contacts
- Any Flickr User (Recommended)

Who can add notes & tags?
- Only You
- Your Friends and/or Family
- Your Contacts (Recommended)
- Any Flickr User

SAVE SETTINGS

Or, return to your account page.

CHAPTER 6

Figure 6.8
Flickr e-mail informing me I have been added to Flickr Newbie's contacts.

From: **FlickrHQ**

Subject: **You are Flickr Newbie's newest contact!**

Hi rich115,

You are Flickr Newbie's newest contact! If you don't know Flickr Newbie, Flickr Newbie is probably a fan of your photos or wants a bookmark so they can find you again. There is no obligation for you to reciprocate, unless you want to. :)

Here's a link to Flickr Newbie's profile:
http://www.flickr.com/people/flickrnewbie/

You can see all of Flickr Newbie's contacts here:
http://www.flickr.com/people/flickrnewbie/contacts/

And photos here:
http://www.flickr.com/photos/flickrnewbie/

So, check 'em out!

DELETE

Or, return to your inbox.

The *advanced search* (see Figure 6.9) adds other fields for a search; all of which can be found in a member's profile. In Chapter 2 I mentioned that it is worth adding as much detail to your Profile as possible. A benefit is that when people search for you in Flickr, rather than search for your name, they might find you by your interests. These are split into the same categories that appear in everyone's *A Bit More About You* profile section. You can search for one interest at a time; combining extra keywords won't work.

Give it a try. You might search for a favorite movie, musician, or quirky interest.

Hovering over someone's buddy icon in the search results provides the option to add them to you contacts straight away.

Figure 6.9
Finding people with the advanced search.

Find people

You can search for a person's Flickr screen name, their first name, their last name, or their email address.

If you search for an email address you'll need to know the whole thing.

Search by name or email

[] SEARCH

Or search by interest

Interests:

[] SEARCH

Books & Authors:

[] SEARCH

Movies, Stars & Directors:

[] SEARCH

Music & Artists:

[] SEARCH

Your Contact's Photostream

Once you've added a collection of people to your contacts list, you'll notice that your *Home* page provides four photos from your contacts, and a link to see more (see Figure 6.10). You can use this to stay right up to date with the photographs from people you know (or people you'd like to know).

Depending on how often you use Flickr, you'll be able to keep up to date from the first *Photos from Your Contacts* page. However, you can travel back through pages of photos, or click an individual one to see more detail. The photostream is also available from the *Your Contacts'* link at the top of almost any page.

There is also an option to view either five or one photograph per contact. This is reflected on the *Photos from Your Contacts* page, and the small stream that you see on your *Home* page. This might be a more manageable option if you have a lot of active contacts. You can also toggle between showing all your contact's photos and only ones from your family and friends.

Remember the 1001 application from Chapter 3. It allows you to select a photostream from your contacts. That way you don't need to actually visit Flickr to enjoy a photostream. What's more fun is that 1001 updates you on a very regular basis, showing you photos from people like your contacts almost as soon as they are added. If you don't have a Mac, a similar feature is available with FlickrFox, which is discussed in Chapter 10.

Figure 6.10
A miniature photostream from your contacts, found on your Flickr *Home* page.

Groups

Groups will be your first real foray into the community aspects of Flickr. Although I've touched on a few features that involve other members, groups enable them to share thoughts, ideas, questions, and photographs.

In this chapter I'll limit the exploration to communicating with friends and family, because I'll delve lens first into the Flickr community in Chapter 7. Here you'll find out how to create, interact with, and administer groups.

Public Groups

I created the Flickr Cameraphone group in January of 2005. Admittedly it's a very topical group; camera phones are a booming industry, and they converge nicely with Flickr (see Chapter 9). What's been amazing has been the group's growth. In less than a year there were almost 500 members and over 4,000 photographs. All with no promotion or invitations.

Which brings me to a significant point: A public group is open to everyone in the Flickr community to see. There are two forms of public groups: one that is by invitation only, and another that any Flickr member can join. Regardless, they are made for the wider community to enjoy, and in most cases, participate.

▶ **Public, Invitation Only** provides members with the ability to share their photographs and discussions with everyone. Membership is granted by invitation, or request; a group admin must first authorize the pending request.

▶ **Public, Anyone Can Join** provides members with the ability to share their photographs and discussions with everyone, and is completely open to Flickr members, who can join without restriction.

Public groups are great when you'd like to openly share with the wider community. Like if you have a hobby or want to share a photographs of a location.

One of my favorites is the Disney Geeks group. My wife and I have fond memories of Disney World on our honeymoon. It's my happy place—the place my mind wanders when I want cheering up. Its description sums it up nicely: "Fanatics, former and current employees, otaku and people with a casual interest in Disney related flotsam and jetsam—this group is for you. Post your photos and revel in the residual Disney geekery."

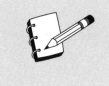

PRIVATE PHOTOS MADE PUBLIC

Adding a private photo to a public group makes the photo available to any group member. It still remains private to the rest of the Flickr community, but the group members can add notes, tags, and comments, regardless of its current privacy settings.

Private Groups

Other than the Cameraphone group (which you can join if you like), I created a group for my family and another for close family friends. Both are private groups.

This form of group provides total privacy; Flickr members cannot see or search for the group, and it's available only to people whom I choose to invite. The fact that I'm a member of a private group will not show up in my profile. Public groups do.

Private groups are great for a small collection of people who only want to share amongst themselves. This is most common for families or close friends, just like what I've used them for. It might also be great for a company or social club.

Searching Groups

Before you start a public group, it's well worth searching to see if anyone else has started one with a similar intent. From the main *Groups* page you can browse all the public groups, or start a search. Searching might be a quicker method if you can think of a few keywords that might represent a topic. It might also provide some light entertainment; for example, the term "dog" provides links to the *Dogs in Costume* and *Destroyed by Dogs* groups.

The results of a search are useful in many respects (see Figure 6.11). At a glance they show several interesting items.

- ▶ The number of groups that mention your keywords is shown at the top of the list.
- ▶ A selection of related keywords is shown, and they link to their own search results, a great way to assist in finding related groups when you can't find the thesaurus.
- ▶ The group's buddy icon is shown, and might help explain its character.
- ▶ The number of members is shown for each result, linked to a page that lists each of their buddy icons. A useful factor that might help you choose the most popular group.
- ▶ If the group is invitation only, it's specified within brackets next to the member count.
- ▶ The number of discussions in the group is next in the list. A subject we'll explore later in the chapter.
- ▶ The number of photos shared within the group is listed with a link straight to the groups pool.
- ▶ The age of the group combined with some of the other items helps you get an idea of how active the group really is.
- ▶ The group's description gives you an idea of what its aim is.
- ▶ If the group has shared photographs, an example is shown.

Figure 6.11
Helpful search results
from the *Group's* search
function.

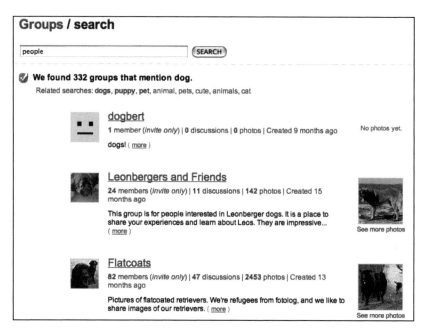

Creating a Group

When you're ready to create a group, you simply follow the *Groups* link at the top of your *Home* page. First-time users will be prompted with a screen like the one in Figure 6.12, which provides you with the option to browse, search, and create groups. It also shows you some public forums (great for help with Flickr), the most popular groups, and the latest ones created.

Figure 6.12
Your *Groups* page
before you join or start a
group.

I'll save the real exploration of groups for Chapter 7, and focus here on creating a group. To get a start, simply select either the *Create Your Own Group* or *Create a New Group* link. You'll be provided with the option to start one of the three varieties mentioned previously: Private; Public, initiation only; or Public, anyone can join.

Once you've made your selection by pressing the *CREATE* button, you need to name the group, and optionally provide a description (see Figure 6.13). For a public group it pays to make sure you name it accurately; otherwise you'll just limit the membership to those fortunate enough to understand what your choice of name means. It's the description where you get to be a little more creative, and even inspire potential members to join.

The name you give a private group isn't as critical. All your members will join through invitation anyway, so you'll have the opportunity to explain what you mean.

The name and description will also appear on the main group Web page. That way when non-members, or members, view the group to investigate a little further, they can read the description. It's a great place to provide all the details you want people to read, including any instructions.

For public groups the next step is deciding what a non-member can access (see Figure 6.14). You can toggle the ability of non-members to see discussions or the group's photo pool. Depending on the group's function, you might want to go gung-ho and make everything available. Alternatively, a non-member can discover a group exists, but they can't take a peek at the group's activities. Being so elusive might encourage more people to try the group, just to see what they're missing. Private groups aren't presented with this option. By their nature, both abilities aren't provided to non-members.

Next up, Flickr offers you the chance to re-label the title of the administrator and member. The default names are predictable: Admin and Member. Some groups have been creative with their naming. The Llamas group uses alpacas and guanacos, and the Disney Geeks group I mentioned earlier uses Cast Members and Guests. This is yet another place in Flickr for you to flex the power of your brain's right hemisphere.

Once you've decided on the names, the group is ready to share. However, you are able to refine a bunch of details, some of which might be nice to modify now, and others can wait until the group is in full swing. So when you've selected the *ALL DONE* button, you're automatically taken to the group *Administration* page.

Figure 6.13
Naming and providing a description for a group.

About your group

Give your group a name and description.

OK, so you're making a **Public (Anyone can join)** group.

What are you going to call it? (required)

What's the group about? (optional)

(This description will come up on your group's page.)

NEXT

Figure 6.14
A group's non-member access.

Your group's page

You can choose what displays to non-members when they visit your group's page.

What would you like to display to **non-members** on your group page? (Members can see everything.)

☑ **Group discussion**
- display a list of recent discussion, with links to view each topic

☑ **Group photo pool**
- display the most recent additions to the group photo pool, and a link to see all your group photos

(NEXT)

Administrator

You can access the *Administration* page (see Figure 6.15) at any time from the *Groups* page by selecting the *Administration* link. You'll always have the options available to you, so you can continually tweak the settings to keep the group flowing.

Members

Hopefully your group runs smoothly. However, you have the option to promote, temporarily remove, or ban your members. I'd hope that in a group set up for your family you won't have to ban anyone. However, families are strange.

You can also edit the role names if you decide on something clever after the group's creation.

On the *Groups* page, beside each group, is a number that represents the number of group members. I've found it handy when I've searched for a group on a specific topic and would like to join the most popular. It's also handy to see how many members have joined any of my own creations.

Your Group Icon

Your group icon is just like your Flickr buddy icon; it's a small image that is used to represent your group and appears on your group's page. Like the buddy icon it can be chosen from an image in your photostream, on your computer, or on the Web. If you're clever you can also create your own 48 x 48 pixel graphic to upload, rather than using Flickr's icon builder.

Figure 6.15
A group's *Administration* page.

FlickrBook / Administration

Have you read the Community & Admin Guidelines?

✓ **Your group has been created!**

Members
From here you can promote, temporarily remove or ban your members. (Edit the role names)

Your Group Icon
Your group icon appears in FlickrLive, and on your group page.

Choose your own Flickr web address
You can create an **alias** for your group so you can direct people to an easy-to-read URL, that will look like http://www.flickr.com/groups/**alias**/.

Name/URL/Description
Describe your group; link to an external website.

Keywords
Help people find your group by assigning some keywords that people can search for.

Categories
Place your group in up to 3 of the Flickr group categories.

Privacy
Control what non-members can see on your group page, and your group's overall privacy level.

Choose Your Own Flickr Web Address

When I first created the FlickrBook group (especially for this book), its Web address was www.flickr.com/groups/60096385@N00/. That's not a trivial collection of letters and numbers to remember. Like your Flickr Web address, the group's address can be customized to an alias like www.flickr.com/groups/***alias***/. I took the simple route and chose an alias of flickrbook. This can't be changed, so make sure you don't make any embarrassing spelling mistakes.

Name/URL/Description

You've already provided a name and description, but it can always be changed. You might also like to provide an external Web site that relates to the group.

Keywords

Keywords are similar to tags, but they provide extra detail about the public group's focus. It's useful to add as many appropriate keywords as you can, because when someone searches in the group search tool, it uses group titles, descriptions, and keywords to generate its results.

Private groups, of course, don't have the option because you don't want public access through searches.

Categories

Flickr organizes all the groups into ten broad categories: Computers & Internet, Culture & Society, Flickr, Fringe & Alternative, Languages, Life, Nature, Recreation, Regional, and School & Learning. To make it easy for people to find your groups when browsing the categories, you can add your public group to up to three of these categories. If you change your mind, or the group refocuses, you can change these later.

As with keywords, private groups don't have the categories option.

Privacy

Privacy administration provides the ability to change what non-members are able to see in public groups. You made these selections when you created it, but they can always be reversed.

It also presents the option to *SWITCH TO INVITE ONLY* or *SWITCH TO OPEN JOIN*, or *MAKE THIS GROUP PRIVATE*. Be careful: the last option is irreversible.

TROLLS

In the early days of the Internet (way back in the early nineties), newsgroups and forums were a great way for people to interact. E-mail was restrictive in so many ways, and was usually reserved for communications between two people, or at most among a small group. Newsgroups and forums, on the other hand, spoke to large communities.

Due to some strange quirk of human nature, some people enjoyed baiting people. A negative post could provoke an extreme action from one or often many people, leading to extremely harsh e-mail known as a flame war.

If someone intentionally posted a message with the intent of provoking this type of reaction, the poster became known as a *troll*. It's thought that the origins relate to fishing, where the use of trolling suggests towing a collection of bait behind a moving boat.

Trolls enjoy their sport in every online community, including Flickr.

It's important to realize that trolls exist, and just as important to know when not to take their bait. Keeping calm and not responding is the best way to deal with a troll. That way they never gain the satisfaction that they crave. They'll move to other waters soon enough.

Adding a Photo to a Group

The main reason you have created a group is to share your photographs with other members. This can be achieved in a couple of ways: through the photo's toolbar, or Flickr's Organizr.

On each individual photo's page, there is a toolbar above the image. You explored most of its functions in Chapter 4, but it also lets you *SEND TO GROUP*. Click the icon and a drop-down menu will present you with the selection of the groups you've already joined (see Figure 6.16). If you're not a member of any groups, it'll prompt you with a link to create or find one you might like. Otherwise just scroll down the list and select the group you want your photo to be linked with.

Figure 6.16
Adding a photo to a group with the photo toolbar.

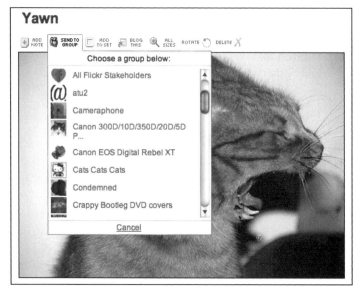

Organizr, as you discovered in Chapter 4, is much better at organizing photographs when you want to manage large batches. Using the browse or search options, you can quickly find a bunch of images that you might want to add to a group.

Click the *Organize* link at the top of your *Home* page for the application. Once loaded you can select the *Your Groups* tab on the right. It works the same way as the *Your Sets* management that we used in Chapter 4; each group you belong to will be loaded into the right window pane (see Figure 6.17). Drag and drop your chosen photographs into any group, or if you'd like to be more specific, click the group you'd like to work with, and when its details have loaded, hold down the "a" key on your keyboard and click the desired photo. Both methods add your selection to the group's pool.

Once added to a group, your photo page will display the group or groups to which it belongs. The adjacent photos in the group pool—the one added before and after your photo—will be displayed in the photostream window on the right-hand side of your Web browser. That way you can explore other group members' photos.

Figure 6.17
Adding a photo to a group with the Organizr.

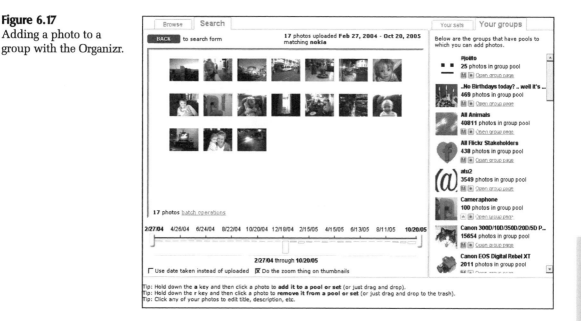

CHAPTER 6

The Group Pool

The next important feature of the group is surfing the group's pool of photos. Unless you're completely narcissistic, you'll want to view what others are up to. As a member, you have access to every photo other members share in the group.

A close friend of mine is in the middle of building a new home, and every few days he uploads progress photos. It's great to see the bricks laid, roof added, and walls rendered. I get to take part in his family's excitement.

Once photos have been added, the group Web page displays several of the latest photographs. Clicking *More* or *The Group Pool* link will display a page full of photos as well as links to more pages if there are more. Each recent photo will also display a little "new" icon. You can also click the *Slideshow* link for a feature-length presentation of every photo in the pool.

If you are the administrator of the group, you can also remove photographs from the pool. You might feel that the image is inappropriate or unrelated to the group's purpose. It's all part and parcel of being the boss. Below each image is a grey cross; clicking it prompts you to confirm that's the action you'd like to take. The feature is also available for any photo that you've shared, even in a group you don't administer.

Your *Home* page also displays a link to *Your Groups*, including a count of recent posts. Selecting the count takes you to a list of the recent topics or replies in each group in which you have membership.

GROUP ICONS

Small icons appear in groups. They provide a visual cue to help identify people and posts.

NEW: Appears next to any discussion or photograph that has recently been added or changed.

PRO: Appears next to anyone who has a Pro Account. Absence of the PRO icon means that the member is still using a free account.

STAR: Identifies the members who are administrators of the specific group.

STAFF: Members of Flickr's staff sport their own icons.

Posting a Message

Sharing photos is the ultimate game, but it helps to be involved in a conversation. Posting questions, answers, or opinions is just as valuable to a group. That's why each group has its own discussions. You can post a new topic or get involved in an ongoing conversation.

In the *Group* page there is a link to *Post a New Topic*. Click the link, and Flickr will provide text boxes like the ones in Figure 6.18. It's just like an e-mail, only you don't provide an address. Enter a subject, and leap right into the what you'd like to discuss in the section called *Your Post*.

If a discussion is already under way, then you can join in by selecting the title. The discussion page will provide the *thread*—a term used on the Internet to describe a group of linked messages with a common subject or theme. This is the conversation, one Flickr member posting a message after another. At the very bottom of the thread, you'll find a text box labeled *Reply to This Topic*. You can add your thoughts as long as you're already a member of the group. If you're not a member, it'll provide you with the opportunity to join the group so you can get involved.

Figure 6.18
Starting a new topic in a
Flickr group.

The conversation also presents a few other details: the author's name is a link to his or her
Flickr photostream, a star icon is displayed next to group administrators, and the PRO icon tells
you whether the member has a pro account.

Once a discussion is under way, it appears on the main group page. Eventually, when there are
several discussions and they don't fit on a single page, a link will appear to display more of
them.

Each individual discussion link shows the buddy icon and the name of the author who created
it, how many replies have been posted, and when the last reply occurred. It's a quick way to get
an idea of the activity in the discussion's thread.

LOCK OR DELETE A CONVERSATION'S THREAD

Administrators can lock a group's discussion thread. This stops further posts
to a group conversation, and can be useful if you want to contain a topic.
Perhaps the conversation is out of control, or the topic is an announcement,
not a request for conversation.

Locked threads can be unlocked.

Administrators can also delete a thread. However, the conversation is lost
forever, and it can't be reversed.

When you administer a group, you'll find links called *Lock* and *Delete* in the
first post of a discussion thread.

PERMALINK

Permalinks in cyberspace are precious. The word is a combination of the words permanent and link. Essentially it means that the permalink is a URL that you can use to get to the same place over and over again.

Some Web sites use dynamic links, and, if you return to the same address later, you'll get a different result.

Each item in a group's conversation has a permalink. This can come in handy if you need to reference a statement made in a group forum. You might need it in an e-mail or a link for a Web page.

When you explore weblogs in Chapter 9, you'll realize that permalinks are gold.

ADDING A PHOTO TO A POST OR COMMENT

When you're involved in discussions, or perhaps just making a comment on someone else's photo, you can add one of your own images to the text. This is achieved with a bit of Hyper Text Markup Language (HTML).

First go to your own photo and select the *ALL SIZES* button in the photograph's toolbar. Below the image that loads is the photo's Uniform Resource Locator (URL). Copy the text (Control + C with Windows, or Command + C with a Mac).

When you add to the group's discussion, or comment on a photo, add the URL in between the quotes of this HTML tag:

```
<img src="">
```

The result will look similar to:

```
<img src="http://static.flickr.com/33/111111_1111_b.jpg">
```

The "b" at the end of the image file name represents the size of the image it will use. You can change this manually for a different size image in your posts or comments.

Square: _s

Thumbnail: _t

Small: _m

Medium: requires no underscore and letter

Large: _b

Original: _o

Alternatively, in the *All Sizes* page, select which format you plan to use, and it will provide the complete HTML at the bottom of the page.

I recommend using a square and thumbnail in most instances. Occasionally the small size can be useful when you want more detail. Anything larger will just disrupt the post or comment, and won't be popular with other members.

GODWIN'S RULE

In the group discussion section I mentioned discussion threads. These have been popular on the Internet since its inception. I also discussed trolls and flame wars in another sidebar.

Mike Godwin is an attorney, and was the first staff counsel for the Electronic Freedom Foundation, an organization dedicated to preserving First Amendment rights in the digital age.

Godwin famously coined his own Internet law, or rather a rule of thumb.

"Godwin's Rule of Nazi Analogies: As a Usenet discussion grows longer, the probability of a comparison involving Nazis or Hitler approaches one."

Essentially he suggested with his rule that most online discussions will degenerate over time, until someone mentions Nazis or Hitler. At which point it is suggested that the discussion has ended, and if it was a heated debate, the person who mentioned Nazis has lost. It's also bad form to intentionally mention the terms to end a conversation.

I doubt you'll find many discussions that include Nazis or Hitler within Flickr; the community is very respectable and incredibly peaceful. It's just worth knowing Godwin's Rule in case you stumble across such an occurrence.

Searching Discussions

Searching a discussion is always useful. If you're interested in a topic within a group, or remember something someone once said, then you can always key a few words into the *Search Discussions* text box, found on the group's main page, and search within a group.

Any topic that contains one or more of the keywords you entered will show up in the list of discussions. When you select the topic to further drill into the conversation, the words you entered will appear highlighted wherever they occur. That way they're easy to find.

Inviting Your Friends

Once you've created a group, you'll want to invite people to join it. There's no point in a one-person group, is there?

Two methods exist for invitations. Once you select the *Invite Your Friends* link on the *Group's* page, you are presented with both options: invite a Flickr contact, or invite a friend who isn't yet a member.

Inviting contacts is a much simpler method if you'd like to boost your group's membership quickly, because if you choose you can invite everyone who considers you a contact. Note that it's not everyone you have in your list, but those contacts that have reciprocated. However, I wouldn't recommend this, unless you know them all very well. You can quickly offend or get on people's nerves when you use such a shotgun approach.

Selecting the *Choose from Your Contacts* option lists all your contacts, including people who consider you a contact without your reciprocation. Each person has an associated check box; simply select the ones you'd like to invite, and write a custom message.

The alternative is to invite people who don't yet use Flickr. This option is similar to inviting people to Flickr. Enter the person's e-mail address, provide their name, and select what type of contact they should be. You can then customize the message.

Inviting people into Flickr only offers you the chance to enter three people at a time. However, it can be very useful when you're the first member of your family to discover how useful Flickr is for sharing photos with friends and family.

Viewing Group Members

As a group gets under way, you'll want to see who has joined. On the right-hand side of the group's page, Flickr displays the number of members. Clicking this link displays the buddy icons for everyone involved. It's split in two: Admins and Members, or whatever titles you decided to use.

Click a buddy icon to go to their photostream, or hover the cursor over the top for the option to select them as a contact.

Leaving a Group

Leaving a group is much simpler than creating one. In each group for which you're a member there is a link to *Quit*, found on the lower right of the group page. Once selected, it'll ask you to verify your intention. All your photos that have been added to the pool will remain in the group, for posterity. If you want them removed, you'll have to do so individually on each photo page, or do so using the Organizr.

If you're the last administrator of the group, and you leave, the oldest group member is automatically promoted in replacement. If you're the last member, the group will be deleted when you quit.

Profiles

Chapter 2 explored how to create your profile. Now that you've started to see how you can interact with others in Flickr, you might see the advantage of completing your profile in plenty of detail. It has a great impact on people finding you because of your interests.

However, you might be using Flickr to share your photographs with more privacy; you might not want to invite the world to be your friend. If that's the case, you don't need to provide much detail, and you can use privacy options, which I'll explain shortly, to further clamp down on interaction. People will get the hint.

Let's explore a little of the Flickr community. A great way to start is by looking for others with similar passions. You can do this by viewing your profile as it appears to others. Select the *Your Profile* link on from your photostream page; found by selecting the *Yours* link at the top of most pages. Now that you've started to add contacts and groups, you'll see that the page has grown to include them. At the bottom of the page you'll also find the *A Bit More About You* section: Interests; Favorite Books & Authors; Favorite Movie; Favorite Stars & Directors; and Favorite Music & Artists.

Selecting any of the keywords in the lists will lead you to a list of other Flickrites who share the same passion—or at least listed it in their own profile. If you select any of these and check the profiles, you'll see the same item.

As a new kind of sport you can select one of their keywords, jump to another list, and passion hunt through the entire Flickr community. Consider it a pastime on cold, wet winter days.

Another method is using an advanced search to find people with a particular interest. Select the *People* link at the top of any Flickr page. This lists your contacts, but also provides a link to an *Advanced Search* (see Figure 6.19).

In addition to the ability to search people's names and e-mail addresses, you can search the items people decided to add to their *Things You Like* section. It's an exact search, so spelling mistakes or truncations result in matches for people who made the same mistake.

At the same time you can explore other people's profiles and the groups they've joined. I even found some people who admit they like belly button lint.

Testimonials

In the Flickrverse, it's nice to be appreciated. In that respect there really isn't any greater honor than someone writing a nice testimonial about you. For the same reason, you might consider writing one for one of your contacts. You can't write them for complete strangers, although that might be nice.

To write a testimonial, view your contact's profile. There is a link on the right-hand side of the page. Concoct your tribute in the text box provided (see Figure 6.20), and complete it by previewing or saving. You can always come back and make changes if you feel you've missed some words.

On the other end, the receiver of your kind words must approve the testimonial before it's made public. This saves any embarrassment, in case the receiver would rather not make public something you said. Once given the go-ahead, your testimonial appears in their profile for the world to see.

Figure 6.19
An advanced search to find people—if only the real world were that simple.

Find people

You can search for a person's Flickr screen name, their first name, their last name, or their email address.

If you search for an email address you'll need to know the whole thing.

Search by name or email

[SEARCH]

Or search by interest

Interests:

[SEARCH]

Books & Authors:

[SEARCH]

Movies, Stars & Directors:

[SEARCH]

Music & Artists:

[SEARCH]

Figure 6.20
Writing a testimonial.

Add a testimonial for Flickr Newbie

Flickr Newbie will have the chance to review this testimonial before it is published, so don't bother with something rude or nasty.

Your Testimonial

(No HTML please.)

(PREVIEW) OR (SAVE THIS)

Or, return to your launch page.

Once you've completed a testimonial, you can make changes to it on your own profile even after it's been approved, viewing it as it appears to everyone else. Select the *Manage Your Testimonials* link on the right-hand side of the page. Each testimonial you've provided will be listed for you to edit or delete. Editing requires the recipient to re-approve.

Profile Privacy

The flexibility that Flickr provides when deciding whom to share your photographs with is also provided within your profile. You might prefer not to share any details. Or you can provide visibility to just your friends and family, hiding it from everyone else.

In *Your Account*, found at the top of any page, you'll find a *Your Privacy* section. Select this for all your privacy options. These are listed under the title *Who Can See What?* and provide a range of options for different parts of your profile.

▶ E-mail address: Anyone, Any Flickr member, Any of your contacts (default), Friends and family, and Nobody.

▶ Instant messaging names: Anyone, Any Flickr member, Any of your contacts (default), and Friends and family.

▶ Real name: Anyone (default), Any Flickr member

▶ Current city: Anyone (default), Any Flickr member

▶ Birthday/Age: Anyone (default), Any Flickr member, Any of your contacts, Friends and family, and Nobody.

There is also a check box that tells Flickr to hide your profile from the search options unless your e-mail address is known or the person who's searching for you is a contact.

For extra privacy you can hide your EXIF data. Some people are nervous about sharing their camera's make and model with the world, and switching on this option hides these details.

FlickrMail

Flickr has its own mail system. All the messages can be forwarded to your real e-mail account, but this adds a level of abstraction that adds a further level of privacy. Being a part of the community you'll receive different forms of e-mail. Some people will want to compliment your work, others might want to make contact, and still others will ask you to join their group.

I received an e-mail (from a complete stranger) thanking me for helping them find Flickr. In September 2004, I mentioned Flickr in my weblog. A photographer in Korea happened to pay some attention, and joined the community. As of this writing, he's added more than 3,600 photographs. It was a joy to receive the FlickrMail from him, making me aware of my influence.

Other messages I receive are compliments on some of my photographs, thank you's when I select a photo as a favorite (see Chapter 7), and invitations to groups. I'm certain that very active users receive dozens of FlickrMail messages a week. FlickrMail is also used when people add you to their contacts.

MACADDICT

Macaddict is a Flickr member based in Korea.

How'd you hear about Flickr?

I remember you dropped a comment on my Mac OS X blog a couple of years ago—I followed the URL you left, discovered your blog and bookmarked it. I occasionally drop by your site to see what interesting Mac or tech stuff you mention. I specifically remember stopping by your blog in Summer '04 and seeing Moblog photos sent to your Flickr account. "Interesting," I thought. I joined up soon after but didn't really upload a lot at first. Then I found the Fraser Speirs iPhoto export plug-in. That's really what triggered a massive amount of my photos to be uploaded. I think a photo-sharing site is doomed without a way to move images quickly and efficiently. Once I discovered that, I was hooked.

What do you like about Flickr?

At first, I cast a wide net for contacts. Most of my photostream was public. Then, as I became a little more cautious, I limited access to personal family photos to contacts I deemed trustworthy. Since then, I have more than 200 "friends" to share photos with. I like the levels Flickr offers—no other photo-sharing site does this, from what I've seen. I can share innocuous shots with the public and family/personal shots with friends and family. Also, Flickr is about feedback—I love getting comments. The groups also provide a way to learn things and share tutorials.

What's one of your favorite photos you've taken and shared in Flickr, and why?

My favorite is "Cailin's mom at nine months" (see Figure 6.21). I was looking for a way to capture the essence of pregnancy, and apparently found it! The comments were reaffirming. I think it takes backbone to submit a photo like this to the scrutiny of the deleteme group—but it ran the gauntlet and was judged worthy for the safe. Anyway, it's all about capturing emotion.

What's one of your favorite photos from another Flickr user, and why?

That's difficult to say. With more than 200 friends and 100 more contacts, I have lots of favorite photographers. cariephoto, kunja, Stitch, fubuki, Special, bocavermelha, javajive, kodama…any of their shots could stand out as a favorite. In a pinch, I would say javajive's work is *National Geographic* quality and always a joy to see. He's got one shot taken before the tsunami, www.flickr.com/photos/javajive/2546696/in/set-133123/ that simply kicks ass.

continued

What's your favorite group, and why?

Well, Pimpshop at www.flickr.com/groups/pimpshop/. I started the group and it's a lot of fun to Photoshop photos people drop into the pool. My other favorite is the technique group, www.flickr.com/groups/technique/.

What's your favorite tag, and why?

"Me" or "self"—it is always nice to put a face with the photographer!

Any interesting stories about Flickr?

I think it's neat to meet other people going through the same life experiences. For example, www.flickr.com/photos/babytomtom/. Jeff is a father with a baby about the same age. We met through Flickr and now occasionally stop by each other's photostream to watch the kids grow up. That just couldn't happen anywhere else. Flickr gives a strong sense of community. I think people from all over the world thirst for family, and Flickr is one big family. It has also helped keep my brother and his family close to us. They live in the U.S. and we live in Korea. I see more of my nephews and nieces now than I ever did. Flickr inspires communication.

Figure 6.21
Macaddict's favorite photo, "Cailin's mom at nine months."

Your Inbox

At the top of every Flickr page you see an icon of an envelope, and a number count in brackets. This tells you how many unread items you have in FlickrMail. Clicking your cursor on either takes you to your inbox (see Figure 6.22). Your *Home* page also displays an unread count, just to make sure you don't miss a message.

Your inbox is a list of messages in rows. Columns include *Sender*, *Subject*, and *Date*. Clicking any of these column headers rearranges the list sorted by your selection. This is useful if you need to arrange messages by ascending or descending sender, subject, or date. Just click once to reverse the order of each. By default the list starts with the latest message at the top of the list. They are also split across pages once you've collected more than 20.

Alongside each message is a check box. Select any that you've read and want to discard, and click the *Delete* button. Alternatively, you can use the *Select All* link, and trash all the visible messages at once.

Any message sent to you indirectly, like an e-mail informing you that you've been added to someone's contacts, comes from a user called The System, also known as FlickrHQ. It's a pseudonym for an automatic message.

Clicking the blue subject link will display the appropriate message. It also provides an option to reply or delete—unless it's from The System, in which case you only have an option to delete.

Your Sent Mail

Above the messages in your inbox you'll see two tabs: *Your Inbox* and *Your Sent Mail* (see Figure 6.22). Click the latter, and Flickr provides the same options as your inbox, but for the messages that you've sent. Note that this doesn't include invitations, but only messages you've used the FlickrMail feature to send.

Which leads us neatly to composing a message.

Compose

On each FlickrMail page is the link to *Compose a New Message*. Anyone who has used an e-mail application will be familiar with the format. In fact, it's as straightforward as writing a note to someone.

Next to the field labeled "To," is a drop-down menu that lists all of your contacts, split into Friends, Family, and Contacts. You can't bulk mail, so you have to select an individual. You can then add a subject and write your message.

Figure 6.22
The FlickrMail Inbox.

FlickrMail may not be useful if you're only using the application to share private photos among close friends and family, but it's an integral part of immersing yourself in the wider community.

Blocking

Like the real world, you'll encounter occasional social discomfort. Thankfully, when another member of Flickr is making you uncomfortable, you can take action.

On any member's photostream page there is a link to *Block This Person*. If you need to use it, select the link and it will provide the repercussions (as per the list below). Once you're certain you simply select the check box, and click the *BLOCK* button. To reverse the action, select the *Undo This* link in their photostream page. However, comments they've made in the past are permanently deleted from your photographs.

Deleting one of their comments can also block a member. Flickr assumes that the author of the comment is a potential candidate for your black list, and offers the chance to block them.

Once blocked, a new link is added to your *People* page. Select the *Your Block List* link to see whom you've blocked. There is also an option to unblock each member.

Blocking a member stops them from interacting with you:

► Comments: They can't add any, and any they've made previously are erased.
► Contacts: They are removed from your contact list, and you're removed from theirs.
► Favorites: They can't add your photos to their favorites, and any they added previously are removed.
► Blog: They can't blog your photographs.
► Notes: They can't add any notes to your photographs.
► Tags: They can't add any tags to your photographs.
► FlickrMail: They can't send you any mail.

Chapter 7
Joining the Community

Everything so far has built up to the features you get to play with in the next few pages. I should warn you though: Flickr is addictive. Using it with family and friends is useful and also safe. This chapter will provide the first hit of the Flickr drug, and then you're on your own.

If you're vaguely interested in looking at other people's photographs, speaking with others about your particular photographic passions, or learning a new reason to take photographs of belly-button lint, then you'll need to know about a few extra Flickr features.

Although most members' photos are available for you to browse, it's the tags and groups that tie them together. There are a couple of features that capitalize on these tags and groups and, with the immense computing power provided by Flickr, offer some fabulous ways of interacting with photographs and people.

This chapter will explore everyone's photos, tags, and groups. We'll also explore something Flickr calls "interestingness"—a feature that capitalizes on the intelligence of Flickr's massive membership and suggests photographs that it believes we'll love.

FLICKR IS CRACK

I meant it when I said that Flickr is addictive. In fact, it's such a common concept that Flickr member fubuki started a thread called "Flickr is crack" in the FlickrCentral group.

The discussion is still ongoing, with some great examples of when you'll know you're an addict. Following are some examples.

Fubuki says you know you are an addict if "you have ever started a real-world conversation with: 'one time, in Flickr...'"

Gini~ believes, "You know you are an addict when a blank day in your Flickr calendar seems catastrophic."

Bistrosavage distorts reality by suggesting that you're addicted "when you notice that your faucet is leaking and your first thought is to report it to Flickrbugs."

Old Shoe Woman suggests it is when "you take a picture of your doctor during an office visit." She then admits that she actually did.

Catmey has a great imagination, and says, "You think of icons rather than people because you only know your contacts that way."

Tangentialism sums up every conversation a Flickr advocate has when mentioning it for the first time, "Flickr.com...F, L, I, C, K, R, no E."

continued

Boback says, "You know you're addicted to Flickr when you are walking down the street staring at buildings, and your friend turns to you and says, 'You're framing that building in your head, aren't you?'"

Jennifer buehrer explains what I've started to experience, claiming, "You know you are addicted to Flickr when you go out and take pictures for Flickr purposes only."

Michaelchung is in trouble, because he seems to have started "mentally putting a pink star on the girl you just met."

Thepretenda thinks like any pure addict when he thinks "of reasons to apply 'tagging technology' to stuff at work."

WootyToot2, chimes in with some advice for those wishing to wean off Flickr. He suggests the Flickr group called Flickr Anonymous, which provides a 10-step program for getting over Flickr.

Everyone

In July 2005, Flickr signed up its millionth member. Since then the community has grown, adding photographs like a jumbo load of Japanese tourists on speed—five photos every millisecond, according to some reports. That makes for a lot of images for you to explore, and if you're interested you can watch the photos being added in almost real time.

On your Flickr *Home* page, there is a view of *Everyone's Photos* (see Figure 7.1). Every time you look at the page, you'll notice that the four images change. That's because those are the photos that were uploaded by members of Flickr just moments before you loaded the Web page into your browser. If you reload the page seconds later, you'll notice that they've changed.

In Flickr's early days, you could keep up with the number of images loaded. If you follow the *Everyone's Photos* link, a page loads with 16 of the most recent photos (see Figure 7.2). By reloading you can watch a single photo move further down the stack.

Today, the photos are uploaded at such a high rate that you just can't keep up. By the time you've reloaded a page, the first photograph in the list has disappeared off the first page. So Flickr provides a link at the bottom of the page to photos that were uploaded *earlier*. They store the latest 160 photos for you to peruse. However, with the rate of new additions you still have to be quick.

Once you've moved to the second page, you'll see a link labeled *More Recently*. That way you can jump back to the newer photographs. If you give it a go, take note of a particular photograph, and see how quickly it moves between pages. It's a great illustration of just how active Flickr members are.

Figure 7.1
Everyone's Photos on the *Home* page.

» **Everyone's photos** (Hide)

From **wiccked** From **fuyanyu** From **induriel** From **Emehache**

Figure 7.2
Everyone's most recent photos.

If you pay close attention, you can also pick the current world time zone that its most active; people, scenery, and objects hint at the country of origin. Images from Europe, Asia, and the Americas appear most often throughout the day. I'd bet that sociologists could study the photostream and glean some fascinating information.

MAY OFFEND?

On any photo's page is an item called *Flag this photo as "may offend"?*

You can use this link for your own photographs, or for others that you find. This will result in the removal of selected photos from public view and they will not show up in a tag search, protecting anyone from innocently finding a photo that might offend. The photograph does stay in the owner's photo-stream, so friends and family can still find it.

It is suggested that if you think that your own photograph might offend some people, it's worth using the link yourself. Leaving offensive photos in full view risks an e-mail warning, or potential suspension from Flickr.

Everyone's Tags

In January 2005, Daniel Terdiman of Wired News, an online news service focused on reporting technology trends and events, reported that Flickr "hosts 23,081 images tagged with 'cat' or 'cats' and only 17,463 with 'dog' or 'dogs.'"

As of this writing, these numbers had grown to 263,572 and 218,928 respectively. The gap is closing, but Terdiman's point, of course, was that a greater number of digital photographers love cats.

Actually, his point was a little more complicated. When the World Wide Web sprang from the mind of Tim Berners-Lee, corporations leapt on to ride what turned out to be a giant bubble. Today's Web is vastly different from those days, and fortunately it's all about the people. Communities now take precedence over commerce.

Thomas Vander Wal, a technology expert, described a wonderful repercussion of large communities that are converging on the Internet. He suggested that keywords, or tags, created and organized by large groups should be called a *folksonomy*. The word is created from "folk," meaning people, and "taxonomy," which is the branch of science relating to classification. In that sense, it means classification by groups of people, used by people.

One benefit of folksonomies, when larger and larger groups are concerned, is that it's a very good system of classification. Two or three people might disagree on particular keywords; however, several thousand will weed out the less popular terms and reinforce the correct or useful.

That's why I said in Chapter 4 that I spend most of the upload effort tagging my photographs. That way they not only become useful for my friends, family, and me, but also it's a great way of tapping into Flickr's group mentality.

On the top of almost every page is a link labeled *Tags*. The resulting page provides several lists detailing every tag in Flickr. Technically it doesn't show every tag; it would be difficult, as well as time consuming, showing the thousands of keywords that people have used to label their photographs. It does give a great representation of the community's tags by splitting them into sections: *Hot Tags* and the *All Time Most Popular Tags*.

Hot Tags

It's fascinating seeing what today's computing power provides. Forget spreadsheets and spinning three-dimensional graphics; Flickr can tell us what today's hot topics are in photography. At the top of the *Tags* page, the *Hot Tags* section shows a bunch of popular keywords that have been used in the last 24 hours and over the last week.

Some hot tags are displayed in Figure 7.3. You can probably tell that the screenshot was captured shortly after Halloween; trickortreating and halloweenweekend give it away. Others, like blizzcon, a computer gaming event, and vegoose, a Halloween music festival, need more investigation.

Figure 7.3
Hot tags from all members. These often include timely subjects, in this case, Halloween.

Hot tags

In the last 24 hours
canondigitalrebel, november2005, a2, finados, cor, fotosafarisantos
zayed, vegoose, minasgerais, antibush, eid, playboy, widescreen, paquetá, bicicleta, normandie, hiptop, stratford, por, november

Over the last week
haintbirthday, tagcamp, trickortreating, vegoose, blizzcon, fotosafarisantos
teamzissou, flickrtreat, alisaintsday, halloweenweekend, marinecorpsmarathon, week14, chflickrmeetupoct05, eid, paradiogo, halloweenparty2005, zissou, halloween05, diademuertos, halloween2005

All Time Most Popular Tags

The *All Time Most Popular Tags* will look familiar, as Flickr uses the same display technique as your own *Tags* page from Chapter 4; the more popular the tag, the larger the keyword's text size.

In the example shown in Figure 7.4, the tags wedding, party, vacation and cameraphone ranked the highest. None of these should come as a surprise. However, they can be amazing to explore. Just as amazing are some of the other tags, like concert, rock, clouds, and yellow. Using the most popular tag list as a starting point for Flickr surfing can lead to a session that spans hours.

Figure 7.4
All Time Most Popular Tags.

All time most popular tags

amsterdam animal animals april architecture art australia baby barcelona beach berlin bird birthday black blackandwhite blue boston bridge building bw california cameraphone camping canada car cat cats chicago china christmas church city clouds color colorado concert day dc dog dogs england europe family festival fireworks florida flower flowers food france friends fun garden geotagged germany girl graduation graffiti green hawaii holiday home honeymoon house india ireland italy japan july june kids lake landscape light london losangeles macro march may me mexico moblog mountains museum music nature new newyork newyorkcity newzealand night nyc ocean orange oregon paris park party people phone photo pink portrait red reflection river roadtrip rock rome sanfrancisco school scotland sea seattle sign sky snow spain spring street summer sun sunset taiwan texas thailand tokyo toronto travel tree trees trip uk unfound urban usa vacation vancouver washington water wedding white winter yellow zoo

Related Tags

Once you've selected a tag that you'd like to investigate, there are several options that can help your journey. One of these is the *Related Tags* link that appears at the bottom of the page.

Related tags, of course, are tags that relate to each other. For example, australia is related to red, rocks, and mountains; newyork is related to police, downtown, and williamsburg; london is related to people, escalator, and hydepark.

Below the three major *Related Tags* are seven others of less relatedness, but still connected. This provides you with a selection of 10 tags that add an extra dimension to your tag surfing.

Occasionally no related tags appear. That just means you've selected or searched for a more obscure keyword. Flickr uses one of those black-magic algorithms to generate the list. So if a term isn't often used it will not have enough data to produce a result. Rather than guess completely unrelated items, Flickr chooses not to show a result.

Felix Turner, a freelance multimedia and Web programmer from New York, created a personal project that has taken related tag browsing to the next level (www.airtightinteractive.com/projects/related_tag_browser/). Type a search term into the browser-based application and it will display blocks of 36 photos using the tag in Flickr. Move the computer's cursor and the application zooms out to display a circle of related tags, just like the ones in Figure 7.5. Each image can be selected to show more detail, or even jump to the actual Flickr photo page.

Figure 7.5
Felix Turner's Flickr Related Tag Browser in action, using the keyword Australia.

AMAZING TAGS

Some great examples of tags I've stumbled upon include: doodle, error, pillowfight, coincidence, silly, and graffiti. Have a browse, and see if you can find some amazing examples yourself.

Clusters

Another option in the tag results is clusters. Some tags relate more than others, since the same word might be used for multiple reasons. Based on other tags Flickr can take a stab at clustering related photographs together.

I used the keyword sleep to generate Figure 7.6. As you can see in the results, there are clusters for sleeping cats, sleeping dogs, portraits of sleepers, and people in Japan asleep. The last one holds even more interesting tales that can lead to images of Japanese salarymen (office workers) asleep in some of the most amazing public positions as a result of overwork or drunkenness.

The clustering results are even smart enough to make the distinction between homonyms—two different words that are spelled the same but have completely different meanings. Flickr is smart enough to know that turkey is both a place and an animal.

The *Clusters* page displays the most recent photographs tagged with the keyword, seen at the bottom, and also allows you to see more of any particular cluster or related tag; all from a single page. For example, the word turkey generates clusters of photographs from both the country and the bird.

Figure 7.6
Clusters Flickr has found related to the sleep tag.

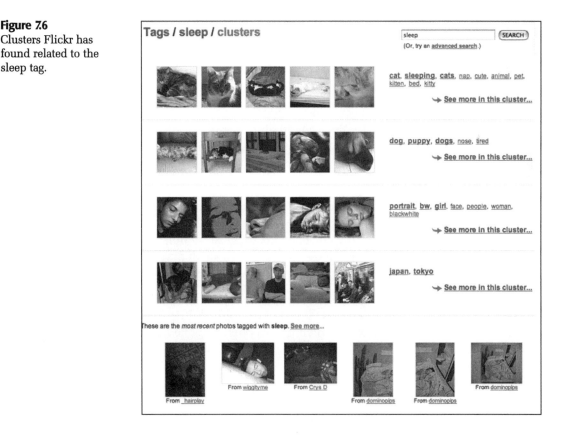

Interestingness

As Stewart Butterfield, one of Flickr's co-founders, says, "It's fascinating to see the wisdom of crowds at work." This can be seen firsthand when using the next tag option, called interestingness.

When I discussed folksonomies, you discovered that the power lies with large groups of people. The more people who use things like tags, the more useful they become. With further computer wizardry, the team at Flickr can harness this group mentality and show us what we all think is interesting.

Instead of sorting the tag results by *Most Recent*, there is an option to sort by *Most Interesting*. Essentially, the new list ranks photographs, in descending order, by what it believes are traits of interestingness. So, if you want to see the most amazing images by a particular keyword, this is the best method.

A lot of this happens to be a black art. Flickr can siphon this group mentality by collecting information from a photograph. Part of the algorithm checks where a viewer clicked through (links from within someone's photostream count less than from another source); who comments on the photograph and when (so a friend or family member is expected, but a complete stranger bumps up the interestingness quota); and who marks it as a favorite (strangers rank higher again). Then there is a bunch of other factors, and a little secret sauce.

In fact this little secret sauce is, as always, under great scrutiny. So much so that there is a Flickr group dedicated to figuring out the interestingness algorithm: The Interestingness Project. The group discusses thoughts on how the magic happens, and even carries out experiments.

I love music by the band U2. I also think that their concerts use a fantastic array of technology. A search for the U2 tag generates several thousand results—suggesting I'm in good company. If I re-sort the search results by interestingness, I can explore some amazing fan photos, some of which rate as professional quality.

Interestingness comes with its own warning. Flickr suggests that before you start exploring it, "You might want to take your phone off the hook, send your boss to an executive training session and block off some time on your schedule, because we don't think you're going to be walking away from your screen any time soon." If even a small part of you enjoys photography (and I'm guessing that's the case if you picked up this book), you'll spend hours using the interestingness feature.

The next step in your Flickr addiction will be aiming to include your photographs in the interestingness list. You can view your own photos ranked by the interestingness algorithm. On the *Your Photos* page is a link in the *Most Popular Photos* list. The resulting list of 200 photos uses the same algorithm as the public's list.

TECHNORATI

After September 11, 2001, the phenomenon known as weblogs boomed. Millions of people worldwide post their thoughts at an amazing pace, with world events unfolding online in real time. For example, when New Orleans was devastated by Hurricane Katrina, many people checked weblogs for the latest news from grass-roots journalists. A Webcam was even streaming video as events unfolded in the city.

With so many blogs, it's difficult to filter through them to find the right bit of information you're interested in. It's for this reason that a Web service, called Technorati (www.technorati.com), allows you to search over 20 million sites.

Included with the weblog search results are the top photographs posted to Flickr that relate to your keywords. That way you can stay in touch with what's most interesting to the world of bloggers by reading and seeing their photographs.

Technorati also provides the top requested search terms for the past hour; a great way of monitoring the pulse of the blogosphere.

Explore

Flickr provides a portal to explore the many photographs that make up its world. So if you want to feel like Alice, and plunge into the rabbit hole, you can select the *Explore* link at the top of most pages; you'll arrive at a new page similar to Figure 7.7. From here there are ever-changing photographs and links.

The first object of note is a randomly selected image pulled from the recent interestingness pool. You can select to view its own page, or view the creator's photostream or profile. It's a quick way of seeing some amazing photography without spending hours wandering in amazement in the interestingness pool.

Figure 7.7
Flickr's *Explore* page, which is more like a portal—similar to the one Alice fell down.

On the other hand, if you'd like to lose yourself, there is a calendar view for interestingness (see Figure 7.8). Select a month from the drop-down list, and just like a calendar, you get a quick glimpse of one of the amazing photos from the day. Select a day by clicking it with your mouse, and a window, like the one in Figure 7.9, will pop up and display some of the day's other interesting photographs.

Figure 7.8
A calendar view of interestingness.

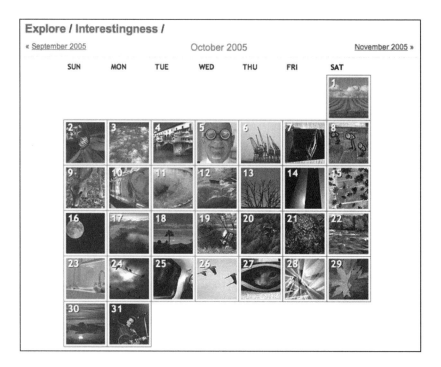

Figure 7.9
Some interesting photographs from October 5, 2005.

From the pop-up window you can select the link at the bottom, which mentions that the photos are some of the interesting photos from the selected day. Following the link provides a list of all 500 photos. This list is split into 50 pages providing a larger image of each photograph, some details, and even a few of the tags that are attached to the images so you can explore photos that are relevant. However, all 500 photos in the day's pool are just amazing. You'll have your work cut out trying to keep up with the beauty.

Another view of interestingness is the collection from the last seven days. Select the link from the *Explore* page and it will present nine photos at a time. When you click the *Reload* button, it will refresh the images with a batch of others. Just try not to wear it out.

The *Explore* page also provides a leap back in time; it displays a photo from the same day last year (see Figure 7.10). Clicking the link takes you to a list of 500 interesting photos from that day, just like in the interestingness calendar view.

Additionally, the *Explore* page provides a selection of favorite sets (see Figure 7.10). Imagine one of your public sets being exhibited to Flickrites; it would be quite an honor. If you reload the page you'll continually get a new selection of sets to choose. It'll lead you to finding some amazing photographers.

The selection doesn't stop there. The *Explore* page is a great place to stop to pick up tips on which groups to join (also in Figure 7.10). Three groups at a time are loaded in to the page, and they're usually a great pick. Anything from *holgagraphy*, who are a group for lovers of a plastic toy camera called a Holga, to *London-alt*, a group specializing in the darker, less glamorous side of the city; or *Stick Figures in Peril*, showcasing warning signs showing stick figures in dangerous, often life-threatening, situations, to *Altered Signs*, a group focusing on signs that have been altered to convey a message other than the one originally intended. Simply reload to see a new selection.

The *Explore* page is a great way of finding amazing photographs in Flickr. It's fun scouring through contacts, strangers, and groups, but if you want to cut to the chase, and find something that most people will love, this is place to start.

Figure 7.10
Additional ways to explore Flickr—a popular pic from that day the previous year, favorite sets from Flickr, and sample groups to join.

Comments, Notes, and Favorites

I'll wager that you've found some photographs that you love. Photos that inspire you to contact the owner and photos that you'll walk through with your mind's eye. You'll be whisked away to other lands, and you'll stumble upon a stranger's story.

Even if you're shy, you'll find yourself pouring out your photographic critique or asking questions in no time. That's why Flickr recommends that any member comment on your photos be allowed (see *Default Photo Privacy* in Chapter 6). When you find a photograph you love, it's worth letting the photographer know by posting a comment. At the bottom of every photo, except those with restricted privacy settings, you will find a text box to add your comment.

Another form of flattery is adding a note to a photo (from the Flickr toolbar as shown in Figure 7.11). You'll find all sorts of uses for this mode of communication. You might like to point out how beautiful a particular feature is, or leave a mark suggesting you've been to the same location. Whatever the case, it's great fun receiving any form of flattery. Remember the biblical adage, do unto others as you would have them do unto you—a statement that explains the Flickr culture quite well.

If you absolutely adore a photograph, you might want to remember it. If you consider it one of your favorites, you can mark it as such. In the photographs toolbar is an *ADD TO FAVES* icon. Clicking it will add it to *Your Favorites*, a collection of all of your fave'd photographs, accessible from the *Your Photos* page.

I've been conservative in favoriting photographs but already have 240 in my collection. I constantly return to see the great collection, and will revisit the photographer's photostream to see what other light they've conjured recently. Any photo that I've already marked carries a pink star in the toolbar.

Figure 7.11
A toolbar found above other people's Flickr photographs.

THE *BOSTON GLOBE*'S PHOTO REPOSITORY

In November 2004, Flickr member Mr. Wright posted a photo of Wal-Mart's distribution center in Temple, Texas. A short while later he was contacted by the *Boston Globe* requesting permission to use the photograph. In return they would pay him $150, which isn't bad when you consider the photo was taken with no intent to sell.

Although the story doesn't seem out of the ordinary, it serves as a great example of what's happening in newsrooms around the world. Newspapers aren't run like Clark Kent's *Daily Planet* anymore; budgets are tight and news media are more inclined to buy articles and photographs from freelancers than to hire full-time employees like Jimmy Olsen. So why not capitalize on photos shared online—just like those in Flickr.

Recent Activity

Maybe I'm narcissistic, but I love to know if people have viewed my public photographs. Fortunately Flickr provides a way to see recent comments and notes, and to see whether a photo has been made a favorite.

On your *Home* page, next to the link to *Your Photos*, is the *Recent Activity* link. When someone comments on your photo, that link might actually change to the word *Comment*, and a *NEW* icon will appear.

The resulting *Recent Activity* page displays any comments, notes, and favorite photographs within a given period of time. Changing your selection in the drop-down box from *Since Your Last Login* to *In the Last Month* displays the photographs, title, number of comments, number of views, number of people calling it a favorite, and the details about that activity, including the member's name, link, and time frame, similar to Figure 7.12.

Also useful is the *Comments You've Made* link, which is right next to the *Recent Activity* link. If you're keen on continuing a conversation, or just checking for replies, you can keep an eye on responses to comments you've made via this link.

Figure 7.12
My recent activity.

ADDING COMMENTS TO SETS

Just like commenting on a photo, Flickr provides the ability to comment on a member's set. Simply load the set's page and click on the *Add a Comment* link.

Once you've added a comment, you'll notice a speech bubble is added to the set's icon. Click it and you'll be taken straight to the set's comments.

Groups and Group Discussions

In Chapter 6 I explored groups as a way to involve you in the Flickr community. I talked about the use of groups with friends and family, and touched on the public uses of groups. In reality, public groups far surpass private ones, and given the inclination, you'll spend many happy hours meeting other Flickr members and discussing any topic your heart desires.

In the last year I've seen a bunch of fabulous groups. I can't claim that I've found every extraordinary or fun group—there are too few hours in the day—but I've picked a handful to give you a head start.

ARTISTIC VIZUALIZATIONS OF THE FLICKR COMMUNITY

David Gleich is a Ph.D. student at the Institute for Computation and Mathematical Engineering at Stanford.

Can you explain your research generally?

My current research interests are numerical algorithms for large datasets. Large datasets are quite often rather difficult to understand, so some of my research focuses on ways of understanding them. I'm a rather visual person, so creating any interesting visualization is helpful to me.

What does the visualization show?

In the visualizations, each point shows one person, and each line shows a connection between people (see Figure 7.13). These pictures are effectively maps of the connections between users on Flickr. There are roughly 30,000 people used to build the pictures.

In the pictures, we've actually "cut" a lot of the connections to show more aesthetically pleasing results. Nevertheless, there are still some landmarks. Each picture shows the core of the Flickr social network. These are the most tightly connected groups of users.

The core is the very intense area—the most tightly connected groups of users. We've drawn the pictures so that intensity roughly corresponds to the number of people and connections in that area. From the dense core, there are a few groups that project off. Different pictures show these "tentacles" of the core in different ways.

Besides the core, the only other landmarks I could give are two more diffuse regions that happen to be somewhat above our drawing thresholds. These are the "blobs" that are distinct from the core in the various pictures.

What's the purpose of this particular research?

The purpose of the research is twofold. First, we want to understand the "Flickr social-graph"—i.e., the direct connections between users. While there have been many academic papers written about social networks and how they have power laws, very few people try to show such a large group of connections. If (and this is a big if) we can draw good pictures of the Flickr social network, then hopefully we can learn something deeper about the network than just how many friends people have.

The second point is to explore large graphs in general. The origin of the techniques used for these pictures was from a set of musical data. We took data from Yahoo!'s music service and built a graph between musical artists based on user ratings. From these, we built a map (really a drawing) of the relationships between about 10,000 musical artists. Exploring these large datasets (Flickr and the music data) is difficult by hand. Where should I look next? What do all these connections mean? Who are the important users? Who are the copycats? By drawing pictures of the data, we get clues to help us ask important follow-up questions—even though the pictures may not directly tell us much.

In layman's terms, what has Flickr shown you?

Unfortunately, the pictures we made of Flickr have shown us much less than we had hoped. At the same time, they raise some tantalizing questions we hope to answer in the near future. I would love to know what creates the core, the tentacles, and the blobs shown in the pictures!

In the music data, there were clear groupings of artists that largely followed genres. Our algorithms were able to find these groups and draw a nice picture showing how they are related. Who would have guessed that independent rock was one of the closest groups to mainstream music?

In the Flickr pictures, we did see distinct groups! However, we are still trying to decipher what characterizes these groups. All we had originally were the Flickr names inside these regions. Since then, we've gotten more of the self-provided metadata on the users. Our plan is to try to use this data to understand more about the network.

Figure 7.13
A visualization from David Gleich's Flickr research on large datasets.

Interesting Groups

There are so many groups that it's impossible to list even just the most interesting in this book. However, I've picked a few that I've stumbled across over the last year that have piqued my interest. There are plenty more: location-based groups, animal-based groups, club-based groups, and many more.

Cream of the Crop

There should be a warning associated with the Cream of the Crop group. The dangers include severe time requirements; once you start browsing the group pool, it becomes very difficult to stop. And you're likely to experience an unavoidable compulsion to improve your own photography skills, since the quality of the photographs is enviable.

Cream of the Crop is designed as a repository for up to four photographs from any Flickr member's collection. These include: the photograph most favorited, the photograph ranked most interesting (or second most interesting if the first is the same as your most favorited), your personal favorite, and, your best of the year. The main rule, descriptions, or tags must indicate why it's part of the group pool.

An example is a photograph of Gracie, Erin Vey's dog (see Figure 7.14). The original photograph included the bottom step of some stairs in the background. Another member made the comment that the stairs were distracting, and Erin removed them with some computer software. The resulting image became the most favorited addition, and so she added it to the Cream of the Crop group.

When I first stumbled across the Cream of the Crop group, I spent hours perusing the group's photographs. I couldn't draw myself away from the screen. I realized that my own photography required improvement, and that I probably should never return to the group for fear of obsessive-compulsive behavior. However, I now return on a regular basis.

Transparent Screens

When a member of a French Internet forum, bored with his computer's wallpaper, decided to photograph what was behind it and use it as the actual image, it created an Internet *meme* (see the "Memes" sidebar). The owner of the forum posted the image to Flickr, created the Transparent Screens group, and several hundred other people created their own impressions (see Figure 7.15).

When a transparent screen is first viewed, it appears to be a clever trick achieved with some computer software. That is in fact the only rule of the group—no fakes. Members cannot use software to manipulate the image, such as using Photoshop to place the background into the image. The image must actually be the computer's wallpaper.

Gradually the photographers used more complicated techniques and achieved some amazing results. iPods with transparent screens, hands reaching into the background, faces behind the screen, and even cats sitting behind the screen were used as subjects.

Figure 7.14
A photo of Erin Vey's dog, Gracie, in the Cream of the Crop group.

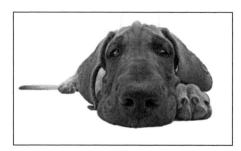

CREAM OF THE CROP BLOG

Cyron Ray Macey, one of the group's Admins, created a Cream of the Crop weblog (http://flickrcotc. blogspot.com/). If you don't have the time to peruse all of the group's pool, you can find a new photo from the group that Macey posts almost daily. It's a great way of getting a fix without getting lost in the stream.

Figure 7.15
Patryk Dwórznik's photograph in the Transparent Screens group.

As many have found, the trick is more complicated than the photographs indicate. Positioning the camera and color correction of the computer screen are both major factors in taking the photograph. Check the group and you'll find many people's images include advice and tips. Give it a go; who knows, your image might end up at the top of the day's interestingness pool.

Infinite Flickr

Ever looked in a mirror that faces another mirror, with the reflection disappearing into infinity? The Infinite Flickr group is like that—photo upon photo upon photo.

Inspired by a Web site called Infinite Cat (www.infinitecat.com), Flickr member normy started the Infinite Flickr group by posting a photo of himself looking at the Flickr Web site on his computer monitor. Kaddy then did likewise, asking a friend to take a picture of him looking at the picture of normy on his monitor. The trend continued, and, as of this writing, there are 170 photographs of members looking at members, looking at members (see Figure 7.16).

MEMES

The Selfish Gene, a book by Richard Dawkins, explores genetics and how genes are really only in it for themselves, propagating solely to continue their own existence.

Out of the book popped the term *meme*, which Dawkins suggested is "a unit of cultural transmission, or a unit of imitation," and meme has since become a popular term online. Culturally, anything that propagates quickly, such as a new Web page or game, is labeled a meme. Technically it might not be correct, but it's now popular to use the label.

Occasionally a Flickr group or tag will be labeled a meme when its popularity spreads quickly.

Figure 7.16
Season Moore's self-portrait for the Infinite Flickr group.

The rules of the group are simple. Open the group's most recent photo, and take a picture of yourself looking at the screen. You might need a tripod with a camera self-timer or a friend to accomplish this task. Then upload the photograph and add it to the group pool as quickly as possible. A slight lag might mean someone else has taken a photograph at the same time and your image is out of sequence. You can then view the group slideshow to see yourself amongst infinity.

Inspired by the group and some fancy technology on an Apple computer, Flickr member monkiineko created a movie that cycles through the photographs (the link is available in the group's forum). Starting at the 105th image, the movie zooms through the photographs, traveling through everyone's monitor until it arrives at normy's original.

ComicLife

In the early eighties, almost any store that sold photography-related items stocked stickers. Each sticker contained a funny comment enclosed in a bubble, just like the ones from comic books. A small craze developed around the stickers, with ordinary snapshots turning into comical frames.

The 21st century adds a twist to the activity. A small company, called plasq (http://plasq.com/), sells an application for the Apple Mac OS X platform called Comic Life, which allows you to add speech bubbles to your digital photographs. However, it goes much further, adding features like templates for page layouts and filters to create special effects, like the one in Figure 7.17, that make photographs look like a painted comic.

Figure 7.17
A comic strip I created with the Comic Life application and shared in the Flickr group.

The ComicLife group contains family photographs converted into comics, instructions, and protest posters made with the application. It's even touted as a tool to make children's storybooks, greeting cards, gifts, and scrapbooks. Regardless, the Flickr group is having fun sharing comedy with co-members.

Bookshelf Project

I love books. For some reason I have an affliction: I buy them, never read them, but proudly display them on my bookshelf like trophies from heavyweight bouts (hey, a year-long round of reading *Cryptonomicon* by Neal Stephenson counts as a boxing match in my mind).

I also like perusing other people's bookshelves. My taste in novels is fairly specific, and I hope that one day I'll trip over a fantastic novel in someone else's home. That's why Flickr's Bookshelf Project is a fabulous outlet; I can view thousands of book spines from the comfort of my own home.

I'm not sure if the group's purpose is to allow such voyeurism or if it is more a channel through which to boast about one's achievements. Regardless, the group requests that any submissions provide photographs with readable titles, or at least notes on the images to provide some information.

What's in Your Bag?

In a similar vein to the Bookshelf Project, the What's in Your Bag group exposes what people carry with them: collections of gadgets, Moleskine notebooks, novels, and even balls of wool.

Flickr member lanzilla analyzed the photos after a few weeks, and listed the breakdown of objects including percentage of inclusions: pen or pencil at 80%, books at 53%, mobile phones at 53%, keys at 41%, personal audio at 39%, breath freshener at 27%, sunglasses at 24%, PDA at 10%, and laptops at 2%.

Memory Maps

In 2005, Google released its Google Maps application. It provided the ability to zoom into sections of the earth to view road maps or satellite images. They later opened up the interface so that some clever computer gurus could create applications that used the images.

Flickr user mathowie realized he didn't need to know how to program to have fun with the application; he just took a screen shot of his childhood neighborhood and uploaded it to Flickr (see Figure 7.18). Using the notes feature, he annotated the image with descriptions of his early years: BMX bike tracks, first girlfriends, and paper routes.

Johnny Huh and kastner saw the fun in mathowie's idea and created separate groups that eventually merged into Memory Maps: a place to share your childhood memories via satellite images. There are now memories from Paris, New York, Rome, London, and even the NASA Dryden Flight Research Center.

To add a satellite image of your childhood neighborhood, visit Google Maps (http://maps.google.com/), search for your neighborhood, capture the image with a tool like SnagIt for Windows or Grab for Mac OS X, save, upload to Flickr, and add notes.

Figure 7.18
Flickr member mathowie's Memory Map.

My childhood, seen by Google Maps

ADD TO FAVES BLOG THIS ALL SIZES

Tri-City Park, a city park I was lucky enough to live near. I would ride my bike around it and run around it while on the cross country team. I used to feed the ducks old bread when my grandparents would visit.

All true stories. I can't believe so many memories exist in one screen full of the map. I wish Google Maps had this kind of annotation.

Here's the live Google Maps URL I used to grab this image.
This photo has notes.

Squared Circle

It's amazing how something as common as a circle can be turned into a game. In Chapter 4, I interviewed Flickr member striatic, and divulged that he created the Squared Circle group when Flickr launched the slideshow feature. Now a few thousand people wander around, in the zone, searching for circles to square.

If you see a circle, like a cake, clock, sign, tonight's dinner plate, or a hedgehog (honest, check the group pool), then line it up and take a photo. Make sure you follow the rules: use a symmetrical circular form that is centered in the frame, fill as much of the frame as possible with the outside edge of the circle remaining visible, use a Creative Commons license that allows derivatives, and tag it with "squared circle" or "squaredcircle."

A repercussion of the format is a wonderful slideshow. Select the option from the group pool and watch as circles morph together; capturing the round world we live on.

From the project a few extra uses of the pool have appeared. Jim Bumgardner, jbum on Flickr, created a Squared Circle Experimental Colr Pickr (http://krazydad.com/colrpickr/index. php?group=squaredcircle), that loads pictures from the pool that match a specific color. Pick bright yellow and up pops a bunch of flowers, a spirit level, and a gold watch, all matching the Squared Circle group rules. The tool can be used for any group in Flickr or the whole pool. He also used a computer to algorithmically produce a poster filled with 542 different images from the pool. You can buy it online at www.krazydad.com/squaredcircle/.

You can also buy some buttons from courtneyp. Simply tag the photograph with the keyword pbutton, and post to the *BUTTONS Order Page* thread in the group's discussion. Visit the Web site http://store.cproductions.net/, and she'll ship them to you for a small fee.

Delete Me

A group whose sole purpose is to weed out the worst photos from the pool, and keep only incredible pictures, has gained its own share of criticism. It's no wonder when criticism is the main part of the game.

The Delete Me group was created as a way for photographers to gain a group opinion, in a black-and-white sense. Group members vote to delete or save a photo submitted to the pool. As the rules say, "Time to be nasty, mean, selfish and arrogant, time to dare to say what we think...and nobody will complain because that's the rules members accept."

When a photograph is added to the group, other members view it, pass comment, and add the tag deleteme or saveme. Each deleteme tag counts as a negative vote. However, a saveme tag counts as a positive vote. Whichever tag reaches 10 votes first determines the photograph's fate. If deleteme wins, it's removed from the group's pool. If saveme wins, it is removed from the group, but it is added to THE SAFE group. An honor not bestowed on many.

The group's administrators suggest that you don't add photographs to which you have an emotional attachment. Also, newcomers must make 15 comments before being able to add a photo.

In protest, another group has been created. The Delete THIS group has emulated the Delete Me group. It states, "The "Delete Me' groups suck. Art is not about popular consensus. Good art is not determined by a vote. The value of art is not in whether it appeals to the largest (or lowest) common denominator." Delete THIS members are encouraged to add photographs that they believe constitute good art, no matter what others think.

Wine Memory Jogger

Living in Western Australia means that I have an appreciation for good wine. I'm not sure that it's the reason I have the appreciation, it's just a great excuse. Nevertheless, I thought the Wine Memory Jogger group was an awesome idea.

No matter how many times I try to remember the great wine I drank the other week, I just can't remember. There is always a plan to write it down for later recall, but I'm too busy enjoying the beverage to worry. So all I need to do is take a photograph of the bottle and upload it the next day to Flickr; that way a list of my favorite wines accumulate online.

Admittedly the group isn't just a way of improving long-term memory; it's a great way to share your wine-tasting experience with a wider group. Discussions include recommendations for tags, so that members can search for varieties, regions, years, and a price range. Comments are occasionally provided for finer details.

If you're thinking that you don't have your camera handy for every bottle of wine, then when you explore camera phones in Chapter 9, you'll learn the 21st-century method. In the meantime, visit the Drunken Photography group to share other photographs taken after you've finished the wine.

The Voice of Flickr

Adding a twist to the senses used to experience Flickr is The Voice of Flickr group. The idea is to add a link to a recording of you speaking. There aren't any hard and fast rules about what you should say, just as long as it's you speaking.

Flickr member drp started the group to share an "added dimension" to the photographs. However, his own audio post included his rendition of the song "Let's Get Away From It All," made famous by Frank Sinatra. Perhaps drp is after a new career.

Food Porn

For some reason, Flickrites are compelled to share almost every waking moment, and some almost succeed.

The Food Porn group is for those caught in a moment of gastronomic bliss. It's suggested that just before you take that first bite, you take a snap to share with the world. Photos of cinnamon buns, homemade apple pie, Texas beef brisket, and pumpkin pie will have you headed to the kitchen.

My only suggestion is that if you're on a diet, don't visit the group. Your stomach will be rumbling in complaint.

Magic Moments

I've often been without my camera and regretted leaving it at home. That's why I'm in awe of the Magic Moments group. How on earth did members of the talented crowd have their camera with them at exactly the right time? Fortunately, with my camera phone, being ready for the quick snapshot is now almost a certainty.

Still, I love perusing the Magic Moments group pool. There are many photos of the perfect kiss, a purple sunset, a flying kite surfer, or a child laughing. The group name sums it up.

If you're time-poor, then visit The Magic Moments Photolog (http://magicphotoblog.blogspot .com/). Etolane, the group's Admin, created the site to collect and display some of the best photos on a regular basis.

Visual Bingo

If you have a spare month or so, then the Visual Bingo group might help you fill the gap. Its sole purpose is to add photographs that relate to bingo calls. You know; two fat ladies, legs eleven, and sweet sixteen.

Many group members are waiting for number 30, Dirty Gertie, additions. Personally I'll be impressed when someone collects the set, producing a collection of all 90 references.

Crappy Bootleg DVD Covers

Several years ago my wife bought me a DVD from eBay. She knew that I loved special features in my collection, and when she bought *Catch Me If You Can* starring Leonardo Di Caprio, she thought she was onto a winner because of the extras that the seller listed. It turned out to be a cleverly packaged bootleg—a copy DVD cobbled together by a pirate.

It also turned out to be a great story at get-togethers, and when the Crappy Bootleg DVD Covers group was launched on Flickr, it was lucrative for my photostream view count, with over 45,000 views and still counting.

After reading about a bootleg copy of *Star Wars Episode III*—days after the cinematic release and featuring Ben Affleck in a starring role—Flickr member El Primo started the group with his scan of a copy of *The Life Aquatic with Steve Zissou*, starring Bill Murray.

With so many such mistakes on the copied covers, the group is a poke at the flourishing pirate industry. Along with my photograph there is an image of the cover of the *Miatchstick Men* (Matchstick Men), *Eif* (Elf) with Well Ferrell (Will Ferrell), and a Chinese version of *Star Wars* starring Antonio Bandaras (Antonio Banderos) and Angelina Jolie.

If you have some great mistakes in your collection, be sure to share the "shoddy Photoshop work."

TOP GROUP POSTERS AND TAGS

In each group's pool, Flickr reports on *The Top Posters*, or the members who've added the most photographs, and *The Top Five Tags* associated with the group. There's also a link to *Photos You've Added* and the ability to see the top 100 tags.

Creative Commons

While surfing people's photographs, you may have noticed varying forms of legal rights. On the other hand, you might have been blinded by the array of photographs in Flickr, and their rights were the last thing on your mind. However, if you care for your photographic endeavors, it's worth understanding the different forms of license that you can apply to your images.

Most people are familiar with copyright. For centuries people have placed restrictions on their work to enforce varying degrees of rights. The form that has been accepted most widely by governments worldwide is copyright. Essentially, it is the exclusive right to the originator to print, publish, perform, film, or record literary, artistic, or musical material, and to allow other authorized entities to do the same.

In some circles, copyright is widely believed to be outdated. The argument against its use suggests that in some cases it's detrimental to societal rights, especially when current copyright law is changed, and retrospectively affects past works.

That's why a bunch of bright people created an alternative. Alternatives aren't new, but with the rise of the Internet, something called Creative Commons has become one of the more popular methods to protect ownership rights, but just as importantly to provide varying degrees of freedom to a creator.

According to the Creative Commons Web site:

> "Creative Commons was founded in 2001 with the generous support of the Center for the Public Domain. It is led by a Board of Directors that includes cyberlaw and intellectual property experts James Boyle, Michael Carroll, Molly Shaffer Van Houweling, and Lawrence Lessig, MIT computer science professor Hal Abelson, lawyer-turned-documentary-filmmaker-turned-cyberlaw expert Eric Saltzman, renowned documentary filmmaker Davis Guggenheim, noted Japanese entrepreneur Joi Ito, and public domain web publisher Eric Eldred."

Creative Commons provides a variety of different licenses protecting some, but not all, rights. As you can tell from the list of minds involved in its inception, they've done all the hard legal work to provide several simple varieties. These come in handy in communities where creators would love to freely share their work, and often hope to encourage varieties of innovation and creativity.

For example, Cory Doctorow, science fiction author and the European Affairs Coordinator for the Electronic Freedom Foundation (see the sidebar in Chapter 4), habitually shares his fiction under Creative Commons to encourage all manner of creativity around his work. His books have been translated, serialized as online audio, and converted to pirate-speak for International Talk Like A Pirates Day. *Wired* magazine (issue 12.11) bundled a CD on its cover in 2005, with 16 music tracks from artists like David Byrne and the Beastie Boys, licensed under Creative Commons. The publisher encouraged "people to play with their tunes, not just play them."

The different Creative Commons licenses are used to protect works in different ways. It's important to understand what each of these mean, not just to enjoy other people's creations, but to decide how you'd like to license your own photographs. Following is a list of the current licenses you can use within Flickr. I've used the details as described on the Creative Commons Web site (www.creativecommons.org) rather than my own words, which could be misconstrued.

None (All Rights Reserved)

By default your photographs will be licensed under full copyright.

Attribution

You are free:

- ▶ to copy, distribute, display, and perform the work
- ▶ to make derivative works
- ▶ to make commercial use of the work

Under the following conditions:

Attribution. You must attribute the work in the manner specified by the author or licensor.

- ▶ For any reuse or distribution, you must make clear to others the license terms of this work.
- ▶ Any of these conditions can be waived if you get permission from the copyright holder.

Attribution—No Derivs

You are free:

- ▶ to copy, distribute, display, and perform the work
- ▶ to make commercial use of the work

Under the following conditions:

Attribution. You must attribute the work in the manner specified by the author or licensor.

No Derivative Works. You may not alter, transform, or build upon this work.

- ▶ For any reuse or distribution, you must make clear to others the license terms of this work.
- ▶ Any of these conditions can be waived if you get permission from the copyright holder.

Attribution—Noncommercial, No Derivs

You are free:

- ▶ to copy, distribute, display, and perform the work

Under the following conditions:

Attribution. You must attribute the work in the manner specified by the author or licensor.

Noncommercial. You may not use this work for commercial purposes.

No Derivative Works. You may not alter, transform, or build upon this work.

▶ For any reuse or distribution, you must make clear to others the license terms of this work.

▶ Any of these conditions can be waived if you get permission from the copyright holder.

Attribution—Noncommercial

You are free:

▶ to copy, distribute, display, and perform the work

▶ to make derivative works

Under the following conditions:

Attribution. You must attribute the work in the manner specified by the author or licensor.

Noncommercial. You may not use this work for commercial purposes.

▶ For any reuse or distribution, you must make clear to others the license terms of this work.

▶ Any of these conditions can be waived if you get permission from the copyright holder.

Attribution—Noncommercial, Share Alike

You are free:

▶ to copy, distribute, display, and perform the work

▶ to make derivative works

Under the following conditions:

Attribution. You must attribute the work in the manner specified by the author or licensor.

Noncommercial. You may not use this work for commercial purposes.

Share Alike. If you alter, transform, or build upon this work, you may distribute the resulting work only under a license identical to this one.

▶ For any reuse or distribution, you must make clear to others the license terms of this work.

▶ Any of these conditions can be waived if you get permission from the copyright holder.

Attribution—Share Alike

You are free:

▶ to copy, distribute, display, and perform the work

▶ to make derivative works

▶ to make commercial use of the work

Under the following conditions:

Attribution. You must attribute the work in the manner specified by the author or licensor.

Share Alike. If you alter, transform, or build upon this work, you may distribute the resulting work only under a license identical to this one.

▶ For any reuse or distribution, you must make clear to others the license terms of this work.

▶ Any of these conditions can be waived if you get permission from the copyright holder.

Setting Default Photo Licensing

I have no intent to make money from my photography (although that would be nice), so I currently use the Attribution license. In fact, while writing this book I realized just how restrictive copyright is. I required a release form signed for each photograph printed, granting me (and the publisher) the right to use the photograph. Had every photograph been under a Creative Commons Attribution license, this would have been a less onerous task for everyone involved.

As I mentioned, the default license for all members starts as all rights reserved. You can keep this, or change the setting so that all future uploads reflect a Creative Commons license of your choice. In *Your Account* is a *Photo Licensing* category. This provides a drop-down menu to *SET DEFAULT LICENSE* for all future uploads. You can set any of the licenses detailed previously for every photo that you upload from this point forward (see Figure 7.19).

Figure 7.19
Setting the default
license for your photos.

Select a default license for your photos

Your Account /

When you upload a photo via the Flickr website, it will inherit the default license type you set here.

You should only license photos you own the copyright on.

Browse the existing photos licenced with Creative Commons.

What the hey?

You can choose to use a Creative Commons license to allow more liberal use and sharing of your photos while still maintaining reasonable copyright protection.

This option will apply to all public photos you upload from this point on (you can also batch-select a license for all previously uploaded photos and alter your setting on a photo-by-photo basis, if you'd like).

Which license is right for you?

The Creative Commons website provides a wizard for you to choose the license most appropriate to your needs. You can check that before you make your decision here.

For more information, you might like to read:

- A list of all 6 licenses and their explanations,
- The Creative Commons FAQ, or
- Information specifically for photographers & illustrators.

Select a default license

This will apply to all photos you upload in future. You can also change the license on all your existing public photos in a batch if you wish.

[Attribution License ▼]

(SET DEFAULT LICENSE)

Or, return to your account page.

Why?

Creative Commons is a non-profit organization devoted to expanding the range of creative work available for others to build upon and share. Current copyright laws are generally extremely restrictive. Creative Commons has done the hard legal figuring to enable you to simply and easily express your preferences with respect to what people can do with your work. We wholeheartedly support and endorse their work. (cc) **creative commons**

You can also set the license for individual photographs by selecting the *Change* link in the *Additional Information* section on the photos page. You also see a copyright or Creative Commons symbol; the latter providing a shortcut to modify the license. If you hold your mouse over the cc logo, you'll see which license is currently associated with the image.

Clicking the *Change* link allows you to change the *Privacy* setting, but you'll see a link to *Add a License for Your Photo*, or, if it's already under Creative Commons, you'll see the logo and a *Modify* link.

Batch-Select a License

If you'd like to change the license for a batch of photographs in retrospect, Flickr provides a batch option, found on the same page as the above default license option. It changes the license for every one of your public photographs with a single click.

DON'T BREACH COPYRIGHT

Speaking of copyright, you should not upload photographs for which you don't own the rights, unless you have permission. With that in mind, don't license a photograph under Creative Commons if it's not your copyright. It's illegal.

Browse the Existing Creative Commons–Licensed Photos

Every photograph in Flickr is either copyrighted or under Creative Commons. Its copyright status is displayed on every individual photograph's page under *Additional Information*. However, you can view photographs based on their Creative Commons licenses. There is a selection of links at the bottom of most pages; look for the one labeled *Creative Commons* in the *Explore* section (see Figure 7.20)

Flickr displays up to five of the most recent photos for each license. You can then select an image to see the photo's page, or select the member's name to jump to their photostream.

There is also a link to *See More*, which displays the 100 most recent licensed photos for that particular category of Creative Commons. The page also provides the option to browse popular tags, displayed like everyone's all-time most popular tags with varying font sizes, or the ability to search for keywords. Such a function is handy when you're looking for photographs to work with, whether publications or mash-ups.

Figure 7.20
Browsing photos by
Creative Commons
license.

CHAPTER 7

MASH-UP CULTURE

Other than providing a resource for publishers looking for photographs, you might wonder what's so useful about adding a Creative Commons license to your photographs. Among many different uses is an artistic craze, called a *mash-up*, that's sweeping the online culture.

Mash-ups aren't new. In fact, we've experienced musical mash-ups for decades. Merging a couple of songs is now common place.

Digital media, like music and photographs, are easy to manipulate with today's software. Sampling music is now so mainstream that we hardly blink when someone uses a Duran Duran beat in a hip-hop track. The same is taking place with photographs—images are easy to change, merge, and mash using software like Photoshop. Just do a search for the tag *photoshop* in Flickr.

Now mash-ups are spreading beyond just works of art and are emerging in software. We'll explore more in Chapter 9.

1337 PHOTO BOOTH

A dance lounge located at 1337 Mission Street in San Francisco has installed a high-tech photo booth. Gone are the days of the traditional 4-photo Polaroid being dispensed from the side. This geek's toy connects to the Internet and uploads the photograph to the ShineSF photostream on Flickr (see Figure 7.21).

Late-night partygoers can gather in the booth, pull faces at the camera, and view the photograph at Flickr when they awake the next morning.

Figure 7.21
The team at the Shine dance lounge, taken at 1337 Mission Street in San Francisco in their photo booth, and uploaded instantly to Flickr.

BRIAN WALSH

Brian Walsh is an entrepreneur in San Francisco. It was his idea to create the Flickr photo booth at his friends' club, Shine, located at 1337 Mission Street in San Francisco. Brian runs CastFire, a company focused on helping producers of online content generate revenue from advertising.

How'd you hear about Flickr?

I have been a fan and user of Flickr since 2004…somewhere in the spring. I heard of it as it was gaining traction in the blog-o-sphere and had to check it out. As the features were just being built out at that point, I didn't completely "get it," but liked the interface. As additional features were added over time and I grasped the power of tags and the public sharing of photos, I was immediately hooked. I have slowly started moving my 18,000 old photos from fotki to Flickr. I am much more selective about what I upload now—the world will ingest my pix! So…it's not just for friends and family anymore. That alone has pressured me to improve my style and skills. You can see my personal photos at www.flickr.com/photos/thepartycow.

What do you like about Flickr?

There are a couple of aspects that I absolutely adore:

1. RSS EVERYTHING! I use the RSS feeds to incorporate into Web sites, blogs, and social networks. For instance, Shine has a presence on Tribe (http://people.tribe.net/shinesf). We use an RSS feed from pictures that I have taken tagged with ShineSF and we take the RSS feed for the photo booth to populate the account. As Shine, and the sister restaurant Sauce, are run by professionals in the service industry, any step that can be automated to increase promotions or communication is absolutely essential. In addition, the RSS feed and API enabled us to implement a slide show from slide.com of the photo booth strips on the www.shinesf.com site. RSS is the http of the nineties and Flickr has fully embraced that.

2. Open API! As evidenced by the Flickr photo booth, the API allows developers, or pseudo developers, to make applications that leverage their serving, hosting, tagging, and image resizing tools. I knew that I could create an ftp site to upload the pictures, but never would have with the API available. There is an extremely passionate user base, developers willing and open to sharing code, and just a great environment to create. We never contacted Flickr to ask if we could do this. We never even worried that it would be an issue. Our experience has been fantastic.

3. Tagging! Yep, tagging. I religiously tag each of the photos that I personally upload to Flickr as well as the strips from the photo booth. Organizing, searching, sharing—such a simple interface. It is amazing the amount of times that someone would approach me for pictures of (insert person, place, event, thing). Now, people can just find the tag and they have all of my pictures. This saves me *soooo* much time in my life—and as you know, my time is precious.

4. Photos belong to more than one set or group. I was always frustrated that an image in other services only belonged to one album. What a pain in the ass. If I do a best-of series, I need to upload the photo multiple times. I don't have the time or desire to go through that process. With Flickr, the image is an object that can belong to other objects—whether they be sets, groups, etc.

How did you come up with the photo booth idea?

A gentleman by the name of Alec Bennett created a mobile art installation called the Photoboof [sic]. A photo booth built on top of a meter-maid vehicle that he drove around the playa. His system would print out the images and after the event, he uploaded them all to his own Web site.

As we were building out the club—it was about 5 in the morning and we had been working all night—everyone was discussing what do with a corner of the club. Well…I came up with this idea to build a photo booth, but to not have it print out images, as a club environment is just a little bit challenging to have printers, paper, inkjet, etc., being used all night. I knew I could use the Flickr API and leverage the incredible user base.

continued

About a week or two later, one of the other owners asked me about the photo booth. I believe my response was, "What photo booth?" Yeah, the club was using this as a cornerstone—I just threw the idea out as a cool, geeky thing to do. So, I spent a couple of long nights getting it up and running and voilà!

How does the photo booth work?

It runs on the LAMP (a computer platform composed of Linux, Apache, MySQL, and PHP) stack. It is actually a series of PHP pages, python code, a Web cam, and a beautiful hack of a mouse! To launch the app, there is java script that is waiting for a mouse click. Hmm...how to do that? I ripped apart a mouse, put in a plunger switch on the wall of the photo booth, and soldered two wires from the plunger switch to the back of the mouse. In fact, I finished it as people were walking in the door opening night! It was quite exciting to see it work. We are now updating the camera from a Web cam to a Canon a310 digital camera. The pictures will have *awesome* quality and the size will allow for great printing.

What's one of your favorite photos you've taken and shared in Flickr, and why?

It is actually a set: www.flickr.com/photos/thepartycow/sets/1683060/

My mother has hysterical laughing fits that just have to be witnessed! Being in the same room is infectious and just makes you double over at times. Or stare in amazement! Over Christmas this year, I was fortunate to be sitting next to her as she entered into a laughing fit, and I was able to catch it. I will cherish that set forever. My children and grandchildren will be able to see my mother through my eyes (see Figure 7.22).

Figure 7.22
The mother of Brian Walsh, caught in the middle of a laughing fit.

What's your favorite group, and why?

www.flickr.com/groups/guesswheresf/pool/

A great time killer when you need to blow off some steam! Just how well do you know your own city?...

What's your favorite tag, and why?

www.flickr.com/photos/tags/burningman/

I have been to Burning Man many times. Each person's experience is uniquely their own. It is great to be able to see the playa through so many different eyes.

Any interesting stories about the photo booth?

Well, here is a funny tidbit.

All of the hardware, from the computer to the LCD screen to the mouse and keyboard came from a failed dot-com that Trip Hosley and I worked out. So, it is Web1.0 hardware running Web2.0 software!

CHAPTER 7

Chapter 8
Flickr Communications

So much goes on in the world of Flickr that it's sometimes hard to keep up: fabulous photographs, fun groups, new features, and additional applications. That's why there are a bunch of resources for those hungry for the latest information.

While writing this book I monitored them all to make sure I added the right detail as well as any interesting features. Without the Flickr communications tools that I'll list in this chapter, it would have taken me many times longer to find everything that I've added.

Some of the resources are simple, like the forums that provide help. Some are a little more cutting edge, like RSS, weblogs, and podcasts. Whichever medium you prefer, you can fill hours keeping up to date with photos, groups, features, and people. You just have to know where to look.

Keep in mind that since Flickr is a community, the Flickr team (or Yahoo!) does not provide most of the information. Flickr members informally communicate much of the information, and because there are so many, the result is a very rich amount of detail.

In this chapter I'll discuss the communications sections created by Flickr, the weblogs and podcasts provided by members, and an interesting medium called news aggregation for getting up to date quickly. Before long your curiosity will be quenched by a torrent of Flickr facts and fun.

Flickr News

The first place for a quick update on what's new is the *Flickr News* section. However, Flickr provides snippets of information about new features and changes on almost any relevant page (see Figure 8.1), so you don't have to constantly monitor the news page. It's a smart notification system, and ensures that you don't miss any of the exciting enhancements that appear. Select the blue link to read more at the *Flickr News* page.

To remove the notification, select the *Dismiss* button at the top right of the notification text box. In most cases it will tell you where you can find the news for reference at a later date, and when you return to this page the message is removed.

> **Hey! A new notification system!** You can read more about how it works on the news page. You can get rid of this notification by clicking the "dismiss" button in the upper right corner of this box. `DISMISS X`

Figure 8.1
A notification that can appear on almost any page.

The *Flickr News* page is a weblog, with each entry showing changes in reverse chronological order (see Figure 8.2). The most recent additions appear at the top, so you can quickly see what's happening. A *weblog* is one of the Internet's buzzwords; it's a self-published Web site for groups or individuals to post information or news (see the "Weblogs" sidebar).

Flickr News usually provides details of new enhancements. However, it is also a place for major announcements, like when Yahoo! purchased the service.

The page also contains the *Dev Change Log*. That's geek-speak for the changes that Flickr makes to the site. Dev is a truncation of the word "developer" the clever crew that actually make Flickr work by developing the application. Traditionally, software would ship with a list of major changes. Flickr doesn't ship as such; there is no shrink-wrapped box sold in stores. So it uses the *Flickr News* page to outline recent changes.

The *News* page is the more formal communications channel for Flickr. At least it's as formal as the people behind Flickr are likely to get; they're more a freeform crew. Each announcement is succinct, but phrased informally, with just a touch of technology jargon.

Figure 8.2
The *Flickr News* page.

Blogs, the common contraction of the term, have flooded onto the World Wide Web and contain personal diaries, rants, announcements, or news about any topic imaginable. Do a search for your favorite topic in Google or Yahoo!, and you're bound to stumble across a wide range of weblogs.

Given that weblogs are cheap and easy to create, they offer a vehicle for almost anyone with access to the Internet to create dialogue. Many people see this as a threat to traditional media. Instead of filtered information being created by multimillion-dollar corporations, anyone can express an opinion. This alone has led to a healthy debate about the potential effects of blogs.

I frequent technology blogs, which keep me up to date on my industry. However, if your stomach is rumbling, look for a food blog, or find travel blogs for itchy feet, music blogs for your ears, or FlickrBlog about Flickr (see below).

I'll provide more detail about weblogs and how Flickr interacts with them in Chapter 9.

FlickrBlog

Flickr's team, although incredibly busy people, will occasionally pop their heads above the sea of code and photographs and let us know what's happening in their kingdom. If you're lucky, you'll hear them speak at one of the conferences that they frequent to talk about Flickr. If you can't attend a conference, you can always check the FlickrBlog.

FlickrBlog doesn't just provide the latest news about the product and community—that's left to the *Flickr News* page. FlickrBlog shares some of the fun photographs, tags, and groups that the Flickr team have found. Flickr being their day job, they have a keen eye for the magical, marvelous, and momentous photographs (see Figure 8.3). It's the informal communications channel that usually focuses on fun.

Figure 8.3
FlickrBlog.

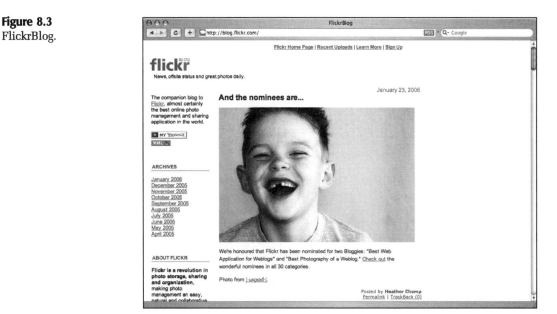

Several of Flickr's team are involved. Occasionally you'll hear from Caterina or Stewart, but more often from a few of the others. George Oates, Flickr's producer and a fellow Aussie, pointed out the pillowfights tag and a great feather-filled snap of a public battle. Heather Champ (see the "Mirror Project" and "*JPG* Magazine" sidebars), Flickr's Community Manager, showed us ElectrikCandyland's Squirrels set, including his series using a camera remote, flash, fisheye lens, and a bag of peanuts—capturing candid nighttime nut pilfering.

Every fan of Flickr should bookmark the FlickrBlog. It provides a regular forum for everything to do with the application. Whether it's member's fantastic photographs, news about the latest features, tips for Christmas presents, or updates about the latest adventure of a Flickr employee, it's as diverse as the photos shared in everyone's photostream.

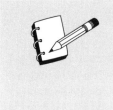

FLICKR'S TEAM

If you're interested in who creates and runs Flickr, you can always find out about who they are by following the *About Flickr* link at the bottom of most Flickr pages. Each of their buddy icons allows you to add them to your contacts. Follow their photostreams and you'll occasionally be treated to a behind-the-scenes view.

THE MIRROR PROJECT

I found the Mirror Project (www.mirrorproject.com; see Figure 8.4) just after my honeymoon. I love trying to capture interesting photographs, but self-portraits have taken a backseat now that I have a daughter; I spend most pixels capturing her antics. However, on the trip I snapped a couple of photos through a mirrored surface: one a NASA spacesuit, the other a mirrored ball on a building in Los Angeles. I uploaded the photographs to the rapidly growing collection at the Mirror Project.

Figure 8.4
Heather Champ's Mirror Project. Champ is also Flickr's Community Manager.

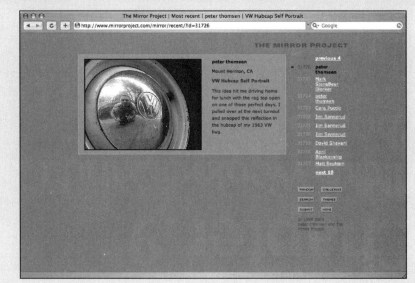

Flickr's Community Manager, Heather Champ, started the project as an adjunct to her own mirror collection, which she started years before Flickr arrived. In an interview for *O*, the Oprah magazine, Champ confessed that she was compelled to capture her own image in mirrors shortly after her parents' deaths. Feeling mortal, she was compelled to create her own memories. Not a bad idea, given the lack of photographs of a photographer; the camera is always pointing in the wrong direction.

The collection now totals well over 30,000 images from people around the globe, dating back to 1999. It's an impressive collection, with portraits encapsulated in ornate mirrors, car hubcaps, or Christmas ornaments.

Champ has even started a Mirror Project group in Flickr, to encourage people to post their photographs in their accounts, and to the project. Search tags for "mirrorproject" for another large collection.

JPG MAGAZINE

Heather Champ, Flickr's Community Manager, is a busy individual. Not only does she keep her day job ticking along and monitor her Mirror Project, but she also works with David Powazek, to produce *JPG* magazine (see Figure 8.5).

Each quarter, the magazine is produced and sold through Lulu (www.lulu.com)—which is also worth perusing, as it is "the Web's premier independent publishing marketplace for digital do-it-yourselfers. It's the only place on the Web where you can publish, sell and buy any and all things digital—books, music, comics, photographs, movies, and, well, you get the idea. We simply provide the tools that leave control of content in the hands of the people who created the content."

The publication ranges from about 50 to 60 pages, and is a bound, 6-inch-wide, 9-inch-tall, full-color magazine. However, the real beauty of the magazine is that anyone is able to submit photographs. There are no guarantees that the images will make the magazine, but it's nice to know that anyone has a chance of having their work displayed in a glossy publication. Simply visit the Web site (www.jpgmag.com) and follow the submission information.

Each issue usually has a theme: *origins*, *lost*, and *fabulous* constitute the first three issue themes, and the fourth is the only issue without a theme.

Figure 8.5
JPG magazine, a quarterly exposition of amateur photographers.

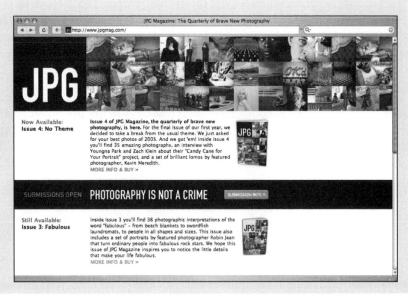

CHAPTER 8

Flickr has a *JPG* magazine group. It isn't for submissions, but provides news and discussions. It also accepts photographs, but not for submission to the magazine.

In today's world, where anyone can afford to publish, it's not surprising to see a photographic magazine by the people for the people. However, it's no kludge; it's well produced, and provides fabulous photographs and interviews that will appeal to most amateur photographers.

Check Flickr's *JPG* magazine group for updates, discussions, and photographs. However, if you want to submit your photo, use the magazine's official Web site.

Flickr Public Forums

There are several forums that exist solely to help Flickr users. It's the first place that you should search for information, point out abuses, provide suggestions for new features or improvements, report bugs, and learn interesting tips and tricks.

You can find the Public Forums on the *Groups* page, or the Support section at the bottom of most pages. There are three forums, each with a different purpose: FlickrHelp, FlickrIdeas, and FlickrBugs.

FlickrHelp

FlickrHelp is the forum for asking simple or complex questions and for reporting unsuitable content. Simple questions, often answered by others from the community, include paying for a Pro Account, using Creative Commons, deleting sets, and posting images to groups. Although I've answered many simple questions in this book, occasionally you'll need to ask something a little more complex.

One post to the group suggested that a scam artist was using the site. Commonly known online as a Nigerian scam—named for the region that propagated the online crime—the member complained that the fraudster, offering a "supposed inheritance from Nigeria of a portion of a sum alleged to be $15.7 million dollars," had targeted him. He'd received a Flickr mail making the proposition. Fortunately, the member, in his late sixties, was a retired U.S. federal agent, which is the wrong demographic to target for a scam. He reported the abuse to the group, and I assume Flickr staff took the right action.

Another member found someone claiming several of his photographs as their own. This may seem innocent; however, it infringes copyright and most Creative Commons licenses. Posting a message to the FlickrHelp forum resulted in the Flickr team removing the offending photos and posting a Notice of Infringement to the thief.

The group isn't just a forum for offenses. They accept any questions—simple or complex—and it's a great place to start with any query. Make sure you search the group for a previous answer before posting a question though; that'll keep the helpful folks' workload to a minimum.

ONLINE SCAMS

Although Flickr is a relatively safe harbor, it's worth being wary of scams, as proven by my federal agent story. The Internet in general is rife with scamsters, and just as rife with unsuspecting innocents.

The age-old rule of thumb applies: if it sounds too good to be true, it is. However, a great resource to check if in doubt is Snopes (www.snopes.com). It has an urban legend database, which can debunk popular scams.

Often, scams such as the Nigerian scams are handwritten by a criminal. However, they follow a similar pattern. For instance, offering a percentage of a very large sum of money to help transfer funds between countries. All you need to provide are your bank details.

Check Snopes and you'll find dozens of references.

FlickrIdeas

If you think of something that might make Flickr a better tool, then FlickrIdeas is the place to let your ideas loose. Some ideas will run rampant, starting a never-ending debate, others might hit a wall when other members slam the idea moments after you've pressed the *POST NOW* button.

In some instances the discussions can get very technical. This, however, shouldn't stop a layman from making a suggestion. In my experience, it's often the computer-challenged that make for the best lateral thinkers; you know—the people who use a computer's CD drive trays as cup holders.

Discussions have centered on making it easier for non-members to view your private photos, creating sets in sets, smart sets that automatically add photographs, and ongoing discussions about censorship using the *Flag this photo as "may offend"* link.

The forum is monitored by the Flickr folk, so a clever idea may well end up being added to Flickr's ever-growing feature set. When a theme resurfaces time and again, it's bound to be popular. When the Flickr member windelbo requested an advanced search, Stewart Butterfield replied with details of using the current search tool, and a hint about a soon-to-be-launched search system.

Everyone has suggestions for improving a service, but it's not everyday that we are provided with a feedback forum.

FlickrBugs

A *bug* is the common computer term for an error in the way a system works, and it has been a term used since well before the first computer. Even Thomas Edison used the term in 1878 when describing the process of invention. It's even worth looking through the Flickr's Public Computer Crashes group to see the result of a bug or two, for a touch of harmless geek fun.

If you bump into a bug, and it's causing you some difficulty, you can visit the FlickrBugs forum to see if anyone else is experiencing the same issue. As with the other forums, you should search before posting a message. That way if it's been discussed earlier, you don't waste any extra time.

Posting to the group can resolve the issue quickly. It could be a user error (don't worry; it won't be the first or last time) or it could be a legitimate bug. In the case of the latter, Flickr needs to know so that they can solve any major issues quickly.

Photo Feeds

Dotted throughout Flickr are *feeds*. By now you should be accustomed to strange terms like *photostreams* and *favorited*. A feed is another term to add to the geek collection. Like the others, it draws from a traditional meaning. Broadcast media has used the term for decades to describe the action of providing data. Just like a satellite feed for a sporting event.

In Flickr's case, a feed contains photographs from photostreams or discussions from a group. It just depends which one you subscribe to. Recent developments have seen feeds for different types of data flourish on the Internet. News Web sites publish their latest items, weblogs provide the latest postings, and television stations even have their shows listed. So it's not unusual for Flickr to add a collection of feeds to their Web site for subscription.

In general, the concept of an Internet feed provides an easier distribution model. Instead of returning to a Web page time after time to look for updates, a person can use a piece of computer software, commonly known as an *aggregator* or *feed reader*, to subscribe to feeds. It's then up to the software to monitor the feed for changes, providing the update when it becomes available. You can then just "set it and forget it."

From a Flickr member's point of view, feeds are a great way to stay up to date with any additions to family or friends' photo collections, and to stay abreast of discussions. It's even useful to watch a stranger's photostream, especially when they're attending an event you're interested in or they just happen to be a fabulous photographer.

To take advantage of Flickr feeds requires a news aggregator. There are dozens available—some that can be downloaded for free and others that need payment. They all act in a similar fashion: subscribe to a feed, and at a definable period it will check for updates.

I use an Apple PowerBook, and a few years ago I installed NetNewsWire Lite (see Figure 8.6), by NewsGator Technologies. Its bigger brother, NetNewsWire has a few extra features, but the Lite version is free. Both are very simple to use, and have provided me with a way to stay up to date with information from major news services, weblogs, and people's latest photographs in Flickr feeds. If you're a Windows user, then a popular choice is FeedDemon, also by NewsGator.

Once you've chosen your feed reader, the next step is to subscribe to the actual feed you're interested in. Depending on how you've set up the software, and the way your Web browser works, this will either be a one-click process or will require a copy and paste action. The best way to find out which method works is to test it.

Feeds are available in three forms, RSS 2.0, Atom, and My Yahoo! You can find these links at the bottom of several types of Flickr pages: a member's photostream page, your contacts page, recent activity, comments you've made, a group's main page, a group's photostream, and a tags page.

Figure 8.6
NetNewWire Lite,
reading a Flickr feed.

RSS AND ATOM

I've already mentioned how confusing geeks can make a technology by including acronyms to describe technologies. So, are RSS and Atom instruments from a rocket ship, or cartoon characters from Nickelodeon? Well, neither—they're the fancy names for Internet subscription services.

RSS stands for Really Simple Syndication. Like many recent Internet standards, it has had its fair share of consternation. With so many people involved, and differing opinions, previous versions went by the names RDF Site Summary and Rich Site Summary. In recent years a new branch of syndication was created, and called Atom, which has its own benefits.

Flickr provides both RSS and Atom feeds, and their basic functionality is similar.

RSS and Atom

To test your feed reader application, click your mouse cursor on either the *RSS 2.0* or *Atom* link. This will result in either a feed appearing in your browser, or your feed reader launching and adding the feed to its collection.

If your feed reader doesn't launch automatically, it might mean that you need to add the feed's URL to it manually. You can do this by right-clicking either the *RSS 2.0* or *Atom* link and selecting *Copy Shortcut* in Windows Internet Explorer, or control-click and select *Copy Link* in Mac's Safari browser. You then paste the link into the feed reader; there should be an option to add a feed (NetNewsWire has a *Subscribe* button).

COMMENTS FEED

Two great feeds for subscription include the *Recent Comments* and *Comments You've Made* pages. With these pages you can see comments about your photographs and follow conversations about others' photos you're involved in.

My Yahoo!

The other available feed is specific to Yahoo!

Yahoo! has a specially designed Web site, called My Yahoo!, that provides you with control over the content that is displayed. The computer industry calls Web sites that host a lot of customized information a *portal*, which is a place to find everything from one location.

When you signed up to Flickr, you also signed up to Yahoo! Doing so provided you with access to all the features Yahoo! provides, like e-mail, calendar, address book, and the portal. To activate it, you just need to visit Yahoo!, log in, and select the My Yahoo! button (see Figure 8.7). You can then customize to your heart's content.

But this book isn't about My Yahoo!, so I'll leave it to you to experiment and set yourself up. However, if My Yahoo! is something that you have or plan to use, then you can add Flickr to its content. Neat columns display any photostream (see Figure 8.8) and group discussions (see Figure 8.9), and you can add as many as you like and view them all on a single page. All you need to do is select the My Yahoo! button on the same Web pages where you find RSS and Atom.

Figure 8.7
The My Yahoo! button.

Figure 8.8
A Flickr photostream in My Yahoo!

Figure 8.9
The Flickr Central
group discussion in My
Yahoo!

Create Your Own Feed

If you've conquered the feeds provided by Flickr (RSS 2.0 and Atom), you might want to create a few of your own. That way you can tailor the results to your liking. Using a generic feed URL and adding parameters, you can fine-tune the results.

Without parameters, the URL www.flickr.com/services/feeds/photos_public.gne provides a feed of every public photo, just like the one on the *Home* page. Enter it into your feed reader, and you'll receive small images of the 10 most recent photographs.

You can vary this feed, making the results more specific. Adding a couple of parameters refines the resulting photographs to specific Flickr members and tags. These parameters are as follows:

▶ **id:** A Flickr member's identification to fetch a feed from their photostream (see the "Member's ID for Feeds" sidebar)

▶ **ids:** A list of Flickr members, separated by commas, to fetch a feed from several people's photostreams

▶ **tags:** A list of keywords, separated by commas, to fetch a feed with only specific associated tags

▶ **format:** The type of feed (rss2, atom, rss_091, rss_092, rss_100, rss_200_enc)

Test out a few by playing with the complete URL. For example: www.flickr.com/services/feeds/photos_public.gne?tags=australia&format=rss_200 provides a feed for the last 10 photos with the tag *australia*. On the other hand, www.flickr.com/services/feeds/photos_public.gne?tags=2005 &id=35034356424@N01&format=rss_200 provides the 10 most recent photos from my own feed with the tag 2005. These are simple examples and their feeds are available already; however, you can create complex feeds for more than one member and tag.

MEMBER'S ID FOR FEEDS

You may have noticed in the example of a feed URL for my 2005 photographs that I did not use my username, richardgiles. It actually requires something called the network service identification (NSID), which looks like a jumble of numbers—in my case 35034356424@N01.

You can find this NSID for any user by looking at the other feeds that their photostream page provides. Just copy the URL link to check it out.

Another alternative is to use a simple Web form, created by Dave Kellam, which will find the NSID when you provide a user's photostream URL. You can find it at http://eightface.com/code/idgettr/.

PLAYING FLICKR

What if Flickr weren't confined to your home or work computer? What if photographs were projected on to giant screens in a local restaurant? Diners in Amsterdam were provided with a firsthand experience when Willem Velthoven (see the interview sidebar) created an exhibition for Restaurant 11 in 2005.

Velthoven took the experience one step further. He put the exhibit into the hands of the patrons—literally. Anyone with a cell phone could SMS a keyword that would display Flickr photographs using the same tag. The three giant screens would display the associated image, tag, and member's name.

I just hope that the images were filtered in some fashion; I wouldn't want a diner's meal ruined with a gory or lewd photograph. Then again, it was in Amsterdam.

Mediamatic (www.mediamatic.net) is a cultural institution in Amsterdam. They do exhibitions, presentations, workshops, and other activities in Amsterdam and internationally. They are responsible for other events, such as the Flickr Peep Show, and workshops on moblogging (see Chapter 9).

WILLEM VELTHOVEN

Willem Velthoven created the Playing Flickr exhibit at Restaurant 11 (see the "Playing Flickr" sidebar). He is the Director of Mediamatic Interactive Publishing, Editor-in-Chief of *Mediamatic* magazine, and Senior Designer for both the magazine and the Interactive department at Mediamatic.

How'd you hear about Flickr?

I'd met Stewart and Caterina before.

What do you like about Flickr?

The social aspect. Attention you get/give. The API. The richness in content connections and the sleek interface. Also, but more in the beginning, its population.

What was your aim with the Playing Flickr work?

To confront the intimacy with public space. To provide a way of sharing the amazement when browsing. To play with semantics of word and image, to seduce people in public space to have live exchanges through the screens, to do it because it was possible.

What did you discover from the project?

That only 10 percent of visitors in the club get it and like it (but that's a lot).

What's one of your favorite photos you've taken and shared in Flickr, and why?

Whoa, many for many different reasons.

www.flickr.com/photos/willemvelthoven/62407634/

This one I like because I love my son Goos and because of the expression of him singing underwater (see Figure 8.10).

www.flickr.com/photos/willemvelthoven/5284193/

This one because it is an effective communicator.

www.flickr.com/photos/willemvelthoven/11918933/

This one because it's nicely meta!

www.flickr.com/photos/willemvelthoven/8513870/

This one because I still love her eyes.

What's one of your favorite photos from another Flickr user, and why?

www.flickr.com/photos/lotte/12144692/

This is nice because it's so private. She took it while she was bored on a rainy day in the train.

What is your favorite tag?

me

Any interesting stories about Flickr?

flickr peep show:

www.mediamatic.net/artefact-200.9203.html

flickr dene voss: www.mediamatic.net/artefact-200.9446.html &

www.mediamatic.net/article-200.9235.html

physical tagging: www.mediamatic.net/article-200.9247.html

theandyface: www.mediamatic.net/article-200.10174.html

Figure 8.10
Willem's son singing
underwater.

Other Flickr Weblogs

In some respects, given the large community, it's surprising that there aren't many external weblogs that discuss Flickr. On the other hand, given that Flickr caters to the community within the site, it shouldn't be surprising. However, there are a few weblogs that are worthy reading for any Flickr aficionado—or is that aflickrado?

Co-founder Caterina Fake has her own blog at www.caterina.net. Visit it, and you'll follow her around the world, traveling for her work. On a recent trip she visited England and Italy, taking photos as she went. She also happens to be a bookworm, so you are treated to passionate reviews.

George Oates is one of Flickr's developers. She's actually a fellow Aussie, coming from just down the road in Adelaide, 1,677 miles from my hometown. Personally, I get a great kick out of hearing news from the inside of Flickr in a laid-back Aussie voice. You can find her talking about her good old Aussie barbeque at http://george08.blogspot.com/.

What would a community manager be without a weblog? Well, I'm not sure, because all communities have one these days. Heather Champ, Flickr's Community Manager, is no exception. You can find her weblog at www.hchamp.com. You'll find some wonderful photography, linked to Flickr, and every few days a rant or two.

Keeping your eye on these three blogs will keep you up to date on the personalities that help run Flickr, and subscribing to their photostreams means you can see the world through their eyes.

Flickr Podcasts

If you just haven't managed to cram enough Flickr-ness into your life, then I can fill a couple more gaps—such as when you're commuting to work or out for your morning jog.

Podcasting is a new Web phenomenon that's seen an explosion in popularity like no other Internet meme. A *podcast* is an audio file that you can subscribe to using RSS (see the earlier details on RSS and Atom). Essentially it means that an audio file will be downloaded to your computer for you to listen to in your own time. It's like TiVo for audio. You subscribe to the audio show you'd like to listen to, and listen when it suits you. I for one am hooked, hosting several of my own podcasts, and listening to about a dozen different shows.

Flickrcast

Every week Bryan Campbell and Jason Matthews host Flickrcast (http://flickrcast.blogspot.com/). The duo casually chats about the latest community news, applications, features, cameras, and accessories (see Figure 8.11).

Flickrcast topics include new Flickr features, breaking news of them before some even reach launch. Weeks before Flickr announced a new search feature, it was discussed in the FlickrIdeas group, and Campbell and Matthews discuss the new option on their podcast. The guys are always monitoring the groups for new and exciting topics.

Figure 8.11
The Flickrcast Web site.

FlickrNation

Not long after Campbell and Matthews launched their podcast, Thomas Hawk launched his own, called FlickrNation (http://flickrnation.com/). The content is similar to Flickrcast. However, there is no competition between the shows; in fact, they cross-promote.

Hawk is an avid photographer, and reports the latest Flickr news with a passion. The show isn't updated as often as Flickrcast, but the weblog is constantly reporting new details.

When Hawk encountered some issues when he tried to buy a new camera from an online store, he posted details to the weblog and reported the details on the podcast. Flickrcast also reported the story, spreading the news of the ridiculous customer service. It's amazing how an online community can rally to correct an alleged injustice.

CHAPTER 8

JASON MATTHEWS

Jason Matthews is the co-host of the Flickrcast podcast.

How'd you hear about Flickr?

It was either Warren Ellis talking about it on his site (www.warrenellis.com), or Cory Doctorow talking about it at boingboing (www.boingboing.net). I read about it a few times and then decided to check it out after trying out a few other photo hosting sites that I had found poorly implemented. Flickr had the community and clean interface I'd been looking for.

What do you like about Flickr?

The community, definitely. Something about the way Flickr is designed has fostered one of the most creative and constructive communities I've ever seen online. A lot of communities devolve into flamewars and bickering or fragment into exclusive cliques, but Flickr has been remarkably resistant to that. It still feels great when someone comments or favs a photo of mine out of nowhere.

continued

What made you start the Flickrcast?

Well, (co-founder) Bryan (Campbell) had been doing another podcast and was telling me it was fun and I should do one. I had some experience with audacity and knew I probably would be able to handle the audio side of it easily enough, but I didn't have a topic for one and didn't feel like doing a show solo. So he suggested a Flickr podcast, which was an idea I'd been kicking around for a while without mentioning it. We didn't know of anyone else doing one, we thought we could come up with enough to say for a weekly show, and it seemed like a topic that would interest a somewhat sizable audience. So we bought copies of Michael Geoghegan's *Podcast Solutions* book, ordered the mixers and mics, set up the blogspot and our media accounts, registered the domain, designed the artwork, and...sat on it. It took us forever to get around to recording that first show. When I woke up one morning and saw a post in flickrcentral asking whether anyone was doing "a flickrcast," I knew we couldn't wait anymore.

What do you hope to accomplish with Flickrcast?

Well I don't think I've ever had a goal in mind for it, so for me it's probably something like "to amuse ourselves and possibly our listeners."

What's one of your favorite photos you've taken and shared in Flickr, and why?

My favorites are usually the ones I've taken most recently, and I have a hard time picking just one from the stream. I will say though that my personal favorites are rarely my most "interesting," according to Flickr's algorithm.

What's one of your favorite photos from another Flickr user, and why?

http://flickr.com/photos/beniko/59066418/

I like this one from beniko (best viewed large). I'd had a similar idea kicking around in my head for a long time, waiting to see it out in the world. I think he beat me to it.

What's your favorite group, and why?

Right now it's probably the Canon DSLR user group, because a lot of the discussions there are relevant to issues I'll encounter while shooting. There are other groups I'm subscribed to whose themes interest me more—Prime Lenses and Quiet—right off the top of my head), but unfortunately there isn't a lot of discussion in those.

What is your favorite tag, and why?

That's a difficult question to answer because I don't really follow global usage of any particular tag. I'd like to say it's something like "quiet," because that style really appeals to me, but a quick glance at the tag shows that I'm not envisioning the same types of photos as most of the people using the tag.

Chapter 9
Flickr, Weblogs, and Camera Phones

I discovered weblogs in 2002. I stumbled across the weblog of David Weinberger, a co-author of the international bestseller *The Cluetrain Manifesto*.

In all honesty, I'd started writing a personal Web site in 1997, but before the advent of the weblog concept, it was a little more difficult to publish to the Web. My site didn't last long because I didn't have the time to dedicate to hand coding the personal entries.

Today, weblog publishing systems make it incredibly simple, and Weinberger and the Cluetrain crowd made the concept compelling by espousing a "markets are conversations" anthem.

So what are weblogs? They are personal Web publications, the name derived from the concatenation of Web and log. It's often easy to describe weblogs as personal online diaries, but they're a little more complex. The real reason for their popularity is not just their ease of publication, but also the authenticity of the author's voice.

With the ever-expanding empire of the Fourth Estate (a term used to describe the collective press), many readers are looking for fresh content with a human voice, not one that is corrupted by a corporate agenda.

Weblogs can be found covering every topic. I explored Flickr's own blog in Chapter 8, but almost any subject imaginable is covered by bloggers. Search in Google or Yahoo! for a favorite topic and you'll find several weblogs. If you don't find one, perhaps it's time you started it.

I've mentioned weblogs several times throughout this book because the blogger culture is firmly engrained in the roots of Flickr. Caterina Fake admits that she and fellow Flickr cofounder Stewart Butterfield were passionate bloggers when they started the application, and therefore made Flickr as blogger-friendly as possible.

That's why Flickr offers a bunch of tools to publish photographs on blogs. You can send photographs from Flickr via e-mail and even straight from a cell phone.

Not only can you publish your own photographs to your blog, but also, with the right permission, you can publish other member's photographs.

CREATE YOUR OWN WEBLOG

There are dozens of ways to create a weblog. Fortunately, many of them are cost-free and easy for the technically challenged.

Three reputable services include Blogger (www.blogger.com), TypePad (www.typepad.com), and WordPress (http://wordpress.com/). If you're interested in starting a weblog, one of these three will serve you well. Each provides free or very cheap accounts that will quickly have you mixing it with the rest of the blogosphere (a cute term used to describe the world of bloggers).

There are dozens of weblog platforms floating around the Internet. If you haven't yet made your choice, it's worth knowing a little about each of the platforms that Flickr supports.

I've used several in the last few years, and as a way of describing the platforms, I'll explain the reasons I used, or ignored, them.

When I started to dabble in blogdom, I looked at Radio UserLand by Dave Winer, a software designer who's well known among webloggers for his involvement with the community's growth. However, the application's many features made it complex. There was no doubt it was a great application, but I wanted something simpler.

I continued my search and found Blogger.com, an incredibly simple platform. It was appealing because it's free and provided a hosting service. This meant I didn't need access to a Web server on the Internet; everything was taken care of.

At the time, a company called Pyra Labs owned it, and I felt a little nervous about its long-term viability. Eventually there was no reason to worry, and in 2003 Google bought the company. Today, it's reliable, simple, free, and run by Google.

The first weblog platform I used for a reasonable time was Movable Type. It's a little more complex because it requires access to a Web server for installation. However, for the same reason it was much more flexible, and I knew that I controlled the content. I didn't need to worry about long-term viability of a company and its servers.

Since then, Six Apart, the company that created Movable Type, has created a hosted service similar to Blogger.com. It's called TypePad, and although it's not free, the rates are very reasonable.

LiveJournal was another early provider of weblogs. It was one of the most popular, and currently has over 9 million accounts. In early 2005 Six Apart purchased LiveJournal, and they now offer a free account.

In 2004, Six Apart modified the license structure to Movable Type. It included a few more restrictions that concerned some users, myself amongst them. Although the legal changes were innocent, when I decided to start another blog, my sixth, I tried another weblog platform called Wordpress.

Like Movable Type, Wordpress requires access to a Web server. However, it is fairly straightforward to set up, and it has won many fans.

In 2005, Wordpress also launched a free hosted service at http://wordpress.com. It's fashionable to make it easy to use weblogs; after all that's one of its major claims. So a hosted service that doesn't require any hardware or software tinkering by the user is an important advantage.

If you want flexibility, and are willing to tinker with your own hardware or software, then Movable Type and Wordpress are the leaders. For those who would rather leave software installs to others, and just want a quick way to post content, then Blogger, TypePad, and Wordpress.com have their share of fans. Any of them work with Flickr, so posting photographs is a snap. If you consider another service not mentioned here, then check whether it works with Flickr first.

Posting Photographs to Weblogs

Flickr makes it simple to publish your photographs straight to your weblog. There are several options: post from Flickr, via e-mail, the Flickr Badge, and Flickr Zeitgeist.

First we'll start by creating our weblog settings in Flickr.

Setting Up a New Blog

From a Flickr page, select the *Your Account* link in the top right-hand corner. In the settings you'll find a section on *Blogging*. Let's start with the *Your Blogs* link. When you first select the link, it will offer the opportunity to *Set Up a New Blog*; however, it enables you to manage a number of weblogs.

Flickr supports a number of blog platforms (see the "Create Your Own Weblog" sidebar). When adding a blog to Flickr, you need to specify which type you use; each type has a slightly different way of communicating with Flickr, so it needs to be specified. Select the weblog platform you use, and click the *NEXT* button.

The next settings vary depending on your weblog choice. You are required to provide details so Flickr can locate and log in to the blog for publishing purposes. It needs at least a username, and optionally your password. Some people prefer not to save their password in Flickr: however, if it's not provided it will request it every time you try to publish.

For your weblog, provide the requested information, which is summarized in the following list.

- ▶ Blogger Blog: Flickr only requires your Blogger username and password.
- ▶ TypePad Blog: Flickr only requires your TypePad username and password.
- ▶ Movable Type Blog: As well as your Movable Type username and password, Flickr requires your Movable Type installation's MT cgi-bin location. This usually follows a convention similar to http://YOUR WEB ADDRESS/cgi-bin/mt/mt-xmlrpc.cgi, but may vary depending on how you configured the Movable Type installation.
- ▶ LiveJournal Blog: Flickr only requires your LiveJournal username and password.
- ▶ WordPress Blog: As well as your WordPress username and password, Flickr requires your WordPress XMLRPC script location. This usually follows a convention similar to http://your.blog.address/xmlrpc.php, but may vary depending on how you configured the WordPress installation.
- ▶ Manila Blog: Flickr requires your Manila username, password, and weblog URL.
- ▶ Atom Enabled Blog: As well as your weblog username and password, Flickr requires your Atom Post Endpoint. Many weblog services can service Atom Posts, but if you're not familiar with it, stick to the other methods for now.
- ▶ BloggerAPI Enabled Blog: As well as your weblog username and password, Flickr requires your API Endpoint. If you're not familiar with it, stick to the other methods for now.
- ▶ MetaWeblogAPI Enabled Blog: As well as your weblog username and password, Flickr requires your API Endpoint. If you're not familiar with it, stick to the other methods for now.

▶ None of the above: If you use a weblog platform that differs from those listed here, Flickr currently doesn't support posting. However, if you use the popular services, it will work with one of these methods.

Choosing a Weblog

In some cases, a weblog platform may have more than one blog. For instance, I have several different weblogs on a single server. One is a personal blog, another is a technology blog, and the third is an old photo blog.

Flickr identifies this, and requests that I choose the weblog I intend to post my photographs to. If I want to post to several, I can always come back to set up another.

Confirming Your Details

Flickr then requests that you confirm the details, including whether you'd like to store the password. When you're sure, select the *All Done* button. If you have more than one weblog, you can now complete the same process for any other blogs you think you'll use.

From here you're ready to post your Flickr photographs to your weblog. However, it uses a standard layout for the post that Flickr has created. In other words, when you post to your weblog, the layout will contain a small version of your photograph, and it will align the text to the left-hand side. It looks attractive, but you may have purposefully built your weblog's design and you might want more control over how your photographs are presented.

Flickr offers a range of layouts, as well as complete customization. Select the *Create a Custom Posting Template*, or edit the template later from the *Your Blogs* page in *Your Account*.

Layout

Flickr provides five standard layouts: Mid size, align right; Mid size, on its own line; Original size, on its own line; Thumbnail, align right; or Thumbnail, align left (see Figure 9.1).

Figure 9.1
Flickr's range of templates for weblog posts.

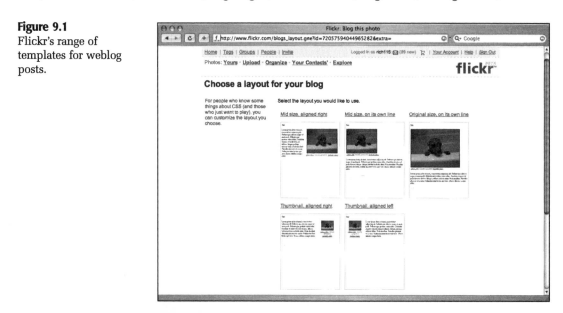

Select any one of the offerings for a preview. If you're happy with the look, then select the *USE THIS* button. An alternative is to select the *CUSTOMIZE* button; however, you'll need some knowledge of Hypertext Markup Language (HTML) and Cascading Style Sheets (CSS) (see Figure 9.2).

Customizing Your Layout

If you're familiar with HTML, or any other computer language, then customizing a Flickr blog template isn't a major task. In general, markup languages are straightforward. They do get a little more complex when they're mixed with CSS. However, if you play around and break the template, you can always revert to one of the defaults, so don't feel like you shouldn't try.

If you're game, customizing the layout can be fruitful. Flickr provides extra tags that enable extra detail to be added to your weblog post (Table 9.1).

I prefer to edit the layout, not because of the alignment, but because I want the image size to match my weblog template. In my current blog layout I have all the images displayed with a width of 380 pixels. I've edited the Flickr template to contain the relevant parameter in its HTML (see the sidebar "My Flickr Weblog Customization" on page 198). It might be subtle, but you can see the difference in Figures 9.3 and Figure 9.4.

Figure 9.2
Customizing a Flickr blog layout with HTML and Cascading Style Sheets.

TABLE 9.1 ADDITIONAL HTML TAGS FOR A FLICKR BLOG POST TEMPLATE

Tag	Description
{photo_url}	The URL to a photo's page on Flickr that can be used to create a link back to the photograph.
{photo_src}	The source URL for the photo in its medium size, which is probably the largest version of the image that you'll require; any larger and it could exceed a browser's window size.
{photo_src_m}	The source URL for the photo in its small size.
{photo_src_t}	The source URL for the photo in its thumbnail size.
{photo_src_s}	The source URL for the photo in its square size.
{photo_title}	This generates the title for the photo, and can be useful if you want to use this as your blog post's title, or perhaps just to label the image.
{photo_desc}	This generates the description for the photo, and can be useful to use as the blog posts entry, or just as the photograph's description, like a caption in a magazine or newspaper.
{uploader_id}	This generates the ID of the user who uploaded the photo, which can be used to link to their buddy icon.
{uploader_name}	This generates the screen name of the user who uploaded the photo, so you can give the owner credit.
{uploader_profile}	This generates the URL for the profile of the user who uploaded the photo. While you're giving them credit, you can give their profile some traffic.
{upload_date}	This generates the date on which the photo was uploaded.
{upload_datetime}	This generates the date and time on which the photo was uploaded.
{poster_id}	This generates your own ID, so you can link to your buddy icon.
{poster_name}	This generates your Flickr screen name.
{poster_profile}	This generates the URL for your profile, so you can link to it.
{title}	This generates the title you entered for a blog entry. However, this title is automatically used to title your entry. You can use this tag for other HTML tags such as alt-text within an image tag.
{description_raw}	This generates the description you entered for a blog entry.
{description}	This generates the description you entered for a blog entry, with line breaks converted to tags, which is useful if your blog software doesn't do this automatically.

Figure 9.3
A blog post in my
Movable Type weblog
using the default
template.

School

A school of fish at Seaworld, Surfers Paradise. The current must have been just right, as they swam, in formation, in the one position, the entire time we stood and watched.

School
Originally uploaded by rich115.

Posted by Richard at 07:39 PM, January 03, 2006
Comments (0) | Permalink |

Figure 9.4
A blog post in my
Movable Type weblog
using my slightly
customized template.

School

School, originally uploaded by rich115.

A school of fish at Seaworld, Surfers Paradise. The current must have been just right, as they swam, in formation, in the one position, the entire time we stood and watched.

Posted by Richard at 07:40 PM, January 03, 2006
Comments (0) | Permalink |

MY FLICKR WEBLOG CUSTOMIZATION

I didn't do much to Flickr's standard template to achieve my customization shown in Figure 9.4. I used the *Original size, on its own line* template, and added an extra parameter.

Instead of the line:

```
<a href="{photo_url}" title="photo sharing"><img src="{photo_src}"
class="flickr-photo" alt="" /></a>
```

I used:

```
<a href="{photo_url}" title="{title}"><img src="{photo_src}"
class="flickr-photo" alt="" width="380" /></a>
```

By simply adding the parameter width="380", I limited the photograph's size to 380 pixels wide. Its height is automatically adjusted to ensure there is no distortion. It's not the most elegant way to achieve the result, because it downloads the original image and resizes it in the browser, but with the Flickr tags provided it was the only way to achieve the result. That's simple, right?

Make any changes to the template, such as adding your own CSS codes if you're familiar with advanced HTML techniques. Once you think you've achieved the right look, select the *PREVIEW* button. If it's what you want, press *SAVE THIS LAYOUT*. You'll be returned to the *Your Blogs* page, and your list will now include your weblog (see Figure 9.5).

If you're a blogger, you've no doubt owned several weblogs already. They can be addictive; I've created at least eight myself. At any time you can add more blogs. Simply return to the *Your Blogs* page and follow the same process.

Figure 9.5
Flickr's *Your Blogs* page with my Movable Type weblog in the list.

Any of the settings you've made up to this point can be changed from the page. You can edit the layout, change settings, and delete blogs from the list.

There is also a *TEST POST* button, which confirms that Flickr can communicate with your weblog. It sends a blog post that is simple, adding a line of text with a Flickr logo. I prefer to test a real photograph by using the *BLOG THIS* icon on a photo's toolbar.

Blog This

When I originally started blogging in 2002, I created a photoblog. I'd format and manually upload photographs to my server. I'd upload them on a regular basis, and when I needed inspiration, I'd try my hand at Photo Friday (www.photofriday.com), a friendly photographic challenge where a new theme is posted every Friday. It was my aim to make the Noteworthy list, for those photos handpicked as the most interesting. However, when my daughter arrived in late 2003, I simply didn't have the time to spend taking, formatting, uploading, and posting photographs. I needed a simple method like Flickr's *BLOG THIS* tool.

On all of your photograph's toolbars is a *BLOG THIS* icon, and if you have permission it also appears on other members' photographs (see "Allowing Blogging" later in this chapter). Clicking it presents a drop-down list with all of your defined blogs (see Figure 9.6).

When you find a public photo that you love enough to blog about, whether yours or another member's, select the icon and Flickr provides a Web form for you to create a blog post (see Figure 9.7). It's simple, with all the smarts looked after by Flickr. Enter a title, add the post content, and press the *POST ENTRY* button. Flickr logs into your weblog and creates an entry using the photograph with the selected, or customized, template. No more copying or uploading photographs to your Web site.

Figure 9.6
Selecting the *BLOG THIS* icon in a photograph's toolbar presents a list of blogs you've set up with Flickr.

Figure 9.7
Flickr's blog form
proving fields for title
and post.

Private photos can't be blogged; you made them private for a reason. However, if you attempt to blog a photograph with private permissions, Flickr will warn you and suggest that you make it public if you want to continue. If you do, Flickr automatically changes the settings and presents the weblog form. Note that the photo is now available for anyone to view in your Flickr photostream.

XML-RPC

We've explored a few technology acronyms in this book, but XML-RPC wins the award for geekiest. It stands for Extensible Markup Language Remote Procedure Call. Essentially it is a simple way for a computer application to communicate with another. In Flickr's case, it sends information to a weblog, so that a new post is added. You'll never need to know what it stands for, and using it at parties won't win you friends.

Allowing Blogging

Like the permissions we set for who can view our photographs, Flickr provides the ability to set who can blog our public photos. Blogging, and photographs, can have varying degrees of sanctity, depending on the owner of a work. I'm fairly liberal, believing that I don't have much to hide, and am happy for others to share my work. However, there are others who, rightly, prefer more privacy. Flickr affords that with the ability to allocate blogging privileges.

Back in the *Your Account* page, select the *Allowing Blogging* link. You can specify a global setting that will affect all of your photostream, allocating who can blog your photos. The options are: only you; you and your family; you and your friends; you, your family and friends; you and any of your contacts; or any Flickr member.

Depending on another member's status in your contact list, and whom you've allowed to blog your photos, someone browsing your photographs may not see the *BLOG THIS* icon.

ONE BUSH STREET FLASH MOB

Flash Mobs capitalize on new forms of communication that enable fast synchronization of large groups of people. For instance, e-mail, text messaging, and weblogs allow quick broadcasts to large groups.

The concept is to rely on e-mail or text messaging to notify a large group of people to converge on a single location at a given time, with a particular theme. For instance, the latest fad is to dress like zombies and walk comatose-like down a busy street. It generates a great deal of interest, and the photographs are priceless.

In most instances Flash Mobs are innocent ways to shock a crowd in a humorous and harmless manner. Do a search for "flashmob" in Flickr's tags and you'll find zombies, pillow fights, and musicians.

It's only on the rare occasion that they are used for serious matters, such as the time an avid Flickr user, Thomas Hawk (from the FlickrNation podcast in Chapter 8) felt his First Amendment rights were violated.

While Hawk was photographing the building at One Bush Street in San Francisco, a security guard approached him and asked him to stop. Hawk then moved to the sidewalk to continue his photography, and the security guard continued making his request. "When I told him I was on a public street sidewalk, he said that actually they owned the sidewalk and that I was going to have to stop taking photographs."

Comedy ensued for 10 minutes as Hawk continued his photography as the security guard tried to ruin the shot with a well-placed hand. Hawk's height worked in his favor, until he had another engagement and he left.

The funny thing about the Internet is the rate at which news can spread. After Hawk posted the details of the encounter on his weblog (http://thomashawk.com/), it received a substantial amount of attention—enough that a flash mob was organized.

On July 30, 2005, a bunch of photographers descended on One Bush Street and exercised their First Amendment right to photograph buildings. CBS decided to tag along.

Several innocent encounters occurred with security, and the mob managed a great selection of photographs. Who knows if the point was proved, but it's apparent that the Internet can facilitate meetings of the mind.

Simply search for the tag "onebushstreet" for the collection.

Flickr Badge or Zeitgeist

If posting photographs to your weblog sounds like too much work, or if you'd like to supplement your own Web site with your photographs automatically, you can use a Flickr Badge or Zeitgeist. They're made to be set and forgotten.

Adorning a weblog with numerous "badges" is a bit of a trend. They add extra personality to a Web site, and using your personal photographs means the visitor can get a much better sense of who you are. For example, a Flickr Badge and the Daily Zeitgeist offer a quick visual snapshot of your life.

The Flickr Badge comes in two flavors: HTML or Flash. Create either of them from the URL www.flickr.com/badge_new.gne (see Figure 9.8).

Figure 9.8

The choice between an HTML or Flash Flickr Badge.

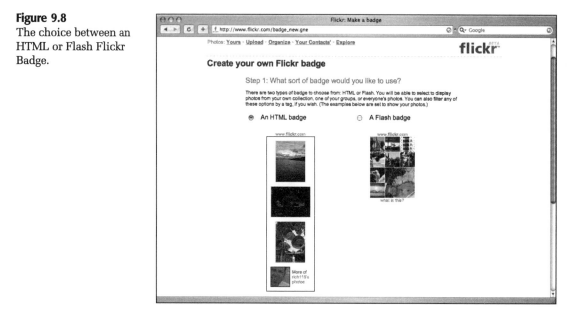

An HTML Badge

HTML is static. That means that when you visit a Web site displaying an HTML Flickr Badge, it doesn't change until a later visit. That might not sound very exciting in today's high-bandwidth, hyperactive Web, but it's simple and doesn't require much bandwidth. Some people find it friendlier and less intimidating than a gregarious Flash Badge. There is also more flexibility with its layout—for example changing the HTML or using CSS to alter the size, color, and arrangement.

The badge displays several Flickr photographs at any single page visit. Using several parameters when creating the badge ensures you control the types of photographs displayed (see Figure 9.9). When a visitor clicks one of the images, a new Web browser window opens at the photograph's Flickr page.

Figure 9.9

Flickr's HTML Badge in action.

A Flash Badge

Flash is dynamic. It can change constantly on a static Web page. It can sit in a Web browser and appear to have a mind of its own. That makes the Flickr Flash Badge a great way to spice up a Web site; it catches the eye as the photographs slide around the badge surface like a picture-scramble puzzle (see Figure 9.10).

It too displays several photographs based on a set of parameters, but because it's dynamic, it constantly changes to show a new selection. Click an image and a new browser window will open aimed at the individual photograph's page.

Which Photos?

Once you've decided the badge type, there are several different photostreams it can display: your public photostream, one of your group's, or everyone's photos (see Figure 9.11). Each option can be restricted to a particular tag, and your public photos can be restricted to one of your sets. That way the badge can be a little more topical. Alternatively, just let it have free range to display any photo at random.

Figure 9.10
Flickr's Flash Badge in action.

Figure 9.11
Choosing the badge photos.

Layout

The Flash Badge, although dynamic, has a restricted layout style and there are no options. If you chose an HTML Badge, on the other hand, there is some flexibility (see Figure 9.12):

▶ Would you like to include your buddy icon and screen name after your photos? If included, it displays your icon at the bottom of the badge. A visitor can select the icon or screen name to visit your entire photostream.

▶ How many photos would you like to show: 1, 3, 5, or 10?

▶ Which ones? Most recent, or a random selection?

▶ What size? Square (75 × 75), thumbnail (100 × 67), or mid-size (240 × 160)?

▶ What orientation would you like? Vertical, horizontal, or none? The last option allows you to style your own HTML. It provides some CSS examples as a guide, but otherwise it leaves the CSS coding for you to design your own layout.

Colors

I'm told, reliably, that red doesn't go with pink. My daughter is in a world of trouble when I get to dress her in the morning. So as a result, when choosing a Flickr Badge, I try to stick with the standard colors. However, the background, border, links, and text colors are all customizable (see Figure 9.13). You can choose from 16,777,216 shades of color by using hexadecimal (see Chapter 5 for the "Hexadecimal Color Codes" sidebar), or pick from a range of standard shades.

Figure 9.12
Customizing the HTML layout.

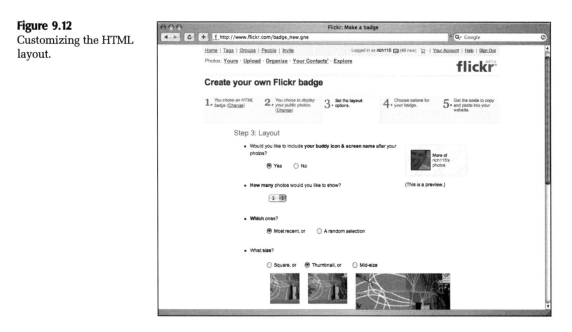

Figure 9.13
Choosing Flickr Badge
colors.

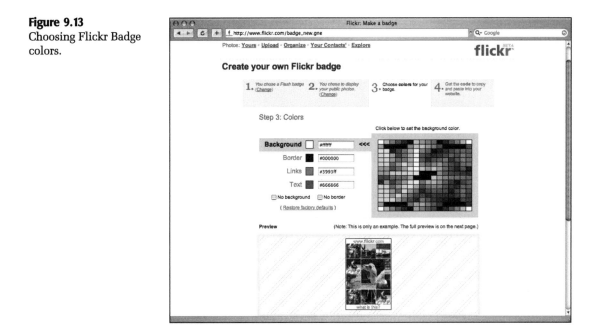

Code

The result from your selections is a customized badge and Flickr-generated code comprised of a variety of HTML, CSS, and JavaScript (see Figure 9.14). Simply copy and paste it into your Web site where you'd like your badge to appear. The badge will then go about its business whenever the Web page is viewed.

Figure 9.14
A customized badge,
and the code.

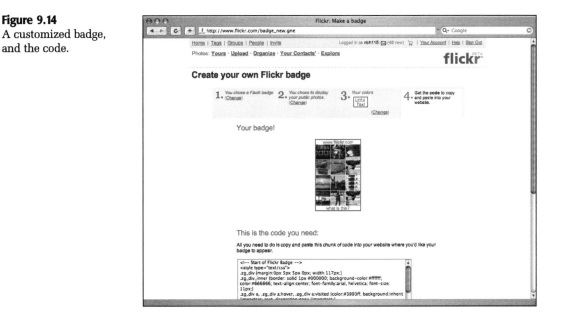

Flickr Daily Zeitgeist

Zeitgeist, according to my Apple Mac's Oxford dictionary, is "the defining spirit or mood of a particular period of history as shown by the ideas and beliefs of the time." Flickr Daily Zeitgeist (www.flickr.com/fun/zeitgeist/) sums up the spirit or mood with photographs from photostreams.

It's very similar to the Flash Badge, except there is a single customization, which is the ability to specify which photos to display (see Figure 9.15). Choose from everyone's photos, your photos, your contacts' photos, or you and your contacts' photos.

Once you add the code to a Web page, it updates to show today's collection of photographs from your selected group. Click an individual image, and it opens a new Web browser window and displays the photograph's Flickr page.

Figure 9.15
Flickr Daily Zeitgeist.

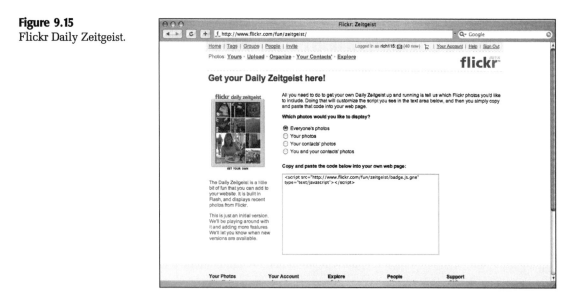

Uploading to Your Weblog via E-Mail

Sometimes you might be lacking the right access to the Internet, and you'll need to upload a photograph to your blog (remember I talked about weblog addiction; it could happen at any time). So Flickr has another avenue to post photographs: via e-mail.

It sounds odd, because you need Internet access to send e-mail. However, there are occasions when it comes in handy. For instance, several months after I first joined Flickr, I discovered the e-mail method. I promptly added the e-mail address to my camera phone, and tested sending a photograph. At the time I didn't have Web access on my phone; however, I knew I could send e-mail. It was the simplest method I'd found for mobile weblogging.

Settings

Sending a photograph to Flickr via e-mail is simple; I explored how you can set the feature in Chapter 3. In the same settings window it provides a second e-mail address, and this time it not only adds the photograph to your Flickr photostream, but will also forward it to your default weblog.

From almost any Flickr page, select *Your Account*, and choose the *Uploading by Email* link. You'll recognize the same e-mail address that we used in Chapter 3. However, also at the bottom will be a question, *Do you want to automatically post photos to your blog?* Select the *Set It Up Here* link.

For Flickr to automatically forward the photographs from an e-mail, it needs to know a few extra settings beyond the weblog details we set up earlier (see Figure 9.16). There is a drop-down menu listing all your weblogs. Choose the one you'd like as your default. It needs to be one of three sizes: thumbnail (100 x 75), small (240 x 180), or medium (500 x 375). Flickr will then resize the e-mail's photo before forwarding. It can use the body of the e-mail message as its weblog post, or you can leave the content blank.

Figure 9.16
Settings for Flickr's
e-mail to weblog
feature.

Save the settings and Flickr will return you to the *Uploading by Email* page. You'll notice a second e-mail address, a slight variation of the first (see Figure 9.17). Using this address, rather than your original, not only uploads your photograph to Flickr, but a version up to 500 pixels wide gets posted to your weblog.

Figure 9.17
Two e-mail addresses, one for posting photos to Flickr and a second that both posts to Flickr and e-mails a photograph to your weblog.

Yahoo! 360°

Yahoo! not only provides Flickr, it has a full range of other personalized services. One is a personal communications Web site called Yahoo! 360°. One component of its features includes a weblog platform, and another is a module that displays your Flickr photographs.

To start your own Yahoo! 360° portal, visit the page http://360.yahoo.com/, and log in or select the *Get Started* button. Both options will present your personal information that requires confirmation, including: name, nickname, e-mail address, and time zone. Follow the instructions and select *Finished*.

You're now ready to start communicating with an arsenal of content: weblog, photographs, RSS feeds, reviews, and lists. I'll let you explore the entire site for yourself because it's more comprehensive than this book can address; however, I'd like to quickly point out its integration with Flickr.

If you'd like to share your photographs as a small channel alongside other modules, Yahoo! 360° is ideal. Select the *Start Sharing Photos* link. It provides an option to use Yahoo! Photo Albums if you have an account, or select the ability to share your Flickr photostream. Select the *Begin Sharing* link and enter your Flickr account e-mail address.

It has now linked your 360° account with your Flickr photostream, and provides the option to display three thumbnail photos, four square photos, or six square photos—all of which can be restricted so they are only displayed to a certain range of people, including the public or friends. It even offers a "Friends of friends of friends" option that's reminiscent of six-degrees-of-separation, minus three degrees.

When you've designed the page to present a parcel of you-ness, you can direct people to your very own Yahoo! URL, which is similar to your Flickr URL. Rather than just a photostream, you can now share your thoughts, reviews, music, and photographs in a single location (see Figure 9.18). It's a weblog on steroids.

Currently, Flickr has no way to post photographs to a Yahoo! 360° weblog, although the site is in beta and will no doubt add extra features in the near future.

Figure 9.18
My Yahoo! 360° and a
Flickr photostream.

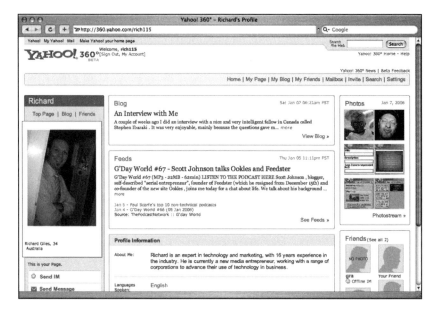

Camera Phones

If you have a camera phone, you can send photographs directly to Flickr from the handset.

This all might sound alien. Why send a photograph to a weblog via e-mail, much less from a camera phone? It sounds like a very geeky pastime, which I'll not argue. However, it makes a lot more sense when put into perspective.

IC Insights, a market research firm, estimated that 365 million camera phones would be sold worldwide in 2005. Others forecast that digital still cameras would reach only 100 million shipments in a single year in 2008. In the meantime, camera phone shipments were expected to boom, reaching over 900 million a year by 2009. There will be more people with camera phones than traditional cameras in no time.

What better way to organize your growing photo collection than by sending them instantly to Flickr from your phone? There's no point messing with cables or Bluetooth protocols when you can simply zap the image through thin air.

When I used the aforementioned e-mail option with my camera phone, Flickr hadn't advanced to its current state. It was simple in comparison to the other methods of shipping photographs from a camera phone (customizing computer scripts on a server), but today there are a bunch of much simpler options.

MOBLOGGING
Using a cell phone to post content to a weblog is known as *moblogging*. The word is derived from mobile blogging, a name given to adding content to a weblog while on the move by using a mobile device like a phone.

THE DANGER OF DATA RATES

It's worth noting that cell phone plans invariably charge a rate for transferring data. That includes the photographs you upload to Flickr.

Before you begin using any of the applications on your handset, check the charges that apply with your network provider. Uploading photographs liberally could cost you more than you expect.

Mobup

Instead of sending a photograph to Flickr via e-mail, new camera phones can connect directly to the Internet to add their content. We've become a connected planet, able to access the Internet from our hip pocket.

There are a few applications that can be loaded onto some of today's camera phone models and used to send photos to Flickr. One of which is an application called Mobup (http://mobup.consultechnology.com/).

Matteo Penzo began Mobup as a personal project. At his company, Consultechnology, they can spend 20 percent of their working hours dabbling in technology they find interesting. Penzo mixed his love for moblogging and Flickr and developed the application (see the sidebar interview with Penzo).

The beauty of Mobup is that Consultechnology distributes it for free under a Creative Commons license (Attribution—Noncommercial—Share Alike 2.5). That means anyone can get involved in developing the application. If you need an extra feature, and you know how to code, chip in and add the functionality.

At the time of writing, the application still has a few limitations. For instance, my Nokia 7610 cell phone can take photographs with a resolution of 1152 × 864. However, Mobup can only capture in 640 x 480. These limitations are sure to be overcome in the short term as mobile technology improves, and Mobup's other features will ensure it's a compelling application.

Mobup will also automatically send the photograph to your blog. One swift action has you adding a photo to your photostream and weblog. Walking around with a cell phone with Mobup installed is true geek couture.

Mobup requires a little work to install. It needs its own activation code so that it can speak with your account. Once you've granted Mobup read and write permissions for your Flickr account— a process the Mobup Web page walks you through—it provides nine digits.

NEW GENERATION MOBILE PHONES

All of the applications that I mention in this chapter only work with the latest generation of cell phones. If you have an older handset you might be unable to use them. Every one of the applications has a list of supported handsets, so check their Web sites for full details.

CHAPTER 9

Download the Mobup application from their Web site (see Figure 9.19), and install it on your cell phone. I achieved this with Bluetooth; a wireless transfer protocol that I have on my laptop and cell phone. However, there are a variety of ways to get an application onto your cell. If you're not too comfortable with the thought of playing with your handset in this way, then Shozu, the next application I'll detail, might be more appropriate—so consider skipping ahead.

Once installed on your phone, open the application, select the *Options* menu, and choose *Configuration*. You can then enter your personal nine-digit activation code that confirms your phone has permission to access your Flickr account.

Now you're ready. It's simply a matter of launching the Mobup application whenever you want to take a photograph (see Figure 9.20). When captured, select *OK*, and Mobup provides text fields to enter title, description, and tags (see Figure 9.21). The application can also retrieve a list of groups you are a member of, and you can select to add the photograph to one or more when it is uploaded. Complete the details, select OK again, and it will upload the image and details straight to Flickr.

Mobup 0.3 has been tested on a handful of Nokia and Motorola cell phones, but they are always willing to test on other handsets. Simply contact the Consulting Technology team.

Figure 9.19
Mobup's Web site, providing a free camera phone application that can send photos to Flickr.

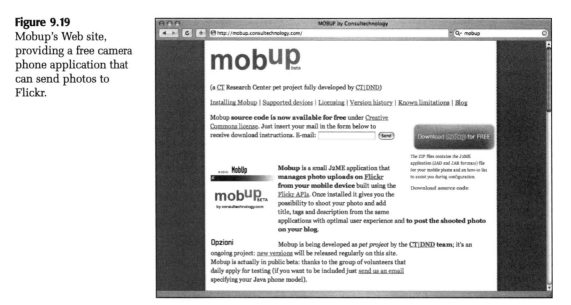

Figure 9.20
Mobup taking a picture on my Nokia 7610.

Figure 9.21
Text fields provided in
Mobup add extra details
to your camera phone
photographs.

MATTEO PENZO

Matteo Penzo started the Mobup application. He is Chief of Production and Research and Design
Director at Consultechnology, an Italian information and communication technology consulting firm
based in Milan, Italy.

How'd you hear about Flickr?

Sincerely cannot remember. Since I'm an avid blogs reader, I suppose it was through one of my daily
read blogs. What I remember well is that it wasn't love at first sight, I needed a serious and months-long
try before becoming addicted. :-)

What do you like about Flickr?

It's very easy to publish (and share) your photos, and the rights management is plain great. It's very fast
to choose whether a photo should be visible only to your parents and close friends or to the whole
world. But I think the greatest aspect is the power of the APIs: The Flickr guys are taking in high
consideration the developers' feedback, and the APIs make Flickr almost infinitely hackable. You can
build a sketch-based search engine or a photo chooser based on its palette, you can build magazine
covers starting from your photos, or you can simply enjoy the easiness of uploading them directly from
your iPhoto.

How did Mobup start?

I've always loved moblogging my photos. I started with a simple PHP app that detached e-mailed
images and placed them in a directory-based navigation environment, and then, once I moved my
moblog to Flickr, uploaded the photos by its e-mail uploading tool. But—due to my phone interface—
the whole thing was creepy; the feature I loved most, tags, wasn't manageable this way. I searched for a
tool that could be installed on my Java camera phone but wasn't able to find anything with the ease of
use and power I needed.

In my team (http://dnd.consultechnology.com) we spend (just like the Google guys) 20 percent of our
working time on personal projects. I involved Vincenzo Lembo—whose role is analyst programmer and
who had already worked on mobile apps—in the development of what should have been just my very
personal Flickr uploader. But then we enjoyed the app and thought it would've been nice to share it
with all the mobloggers out there, for free. We published a call-for-participation to collect a sufficient
beta user base in order to reach the greatest number of devices possible (the beta testers crew is *still*
growing after three-plus months of development) and started sharing Mobup with them. (It was mainly
a private beta.) Once the main bugs were fixed, we delivered the app to the world, maintaining very
frequent version deliveries (more or less one every 15 days).

continued

What is the aim of Mobup?

Mobup is a free mobile uploader to Flickr. It is a small (less then 35k in size) J2ME application that manages photo uploads on Flickr from the users' mobile devices (usually Java-enabled camera phones) built using the Flickr APIs. Once installed it gives you the possibility to shoot your photo and add title, tags, and description from the same application with optimal user experience and to post the photo on your Flickr-declared blogs.

Mobup is being developed as a pet project by the CT I DND team; it's an ongoing project: new versions are released regularly on the Mobup site (http://mobup.org).

We've released the source code under an open source (Creative Commons) license in order to hasten the development cycle of the application (we currently have more than 18 programmers from around the world working on the code) and easing the job for newcomers on the Flickr APIs. For example, Mobup is not really optimized for the Japanese mobile market, but there's a Japanese programmer who's actually porting the whole application for the Japanese devices.

What have you discovered from the project?

That it's better *not* to install tools such as Mobup on your mobile phones. They give you addiction. :-)

We also discovered that Flickr could *really* be a game. We're testing a real-world "Quake-like" game based on a personalized version of Mobup.

What's one of your favorite photos you've taken and shared in Flickr, and why?

For sure this shot I took in Tikehau: www.flickr.com/photos/matteopenzo/3999850/in/set-714251/ (see Figure 9.22). I was on the side of the pool facing the lagoon and with our on-the-water bungalows. Tikehau is a very small island in the Tuamotu Islands in French Polynesia. I was there with my wife for our honeymoon. Our hotel was on an islet inside the lagoon, everything was very romantic, and this shot summarizes the beauty of the nature, the calm, and our mood at that particular time.

What's one of your favorite photos from another Flickr user, and why?

Umm...it's difficult to choose just *one* photo. I'd say the "Red Pond—Soda Lake" by Vision Aerie. You don't know whether it's a macro or whatever until you read the description. And the color balance is just fantastic.

Figure 9.22
Matteo Penzo's favorite photograph taken on honeymoon in Tikehau.

What's one of your favorite groups, and why?

I'm not a big fan of groups, really. But I frequently look at JPG Mag (www.flickr.com/groups/jpgmag) seeking great shots and inspiration.

What's one of your favorite tags, and why?

Don't have any. I use tags as a way to browse around following inspiration. I've spent a whole Sunday afternoon looking at the photos found using "Polynesia". :-)

ShoZu

While Mobup is mildly comprehensive, it's a little complex to install. For people wanting something much more simple, there is ShoZu (www.shozu.com/portal/).

ShoZu is similar to Mobup but doesn't have the blog-posting feature. However, it is insanely easy to work, and once installed it's even easy to forget that it's there. Take a photo using the camera phone's own software, and it can automatically connect to the Internet and send the image to Flickr without your intervention.

A company called Cognima, whose aim is to develop mobile services, created ShoZu. The company's foundation was developing a data replication framework. They initially began licensing their software to cell phone carriers but quickly realized that they moved slowly to adopt new services. They built ShoZu to demonstrate the capability of their technology, and it quickly became more than a demo.

The ShoZu team almost accidentally created the name ShoZu when they were brainstorming ideas for its moniker. One team member wrote the word Sho2u on a whiteboard, an abbreviation of the words "show to you," and the others misread the scrawl.

To use ShoZu you must first create an account on their Web site (see Figure 9.23). It's not onerous; simply visit the site and follow the prompts. Enter a few particulars, like e-mail, username, and password, and your account is activated. It then requires write permission from Flickr, which you authorize.

In an attempt to simplify installation, ShoZu sends a text message (SMS) directly to your cell phone. To do this it requires your cell number. Once you've chosen your region and country and provided your number, they ask for the make of your cell phone. As of writing, ShoZu supports over 30 types of handsets. This enables the site to provide instructions for installation.

To download, and subsequently use ShoZu, your mobile phone account will need to be enabled for GPRS or 3G Internet data access. If you're unsure of this, contact your network operator. Given that it costs money to upload data, like camera phone photographs, they'll be happy to help.

CHAPTER 9

Figure 9.23
ShoZu's Web site, providing a free camera phone application that can automatically send photos to Flickr.

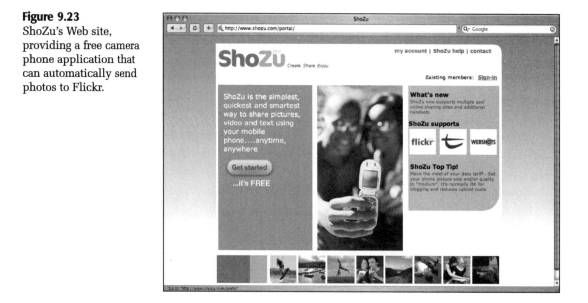

Once installed, you have everything you need to start using the application. However, a couple of extra tricks help tag your photos. In your ShoZu account, administered through their Web site, you can specify some tags (see Figure 9.24). These are automatically added to the photographs every time you use ShoZu to upload. Tags like cellphone, mobilephone, and moblog might be handy to include.

Alternatively, when you take a photograph, the application provides an option to *Open ShoZu*. Select it, then *Options*, and then *Description*. Simply add any tags in this field within angle brackets, and then select *Options > Save to Web*. For instance, adding <holiday cruise> sends the two tags, holiday and cruise, to Flickr as it uploads.

This also works retrospectively. If you think of tags for photographs that ShoZu has already uploaded, add them in the descriptions field, and the application will automatically communicate with Flickr and add them to your photo's tags.

Figure 9.24
Add tags to your ShoZu account, and they'll automatically be added to every photograph uploaded with the application.

Personally, not being an expert with a phone's keypad, I elect to automatically save photographs to Flickr. That way, when I take a photograph, I can slip the phone back in my pocket and forget about uploading. When I'm next in Flickr, I'll make changes to the title, description, and tags. Turn this feature on by accessing the ShoZu application's *Settings*, select *Capture*, and change the *New Images* option to *Auto Save* (see Figure 9.25).

Behind the scenes, your photographs are uploaded to ShoZu's Internet servers, which then forward the pictures on to Flickr. It keeps a copy on the ShoZu servers until you delete them from your cell phone. At that time the ShoZu application communicates with the ShoZu service and the photos are removed. However, they are not deleted from Flickr. You need to do that yourself.

One feature that demonstrates ShoZu's robustness, and the level to which the Cognima team thought about the application, is what happens when the cell phone connection is lost. If in the middle of transferring a photograph your phone's battery dies, or you lose a connection to your service provider, the details are saved. When ShoZu recommences the transfer, it continues from where it stopped. It doesn't start the transfer from scratch, thereby saving you the cost of transferring data again.

Likewise, when you travel overseas and use ShoZu, it pauses to warn you that the cost of transferring photographs while roaming overseas might be incredibly expensive. It provides the option to cancel, or continue the upload.

ShoZu is a great application because it's so easy to use, and yet it's so robust. While on holiday with the family, I tried to take a photo each day with my camera phone. It was like a visual diary of the trip. Every photo I took with my camera phone was automatically added to Flickr.

Figure 9.25
Automatically save
photographs to Flickr
using ShoZu.

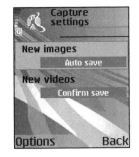

ANDY TILLER

Dr. Andy Tiller is the Chief Technology Officer for Cognima, the company responsible for ShoZu. I spoke with Andy on the phone about their business, and his personal use of Flickr.

How'd you hear about Flickr?

I first came across Flickr about 18 months ago. It was actually pointed out to me by some friends at Kodak, the Ofoto people in Emeryville. At the time, before Flickr had been bought, Kodak was seriously looking at an acquisition, and we were working with Kodak, and they said this is an interesting service. So I became aware of Flickr then, and used it a little bit and stayed aware and saw how much it was growing, and how popular it was with end users. When I realized that the API was completely open, I thought that there was an opportunity for us to do something, which could get to an existing, very motivated, enthusiastic, knowledgeable, user base. Many of whom would have the right kind of phones.

What do you like about Flickr?

I can answer that from two perspectives. One from a personal perspective as a Flickr user. What I really like is the way that everything is nicely integrated. If I leave a comment on someone's photo, then I don't have to manually go back and bookmark that photo and see if anyone has followed up on that thread, I can just click on a link on my home page and look at comments I've made, and that others have made following mine.

I really like how easy it is to get to know other users through discussion groups and so on. It's a really good community site. There are a lot of other sites that do something similar, but Flickr is the best implemented, most consistent experience there is. I think there are simpler interfaces that may have more mass-market appeal, but for anyone who wants to spend any time getting their photos published and interacting with others that are interested in them, I think that Flickr is certainly one of the best.

That's from a user perspective. From the perspective of Cognima, having created ShoZu and integrated with Flickr, I obviously like the fact that it is an open environment. They have en excellent API. We can actually develop a relationship directly with our end users directly through the groups that are on Flickr. We have a ShoZu beta user group, and that's a really big help, because user feedback has been very important to us. Making sure that ShoZu meets the needs of our real end users.

Of course the guys at Flickr have been very supportive as well. It's been great getting to know them, and having their support to promote ShoZu.

What's one of your favorite photos you've taken and shared in Flickr, and why?

I have a few. I don't know if you've come across the sad umbrella group, but it's a place for people to post pictures of umbrellas that have been discarded on the street which are broken or old. It was pointed out by Stewart Butterfield as one of the quirky things that Flickr has. I was on the station platform on my commute one day and I looked down and spotted this umbrella on the railway track, so I was delighted because I'd just heard about this group. So I took a picture to send up, and I've put it in the sad umbrellas group.

www.flickr.com/photos/atiller/63145639/

I've also got a pretty blurry picture, but I went to a conference, and Stewart Butterfield and Adam Seifer from Photolog, were there. Ostensibly quite competitive with Flickr, but what I really liked was the two of these guys being very friendly and supportive of each other, and it was really nice to see that they weren't treating each other warily like competitors, it was a very nice kind of interaction that they had, answering questions and supporting each other's views.

www.flickr.com/photos/atiller/59431054/

At the same event I took a photo of Adam, the Photolog guy, taking a picture of his food. I don't know if you have come across him, but he takes a picture of everything he eats and posts it up to his Photolog. It's all very meta.

www.flickr.com/photos/atiller/59106299/

Another one is a picture of some flags against a blue sky, which is something that I just snapped in Regent Street (see Figure 9.26). It's probably my best photograph with ShoZu from an artistic point of view.

www.flickr.com/photos/atiller/56545101/

What's one of your favorite groups, and why?

Well obviously there is ShoZu Beta that I am involved in, but there are a number of others that I belong to. There are a number of camera phone groups, and a London group, because we're based in London.

What's one of your favorite tags, other than "shozu," and why?

Yes, other than "cameraphone," which is a common one for pretty much everything I upload.

The concept of tags I really like because you can find photos so easily. In terms of favorite tags, it's almost against the point, in that you put something appropriate on and that can guide other people to your photos.

I love the concept; I think it's marvelous. Especially because we can use it a lot to see if we've got new users and any interesting photos going up.

Figure 9.26
A photo from Andy Tiller's camera phone of Regent Street that was uploaded with the ShoZu application.

Nokia Lifeblog

Nokia is a powerhouse in the mobile phone industry. In 2005, reports expected it to have sold over 260 million units, which is about 32 percent of the market. It rose to dominance in the nineties with its unique understanding of the cell phone customer.

Nokia still continues to innovate, adding features and functions like cameras and music players, and importantly capitalizes on its understanding of an owner's experience. For instance, Christian Lindholm, formally the Director of Multimedia Applications at Nokia, created an application called Lifeblog.

Phones will obviously become *the* device. We carry them with us almost everywhere, and they become a part of our person. We store parts of our personality in the devices, such as address books, meetings, and now photographs and music. It makes sense that they become our personal log.

Lindholm believes that the world is at the start of three mega trends: the digitalization of memories, the increase in content due to digital media, and the evolution of the ubiquity of the camera. So he created a "multimedia diary where time is the spine."

Lindholm now works at Yahoo! as its Vice President of Global Mobile Products—an unsurprising move given the convergence between the World Wide Web and mobile devices.

Lifeblog comes as two applications: one for a Windows computer, and the other for a range of Nokia phones. The applications can work together, or separately if you prefer. I use an Apple PowerBook, a platform the computer software isn't available for, so I just use the phone application.

As you use a Nokia phone to send text messages, make notes, take pictures, and record videos, Lifeblog automatically captures everything and stores it in a manageable horizontal timeline. I can view text messages I sent a couple of months ago, and the photographs I took with the phone moments later. It puts everything I do with the phone into the context of time, which makes it a natural interface.

When Lifeblog was first released in 2004, it lacked an ability to post to a weblog. This was no doubt a feature it aimed to add quickly, because it was announced within months. It now has the ability to post to a range of Web sites (using the Atom standard), including Flickr.

The Lifeblog mobile software is free, simply visit www.nokia.com/lifeblog/ for the details of supported handsets (see Figure 9.27). Once you're sure yours is supported, you can download the application and the trial software for your PC, which lets you store up to 200 messages, images, and video clips. It's unnecessary to use the PC software, but it's a convenient way to keep a backup and manage all the photographs outside of the handset. It just requires a fee to license.

Downloading is easy: Pick your phone, choose to download one or both applications, select if you need to use the Nokia PC Suite, and download.

Figure 9.27
Nokia's Lifeblog home page.

Mac and PC users do not need to use the PC Suite; you just need a way to transfer the down-loaded file to your mobile handset. In my case I used the Bluetooth application on my PowerBook to wirelessly send the file. However, you can buy Nokia cables and use PC Suite for Windows to transfer just as easily.

After installation Lifeblog gets to work. At one point I went months without referring to the application and then found that it had been busily recording all my text messages and photographs seamlessly in the background.

To use Lifeblog to post photographs to Flickr, there are couple of settings required. Within Lifeblog's phone menu, select *Options > Settings > Weblog Settings*. It requires a username, password, server address, and Internet access point. Flickr provides the first three details at its Web site, www.flickr.com/tools/lifeblog, varying the details for each member. If you haven't already, speak to your network provider for the Internet access point.

A further option allows you to optimize images. This reduces the size so that it's quicker and cheaper to send via a cellular network. In most cases photographs viewed on Web pages can have a lower resolution. However, because Flickr resizes the photographs when they are uploaded anyway, it's not as necessary. If you'd rather have images larger than 576 x 432 uploaded to Flickr, then choose not to optimize them.

Once set, the phone connects to the Internet to confirm your list of weblogs. In some cases a weblog server will provide a list to choose from; however, Flickr provides the name of your photostream.

Lifeblog isn't as automatic as Shozu. It stores everything on the phone behind the scenes, but if you want to upload to Flickr, you'll need to take action. From its in-phone interface, find the photograph you'd like to upload and select *Options > Post to Web*. There are several fields you can edit: select a weblog, a photo's title, details, and body text. The last two actually merge when posted to Flickr, and appear as a single field in the photo's description.

Finally, select *Options > Send*. The phone will connect to your service provider's network and upload the image to your photostream. When done, it adds an item to the Lifeblog timeline indicating the upload (see Figure 9.28)—a neat way to see when you've added photographs to Flickr—and stores all the details (see Figure 9.29).

Figure 9.28
Lifeblog's timeline.

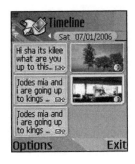

Figure 9.29
Lifeblog's photo details, after an upload to Flickr.

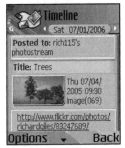

INDECENT EXPOSURE

Ten or twenty years ago the world seemed like a much safer place. However, it was also a lot easier to get away with a crime. Not only are there surveillance cameras littered around our Orwellian world, but also a good number of people walk around with the means to document unlawful acts.

When Thao Nguyen, a New Yorker riding the subway, witnessed an act of public lewdness, she reacted like any Flickrite should: She thought first of her camera.

The act, directed at her, was not something an individual wants to be faced with. It was disturbing, but she reacted by taking a photo with her camera phone. Certainly making a brave, and possibly dangerous move, she startled the offender, who quickly left the train.

Nguyen then uploaded the photograph to Flickr, and a week later the image circled NYC on the cover of the *New York Daily News*. After several days a man was arrested.

In the weeks following the incident, two threads of discussion ensued. Firstly, would placing such power in the hands of millions of individuals dissuade publicly unacceptable acts? Secondly, was it dangerous to provide the power to almost instantly judge an individual? Many people initially even questioned the authenticity of the photograph, suggesting it could be a fake used in spite.

There's no doubt that both threads will continue to rage as camera phones become more pervasive.

In the meantime, Nguyen removed the photograph from Flickr.

> "I promised that I would take the subway pervert's image down when he turned himself in. Well, he finally turned himself in and hopefully he will get some therapy or counseling to help him stop flashing people.

> We caught this guy because of you folks. Whether or not you were supportive, I really appreciate everyone who took the time to pass around the image and the story. If it weren't for you folks, then this man would probably still be out there. I always wanted to make a difference in the world but I didn't think it would be through this way."

CITIZEN JOURNALISM

Recent terrorist attacks have changed the way we view news media. We collectively hold our breath when we see a newsbreak, praying another tragedy won't befall another city or nation.

They've also changed the way we report news. Many individuals take it into their own hands to provide up-to-the-minute news, now branded "citizen journalism."

In the 2005 London bombings, a raft of photographs drifted onto the Internet as the disaster occurred. Everyday people carrying their camera phones snapped images of torn busses and shocked faces through a smoke-filled tube station.

Within minutes people were viewing the images on the Internet, and within hours television was broadcasting the amateur photographs.

Several photographs taken on camera phones even made *Time* magazine's "Best Photos of the Year 2005," with its caption explaining, "Camera phones turned bombing survivors into photojournalists."

I watched Flickr as the events unfolded, and within six hours there were 187 photos in the Flickr group pool for "The London Bomb Blast." It included screen grabs, shots from television, and photos.

If you keep an eye on Flickr's *Hot tags* list, found by selecting the *Tags* link at the top of most pages, you can get a sense of what trends are enveloping the world, from disasters to the Super Bowl.

CORPORATE ESPIONAGE

For decades corporations have been paranoid about their security, implementing electronic alarm systems, paper shredders, and non-disclosure agreements. Today it takes just a camera phone; something only James Bond would have had a few years back.

Recently, I spoke with an executive from a large international corporation. His staff had discovered photographs of an internal presentation available to the public on Flickr.

This photograph showed a meeting with PowerPoint slides clearly showing information that their competition would love to see, from which the competitive damage could have been significant. Fortunately they found the photographs quickly, and located the offender.

Whether the intent was malicious or accidental, it demonstrates the ease with which information can leave companies' walls. With an application like Mobup, Shozu, or Lifeblog, photographs can be transmitted to Flickr in a few seconds, leaving no trace.

Will cell phones soon be banned from internal meetings—checking a handset at the door like a handgun in an old western? Or will boardrooms jam cell phone signals in some Orwellian twist? There's no doubt that it will come to a head in the next few years, but in the meantime, you and I are responsible for acting lawfully and responsibly.

Chapter 10
Third-Party Flickr Tools

I've mentioned a few times throughout the book that the Internet's hacker culture is alive and well. Hackers, traditionally, are people who are skilled in creating code, hacking together a computer language so that the computer performs useful functions. In many circles the term is an affectionate name, but it has been corrupted by the media to describe someone who malignantly breaks into computer systems. I use the term hacker in its positive form, especially for the skilled people who've extended Flickr's functionality.

When Flickr's public beta was launched, a decision was made to make the application open. This made the service useful for activities that go beyond storing and sharing photographs. It meant that hackers could add on other applications that spoke directly to Flickr to retrieve, add, search, remove, or perform dozens of other functions. This led to the creation of games, screensavers, extra applications, and new art forms.

The openness also facilitated *mash-ups*: applications that use services and content from different sources to provide a completely new experience. Google Maps (see the "Google Maps" sidebar later in this chapter) was mashed with Flickr to provide satellite maps with photographs taken in different locations. Using the right plug-in, which we'll explore later in this chapter, you can look up your city in Google Maps and find photographs taken by Flickrites embedded in a satellite view of your hometown.

This new hacker and masher culture is extending the functionality of the Internet. I now use dozens of applications on the World Wide Web that are fun or functional. Many are created by amateurs, which Paul Graham, essayist, programmer, and programming language designer, pointed out is a word derived from the Latin source, *amator*, which is defined as "a lover, devotee, or enthusiastic pursuer of an objective." This makes sense when you encounter some of the freely available software on the Internet.

This chapter will explore several tools that add extra functionality or fun to the Flickr-verse. We'll start with Yahoo! News and its search engine, and then take a look at a range of applications that people have hacked together in their spare time—Flickr lover software.

MASH-UP SOFTWARE

Mash-ups have leapfrogged from ice cream to music, and now to software.

Mash-up ice cream is probably centuries old. A local ice cream parlor provides a selection of flavors that can be mashed together to provide a personal taste.

Mash-up music mixes two or more tracks to create a new sounding song. It's been around in clubs for a few decades and is an art form unto itself.

Mash-up software is a recent phenomenon. Hackers combine two or more services to produce a new function—for example, finding rental properties on a satellite map or comparing prices at online stores. A single application provides a service that, combined with another service, adds additional abilities.

With large communities forming online, open software services, and a need or passion, new mash-up software is being rapidly developed.

FLICKR'S API

An Application Programming Interface, or API, is a way for a software application to communicate with other software applications. In many cases these are closely guarded secrets, because they're seen as the keys to a company's treasure. If you're the only one who knows how to write code to speak to your application, it means that you get to write that code, and probably sell it.

However, in recent years there has been a realization of the benefits of opening an API. Others can more readily contribute or add on to a service, just like Flickr's community. That means the software benefits from additions from people outside of a company's walls. Bill Joy, co-founder of Sun Microsystems, is famous for saying that you can't hire all of the smart people; so, why not have them contribute for free?

If you're keen to look at Flickr's API, they publish it on their Web site. You can find all the gritty detail, and even links to API kits that others have created to get you started quickly.

To get started, you'll need an API key; otherwise Flickr does not allow a connection. The key allows Flickr to track API usage, which shouldn't bother anyone who isn't being subversive.

Once you're ready to start, you can read the documentation, join the Flickr API development list for assistance, and even join the Flickr API group to promote your handiwork.

You can find all the right links at www.flickr.com/services/.

If you intend to use the Flickr API for commercial use, Flickr asks that you contact them before you launch the service.

Yahoo! News

When Yahoo! purchased Flickr, there was an expectation that their own services would include Flickr photographs. Many believe the purchase is a major push by the mega-Internet company into community-based applications. A new wave is sweeping the Internet that leverages large groups of people, and Yahoo! wanted to make sure it wasn't left behind.

The first Yahoo! service that mashed Flickr was its News search. In fact, it's the blog search that shows the results. Blogs are considered a form of citizen journalism, and in instances are used as a source of news. So Yahoo! includes blogs in its News search results, and as part of the features it adds Flickr photographs tagged with the search keywords.

At the time of this writing the feature is well hidden. Visit Yahoo! and select the *News* search tab. Type in your search request and click the *Yahoo! Search* button. On the right you'll see a box labeled *BLOGS BETA*. Follow the link labeled *More Blog Results*, and the resulting page will include the most recent public Flickr additions with the search keywords (similar to Figure 10.1).

I know what you're thinking. Why not just search for tags in Flickr? It's a valid point, and if you're only interested in looking at the photographs, its much quicker using Flickr's own search. However, for newsworthy events it's often useful to see a summary of top blog search results and images, since it adds more context to the information. Not only can you read some of the details, but you can also view photographs—for instance, reviews and images from last night's rock concert, or perhaps a political demonstration with photographs from the scene, or even what the snow looks like this time of year in Colorado.

Figure 10.1
Flickr images in Yahoo!
News search results.

Location Applications

There is one piece of information that many people predict will be a part of photography in the near future. Cameras will automatically add information about a photograph's location, which, coupled with a computer, means you can see the photographs against a map. Some cameras, like the Ricoh Caplio Pro G3 GPS camera, already add geospatial coordinates to photographs automatically, making it simple to tag photographs with their location.

Think of how that might affect sharing your photography. Instead of explaining your latest holiday's winding trail, you can show it mapped out with photographs from each stop. Or perhaps if you want to view photographs from your childhood town, viewing against a map means you can see just how many changes have occurred.

Major corporations are even working to produce search results that show locations. Imagine searching for a product or service via an online search engine. When you find what you want, the tool shows you the a map and a photograph of the shop front so you know where to go to make your purchase.

Although most cameras don't yet have the location feature, that doesn't mean you can't start adding and using the detail yourself. Several people have created tools for Flickr that can show the results against maps. Armed with a way to add geographical information, you can start populating a number of new Flickr add-ons.

eGoWalk

eGoWalk uses Yahoo! Maps, which are a little less comprehensive than Google Maps. The tool grabs your contacts locations, and if they live in the United States, adds them to the map.

You'll find eGoWalk at www.androidtech.com/egowalk. The front page offers a description of the tool and a link to *Make a Map*. After presenting a little more detail on how the application works, you can select *Show Me My Map*. When the link is selected for the first time, eGoWalk will authenticate with Flickr, because it needs to request read access from your account (see the sidebar, "Third-Party Applications" later in this chapter). Once access is granted, it will ask Flickr for your contacts' locations, and if they are public with a listed location in the United States, it will add them to a map (see Figure 10.3).

Each city with one or more contacts will display an icon: diamonds represent cities with a single contact, emeralds have two to five contacts, and a ruby icon shows cities with 10 or more contacts. The more contacts you have, the longer the map takes to generate.

At this time the map only shows contact icons, and not their photographs. Clicking the icon loads the contact's profile.

EGOWALK FLICKR GROUP

Flickr has an eGoWalk group, which you can join to participate in the discussion about the application.

GOOGLE MAPS

In early 2005 Google Maps (maps.google.com) was launched. It initially provided searchable illustrations of roads and main geographic features, but within several months they added satellite imagery.

Google Sightseeing quickly became a popular pastime. People started with a quick trip to their house and eventually moved to major landmarks. Fun explorations included monuments, bridges, baseball games, sunbathers, and even Area 51, the military base that is rumored to house a crashed alien spacecraft.

Like Flickr, Google Maps published its Application Programming Interface (API). This meant that dozens of other uses emerged from the Web, allowing other uses of the illustrations and satellite imagery.

One well-publicized application combined real estate listings with maps, providing a visual way to browse for a property sale or lease (see Figure 10.2). Not only could you view the illustrations or satellite image, but it also displayed thumbnails of the property.

It didn't take long for people to combine Google Maps with Flickr.

Figure 10.2
HousingMaps, which combines Google Maps and craigslist property listings.

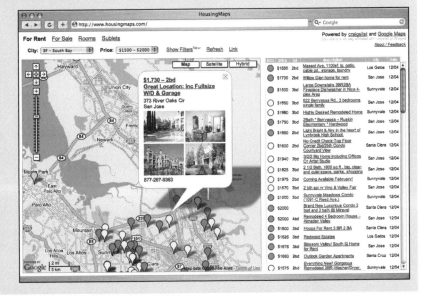

CHAPTER 10

Figure 10.3
eGoWalk in action, with
some contacts in San
Francisco.

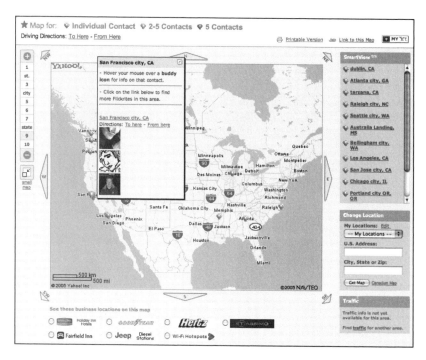

GEOTAGGING

Having made it this far in the book, you know how useful and fun tagging can be. Well, that's no different from geotagging; it's just a little more difficult.

With any two-dimensional map you require two coordinates: the horizontal position, left to right; and the vertical position, top to bottom. In a street directory, it's simple—usually a combination of the letters *a* to *z* and the numbers 1 to 10. However, the world is bigger than an average street map, and therefore requires a method that provides a larger combination but is still relatively easy to use.

Many moons ago, just after someone realized the Earth was round, latitude and longitude were created to easily reference locations. Essentially, north and south was named latitude, and split into 180 degrees. Everything north of the equator was between 0 and 90 degrees, and everything south was between 0 and -90 degrees. East and west were split into 360 degrees: east of Greenwich in the United Kingdom was up to 180 degrees, and west adopted everything down to -180 degrees.

I may have exaggerated when I suggested it was easy, because each degree was then further subdivided into 60 minutes, and each minute into 60 seconds. This is known as sexagesimal, because it's based on sixtieths, and provided the granularity required to map accurately.

All that is well and good if you're a sailor from the 18th century, but minutes and seconds confuses the heck out of a 21st-century decimal boy like myself. So, there are tools online to convert to decimal angular measurements.

Cutting to the chase, we need to tag our photographs with a decimal latitude and longitude. There are several ways to lay your hands on these numbers.

The first method is for gadget junkies. There are handheld Global Positioning Satellite (GPS) receivers that can be bought for a few hundred dollars. You can carry these with you as you take photographs, noting the coordinates.

Fortunately, Google Maps is a cheap method to retrospectively gather coordinates. Search for the location, select the *Link to This Page*, or *Email* links, and the URL provided contains the latitude and longitude coordinates. For instance, the URL http://maps.google.com/maps?ll=-20.661779,116.711540 &spn=0.040055,0.064090&t=k&hl=en is a map of Dampier, Western Australia, with a latitude of - 20.661779 and longitude of 116.711540.

If I wanted to tag a Flickr photograph with these coordinates, I'd add the tags *geotagged*, *geo:lat=-20.661779*, and *geo:long=116.711540*.

For a bunch more information on geotagging, you can visit the group GeoTagging Flickr. The group hosts discussions about tips and methods of adding location data, and also provides a list of tools.

Mappr

Mappr (www.mappr.com) is a mapping tool that leverages the simplicity of tags. It hunts through Flickr's public photos and makes an educated guess at locations based on tags that relate to a geographic region. It then displays results on a map of the United States (see Figure 10.4).

For instance, a photograph I took while on my honeymoon at Kennedy Space Center, Florida, was placed in the right location on Mappr because of the tags *florida* and *unitedstates* (see Figure 10.5).

If you'd like to assist Mappr's accuracy, it also searches for geotags (see the "Geotagging" sidebar). Add *geo:lat* and *geo:long* tags to a new upload, with the correct coordinates, and it removes any of the guesswork from the application. Combine this with the tag *mappr* or *mappr:include* to ensure that it finds the new photographs when it next checks Flickr's recent additions.

There is also a tool to retrospectively add photographs to Mappr. Add the URL of a Flickr photograph page, and it will add it to its collection if it hasn't already guessed and added it previously.

Figure 10.4
Mappr's view of the United States with several thumbnail Flickr photos.

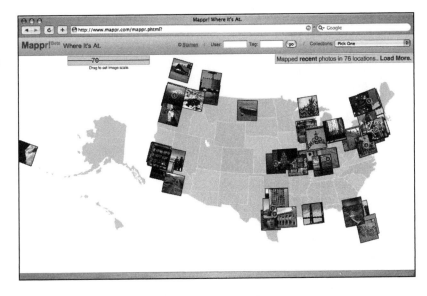

Figure 10.5
Kennedy Space Center's location was determined by Mappr based on the tags I added in Flickr.

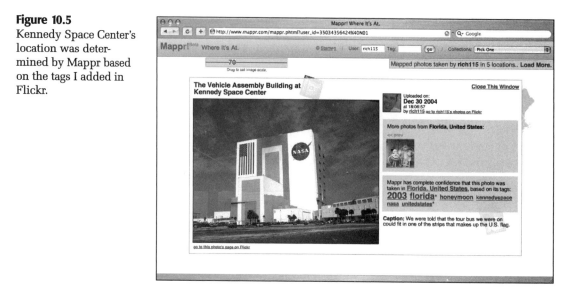

Mappr can display several collections of photos: choose a Flickr member name, a particular tag, or from a pre-selected range such as Flickr's newest photographs, the graffiti tag, or a location like New York.

Watching the correlation between tag keywords and locations can be fun. For instance, there is a town called Beach in North Dakota, but it appears to be about 600 miles from the nearest stretch of actual beach. However, Mappr suggests that a good sum of photographs featuring golden sand, tanned bodies, and deck chairs are from the north-central United States.

MAPPR FLICKR GROUP

There is also, as usual, a Flickr group for Mappr.

GEOTAGGING AND PRIVACY

You need to be careful about what information you show in public. Just like the real world, there are people with less than honorable intentions.

Providing location information can be hazardous. It's best to be careful about providing anything other than public locations with geotags. Mixing photographs of children with geotags that provide location data for homes and schools can provide a little too much information.

Remember that you can always mark a photograph as private. Flickr still provides you with access to the metadata but doesn't publicize your location.

A good rule of thumb is to provide geotags only for photos for which you'd be willing to publicly broadcast the address.

Geobloggers

Geobloggers (www.geobloggers.com) is a lot more comprehensive than Mappr. Geobloggers uses Google Maps and Flickr, combining them in a mash-up Web service (see the "Mash-Up Software" sidebar earlier in this chapter). The map is very detailed, providing an illustration of the globe or actual satellite photography, right down to street level; cars, boats, and landmarks are very visible.

To upload photographs to Geobloggers, you need to log in to Flickr. When you visit the site for the first time (see Figure 10.6), it requires you to log in to the application and authorize its write permission for Flickr. Once completed, you can upload or import photographs from Flickr.

The best method to add a photograph is to find the location of your photograph on the map first. Simply drag the map until you've centralized the approximate location, or double-click your mouse on the section of the map and use the bar on the top left of the map to zoom in. If you know the latitude and longitude, you can use the *Map Tools*, found in the *Windows* drop-down menu, which provides a *Jump to Location* option.

Zoom in as far as the map allows. You might need to toggle to the satellite image, as in some cases Google displays only the drawing (at this time it doesn't have satellite photographs for the entire world). Once you've found the right spot, select the *Your Account* menu, and choose *Import Photo from Flickr*. A new window will appear with the option to *Import from Your Most Recent Photos*, or you can choose a photograph from one of your sets (see Figure 10.7).

Once you've located the photograph in the window, click the *Add to Map* link. A dialog box will attach itself to the cursor, which you can pin to the exact location by clicking the mouse button when the cursor is in the correct position. Geobloggers then automatically adds the correct geotags to Flickr for you—a handy method of geotagging (see Figure 10.8).

Figure 10.6
Geobloggers combines Flickr and Google Maps.

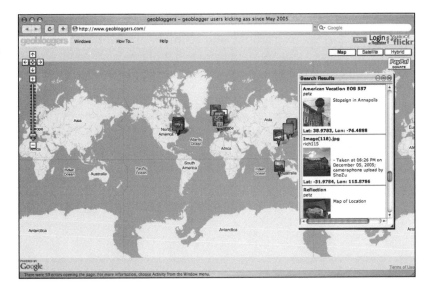

Figure 10.7
Geobloggers' import
from Flickr option.

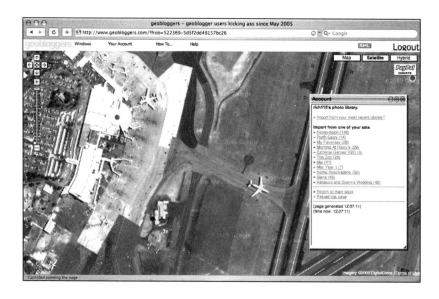

Figure 10.8
Geobloggers
automatically adds
geotags to your
imported Flickr
photographs.

Admittedly, half of the fun with Geobloggers is exploring the world and finding other people's photographs. Drag the map around and zoom, locating interesting items and selecting them to see the detail. There is plenty of the globe that I have yet to visit, and although it's not quite as satisfying as a holiday, it's still great fun exploring places like the Statue of Liberty from above (see Figure 10.9).

Geobloggers is incredibly comprehensive. I've discussed only the basics here; a chapter could be dedicated to exploring all its features. Geobloggers also includes some great documentation that explains some of its advanced search options, subscribing with real simple syndication, creating your own map, and even using its own open API.

There is bound to be a range of additions, or integration with Flickr, in the near future. Dann Catt, the creator of Geobloggers, joined the Flickr team at Yahoo! in January 2006.

Figure 10.9
A photograph of the Statue of Liberty, New York City, in Geobloggers.

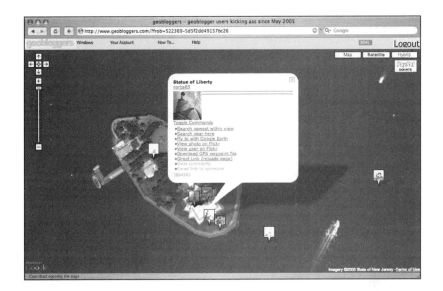

Flickrmap

Flickrmap (www.flickrmap.com) differs from the other location tools because it is meant to be added to your own Web site or weblog rather than hosted by another. It then monitors your Flickr account for new photographs with geographic information—like geotags or place names—and adds them to your map. Its image of the Earth isn't as comprehensive as other mapping tools, but offers a quick, rough view (see Figure 10.10).

You can subscribe to Flickrmap for a small yearly fee. Once you've paid, you can download the software and install it on your own Website or weblog. Once in place, it is charmingly simple. The map will automatically check the last 50 photos whenever your installed map is loaded. If it's left open in a browser, it will also check hourly for updates.

Figure 10.10
A whole-Earth view of Flickrmap, with a collection of different user's images.

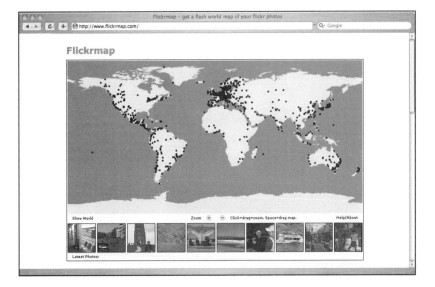

Flickrmap can also check previous photographs. Log in to the Flickrmap Web site and select the *Find New Photos* tab. There is an option to check every public photograph in your account, 10 at a time. Select the check box labeled *Automatically Refresh This Page Until All My Photos Are Checked*, and the Web page will refresh until it has searched your entire Flickr account.

Just make sure that if you don't use geotags, and rely on location names, that you be as descriptive as possible. Missing a city, state, or country in the tags can mean Flickrmap can't be certain of the location. To ensure you get your tags correct, there is a search tool for the application to check if it will find a match. It's found under the *Location* tab.

Navigating the map is straightforward. You can drag and zoom to focus on specific locations. Alternatively, you can mouse over a particular photo from those displayed at the bottom, and the map refocuses on the particular locale.

If you click on a photograph, the map is replaced with the image. At the bottom of the page the photo collection changes, displaying the next nearest images. Mousing over each of these displays the titles, locations, dates taken, and even the distance from the current photograph (see Figure 10.11).

Figure 10.11
A selected photograph in Flickrmap and the details from a nearby image.

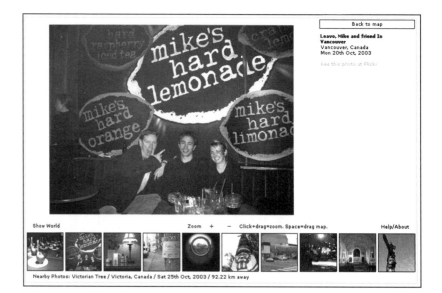

Trackmap

If you're a real gadget junkie and own a Global Positioning Satellite (GPS) receiver, then Trackmap (http://trackmap.robotcoop.com/) is a great tool. In addition to displaying Flickr photographs on a Google Map, it uses a GPS track to plot a route. It draws a line that tracks your journey, and marks the locations of your photographs along the way (see Figure 10.12).

A GPS track contains GPS coordinates and times. Trackmap uses the time stamps from your Flickr photo pool—because it is contained in the EXIF data (see Chapter 4)—to marry up the right images to the correct location. That means you don't need to add geotags or any extra detail to Flickr; Trackmap does that automatically.

Figure 10.12
A journey as it is
mapped in Trackmap.

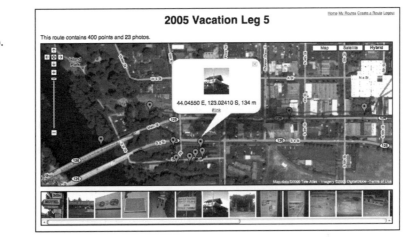

THIRD-PARTY APPLICATIONS

The first time you use a third-party application that requires access to your Flickr account, it will require authentication.

At anytime you can find out what applications have access and, if necessary, revoke it. The list is contained in *Your Account* under *Authentication List*.

The list displays three types of permission (see Figure 10.13). *Read* provides access to all your photographs, including those marked private. *Write* means the application can see all your photographs, and it can upload new photos, and add, edit or delete metadata, such as titles, descriptions, and tags. *Delete* offers all this and the ability to delete photographs.

An application doesn't need permission to display your public photos. If this is all it requires, it won't be displayed in the list.

Figure 10.13
My authentication list.

Application	Permissions	
1001	write	Remove permission?
FlickrExport	write	Remove permission?
QOOP	read	Remove permission?
geobloggers	write	Remove permission?
fd's Flickr Toys and Utilities	write	Remove permission?
Flickr Uploadr (Macintosh)	delete	Remove permission?
ShoZu	write	Remove permission?
Flickr Backup	read	Remove permission?
s1001	write	Remove permission?
archivr	read	Remove permission?
eGoWalk	read	Remove permission?

People Applications

The location of a photograph is only a small aspect of Flickr's collection. People obviously play a big role in the community, and a list of extensions to Flickr wouldn't be complete without tools that explore members' relationships or combine their photographs.

There are plenty of these extensions, but two stand out.

Flickr Graph

Marcos Weskamp calls Flickr Graph (www.marumushi.com/apps/flickrgraph/) "a social network visualization." That's a good summary, and I'm not going to argue with its creator. The application graphs connections between Flickr contacts, connecting each person found in a member's contacts list.

The tool provides a search box for entering a member's username or e-mail address. The results are a handful of contacts from that member's public profile. You can then expand the connections by double-clicking another member's buddy icon, and it displays a handful of their connections (see Figure 10.14). I couldn't find a limit to the number of open connections; it provides a comprehensive social network, unless you don't have any connections.

Each connected member is strung together by a virtual wire. You can drag each contact around the page and watch as each of them bounces around the screen. If a member is connected to more than one person on the page, they're strung in between.

When an individual is selected, there is also the option to *View Pics*. This displays the member's latest public photographs, tags, location, total images, and the link to their photostream (see Figure 10.15).

I'm sure that someone could find a scientific use for Flickr Graph. However, it's another application that provides an interesting diversion—exploring social networks, looking for common connections. Who knows, you might find a long-lost relative amongst the crowd.

Figure 10.14
Flickr Graph showing a bundle of my connections.

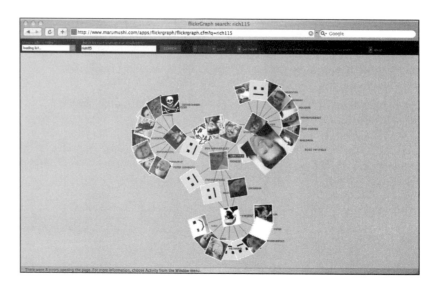

Figure 10.15
My details as shown in Flickr Graph.

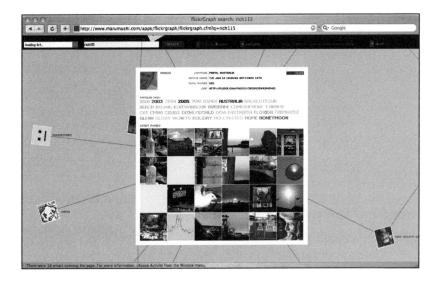

50 People See

Even though it is such a technical crowd that hacks applications for Flickr, it's great to see many with an artistic slant. 50 People See (www.flickr.com/photos/brevity/sets/164195/) is a computer script that merges together a collection of photographs tagged with a specific keyword. It then produces an averaged image of the collection—a result that looks eerily similar to an impressionist painting, by Claude Monet perhaps.

Neil Kandalgaonkar, a programmer living in San Francisco, wrote the code to combine the photographs. In the spirit of openness he has provided the computer code—written in Python—so others can play with different tags.

Fun Applications

Half of Flickr's appeal, if not all of it, is the fun you can have in the community. That's why many hackers have created applications that are less functional, and made to toy with. The number of extensions in this category is vast, and hours can be lost playing games, creating badges, and creating captions.

Flagrant Disregard's Flickr Toys Collection

John Watson's enthusiasm for Flickr is obvious. As of this writing, he's created 17 applications that take advantage of Flickr's open API (http://flagrantdisregard.com/flickr/). From a Flickr Badge, worn proudly by hundreds of members, to a *Name That Contact* game, Watson provides little toys that have delighted members of Flickrdom.

I won't list all the applications, but I've picked a few of the popular toys.

Badge Maker

Almost as soon as the Badge Maker application was released into the wild, Flickr members were dreaming up opportunities for its use. Wearing a badge to get noticed, or for access to private events, were among the suggestions.

In reality, of course, it's an unofficial but fun trinket to play with. Many have printed, signed, laminated, and worn the badge proudly. Anyone can create one from the Flagrant Disregard Web site, adding in a name, a description, dates, and uploading a photograph or pointing to a static image from a Flickr account. The application automatically creates an official looking image (see Figure 10.16). Members are even prompted with a request to add the result to their Flickr photostream.

Name That Contact

Put yourself to the test. How well do you know your contacts in Flickr? Name That Contact will test your memory and mental ability.

The game grabs a public photograph from one of your contacts. It provides a choice of three contacts, from which you can select (see Figure 10.17). You might recognize a place, face, photograph, or photographic style, and know whose collection the image is from. Other times you might have to guess.

Each right or wrong answer adds to your total percentage. It also keeps a tally of your responses matched to each of your contacts, and the number of times your contacts have seen your photographs, including the percentage correct.

It's another fun game that quickly demonstrates which contacts you know the best, and who might still be a stranger.

Captioner

In Chapter 7 I introduced the ComicLife application for Apple Mac computers. It's a comprehensive tool that allows you to create detailed comic strips, including speech balloons, panels, and special effects for changing photographs into ink paintings.

Captioner is the poor man's comic maker. However, if you have a photograph to which you'd like to add some speech balloons (see Figure 10.18), then Watson's simple tool is free and easy to use.

Figure 10.16
My Flickr Badge, from John Watson's Flickr Toys collection.

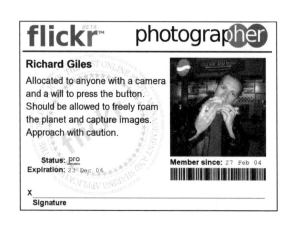

Figure 10.17
Name That Contact, from John Watson's Flickr Toys collection.

Figure 10.18
A photograph and captions created with John Watson's Captioner.

Choose a Flickr photograph's static URL, select the type of speech bubbles you need—speech, thought, or action—and add the text. Captioner will then provide the balloons and extensions for you to drag and drop onto the photograph right in your Web browser; no other application required.

Once complete, you can download the finished result, or automatically add to your Flickr photostream.

CHRISTOFER DIERDORFF

Christofer Dierdorff has been a photographer for 35 years, 27 of which he's spent producing portraits. He has photographed some of the world's leaders and dignitaries including President Clinton, Princess Margaret, Madeleine Albright, the Dalai Lama, and Archbishop Desmond Tutu. You can find some of his photos at Flickr.

After 35 years in photography, does Flickr offer you anything new? If so, what would that be?

Flickr is completely original! There's nothing else out there like it. The driving force behind other purported photo "sharing" sites is purely economic. Under the guise of sharing, the sole purpose of these other sites is to derive income through selling prints and coffee mugs. They are not there to build community, like Flickr.

How'd you hear about Flickr?

I simply stumbled upon Flickr. I was Web surfing for information on an upcoming vacation. I kept running into chat rooms and blogs that were saying, "Take a look at my vacation photos on Flickr." These were people from all around the globe at hundreds of different sites. I hardly ever saw this kind of invitation in regards to other photo "sharing" sites. Everywhere I looked, it was Flickr, Flickr, Flickr. I had to check it out for myself. That's how I stumbled upon Flickr.

What do you like about Flickr?

I mostly appreciate Flickr because of its ability to build community worldwide by sharing one's life experiences through images. Flickr is also extremely egalitarian. It's truly an open community.

Also I enjoy Flickr's ability to give you the priceless gift of what turns out to be a global photo critique. The feedback you receive through people's comments, blogs, and e-mail is invaluable. Additionally, tools like "Most Views," "Most Favorited," "Most Comments," and "Most Interesting" provide you with a precious statistical overview of your images that takes you from isolation to inclusion.

What's one of your favorite photos you've taken and shared in Flickr, and why?

I don't have a favorite. I'm waiting for the Flickr viewers to tell me which one is their favorite.

What's one of your favorite photos from another Flickr user, and why?

There are so many photos by other people that I like. Since I do portraiture, one of my Flickr favorites is the portrait work being done by Anndra Dubhacan (a.k.a. "Fack to Bront") of Scotland. His stuff is just wild. Some images are highly manipulated through image processing, but the technique totally works. I love it. He's got a great eye, wonderful stuff.

What tip would you give a new photographer?

Join Flickr.

Flickr Montager

I've often seen mosaics created with hundreds of photographs, that when viewed from a distance look like a single image. I've also played with software on my computer to grab hundreds of images from my hard drive and generate a similar mosaic from a particular photograph. However, these are not as easy as Flickr Montager (www.deviousgelatin.com/montager/).

A mosaic works by adding together a bunch of images, matching each one's average color with a small area of the desired end result. The larger the collection, the greater the variety of shades of color, and the easier it is to find a match for a particular area.

Montager uses Flickr to provide a large collection of images. Pick a tag, and it will use that tag's pool of public images as its color palette. Then you simply pick a photograph you'd like to montage, and the application gets to work. For the best effect, choose an image with distinctive shading, like a close-up of a face.

The final result (see, for example, Figure 10.19) should resemble the original image but should be composed of dozens of photographs tagged with your chosen keyword.

Figure 10.19
A mosaic using Flickr
Montager.

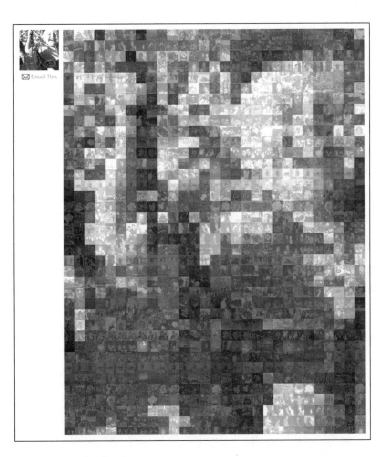

Flickr for TiVo

These days, hacking isn't confined to software. Hardware enthusiasts modify their gadgets to add extra features. It's similar to the DIY electronics culture of the seventies, but the kits are replaced with off-the-shelf toys and tools. Some enjoy popping open the cover and the smell of burning solder; others prefer to modify the computer code in a consumer good. From handheld games to a Toyota Prius, nothing is safe.

In some cases toying with the modifications is simple. For instance, Flickr for TiVo (http://home.comcast.net/%7Emajor_clanger/TiVo/) is a hack to allow browsing Flickr photographs on the popular set-top box. It requires a broadband-connected TiVo Series2 DVR. Add the software and use your Flickr member name to authenticate and display sets, groups, contacts, and photographs.

The software won the Best Photo Application at the 2005 TiVo Developer Challenge. Its creator, Andrew Wallace, proved that it's worth tinkering with toys by winning himself a Nikon Coolpix 5200 digital camera.

Colr Pickr

One day, someone will have the need to match a color to a Flickr photograph. When that day comes, Colr Pickr (http://krazydad.com/colrpickr/) is the tool. Jim Bumgardner, its creator, isn't under any illusions though. He points out, "To those that question the utility of this little application, let me point out that it is a toy—like all the stuff on my Web site. Its purpose is simply to provide wonder and delight. Nothing more, nothing less. Isn't that enough?"

He has a great point. The little tool is great fun, and had me guessing how he achieved the result. To the novice computer user it's a little bit of black magic. The truth is it uses some code he's shared with some other fun projects, like CoverPop (www.coverpop.com) that displays collections of things like book covers or vintage packages.

Bumgardner explains his method of sorting colors. "Then I download all the thumbnails (again with Perl), and analyze them for color, using ImageMagick to reduce each image to 1×1 and recording the color of the remaining pixel." If you don't know what that means, it's not a concern, you can still appreciate the color.

The application allows you to select a shade of color from a chart, and adjust the brightness (see Figure 10.20). It then displays a collection of photographs from the Color Fields group in Flickr.

Figure 10.20
Krazy Dad's Flickr Colr Pickr.

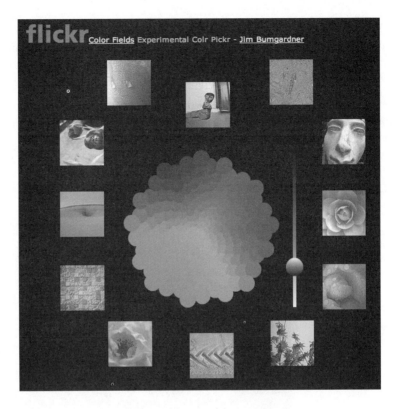

Memry

Everyone has played a memory game. Memry (www.pimpampum.net/memry) is the classic with a Flickr twist. Provide a keyword and it will create a four-by-four or six-by-six tiled area. Select any tile and it flips over to show a photograph from Flickr's public pool, tagged with the chosen keyword. Find two matching tiles in a row and they both remain flipped. Pick a non-matching pair, and they flip back to the hidden position.

Figure 10.21
The Memry game, using the monkey tag.

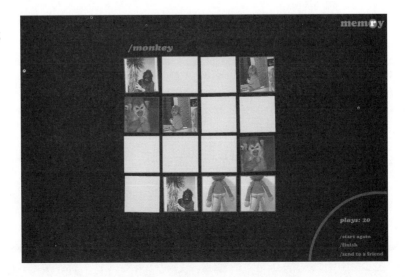

Spell with Flickr

Spell with Flickr (http://metaatem.net/words/) is a simple application that has been used all over the Web, probably because it can be applied to so many situations. Names, phrases, special occasions, and statements can all be spelled out with photographs from Flickr.

Erik Kastner created a Web form for submitting letters. Once you've picked a word or phrase, it queries a few Flickr groups for individual letter photographs. It then compiles them onto a single page (see Figure 10.22). If you're not happy with any of the letters, it allows you to swap it without affecting the others. It then provides the HTML so you can add it to any Web page.

Figure 10.22
"Flickr Rocks,"
generated using the
Spell with Flickr
application and
photographs from
Flickr.

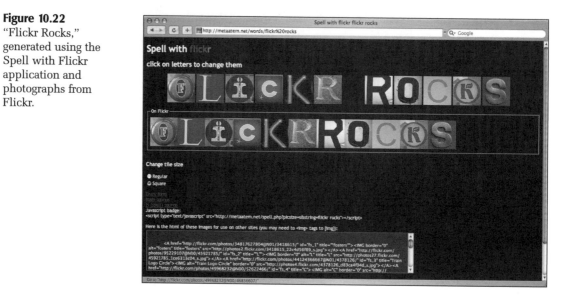

Useful Applications

The majority of extensions to Flickr focus on fun. However, one application stands out as a very useful application. In Chapter 2 I mentioned Stewart Butterfield's accidental deletion of every one of his Flickr photographs, and in Chapter 5 you explored a service from Englaze that created a backup DVD. That service is useful in many respects, but there is an alternative that is freely available.

Flickr Backup

Flickr Backup (http://sunkencity.org/flickrbackup/) is free for download and uses an open-source license, meaning computer programmers can access the source code and make changes to the program. It's available for any computer platform, including Windows and Mac.

When you first launch Flickr Backup, it will request authorization and then download thumbnails of every one of your photographs (see Figure 10.23). It's bandwidth hungry, so I'd suggest avoiding its use over a modem; it is best used with broadband only.

Figure 10.23
Flickr Backup, an open-source project to back up your Flickr photographs.

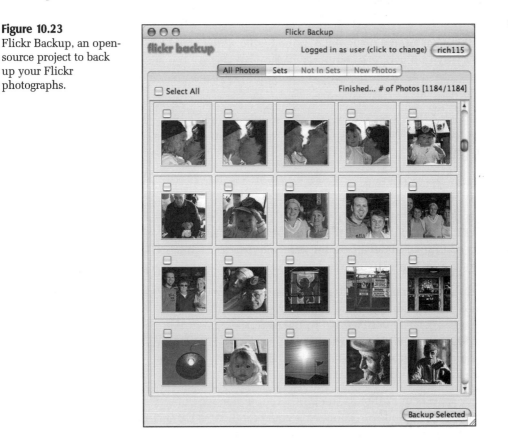

The application provides two options: *All Photos*, or *Sets*. You can download every photograph or select individual photos to back up from just one to all of them. Alternatively, you can back up one or more of your sets.

Once you've chosen which photographs or sets you'd like to back up, select the *Backup Selected* button. The application will download all the selected photographs from Flickr, placing them in the chosen folder on your computer. This can take some time, depending on how many images you've chosen, and your Internet connection speed.

If you'd rather just back up straight to a CD or DVD, it offers the option to select the media's location.

Browsers

For someone not familiar with the world of the Internet, "browser wars" sounds like a conflict in Africa at the turn of the 20th century. In fact the war is most commonly discussed with respect to the Web browser market share battle between Netscape and Microsoft's Internet Explorer in the late nineties.

More recently there has been a resurgence in the battle. Some new browsers on the block are innovating their way into people's computers. Extra features are the latest arsenal, with extensions created by battalions of computer programmers eager to extend the browsing experience.

Due to Flickr's open API, it's become a popular addition to some browser's features. Many of the features that we've explored already are being added into applications so that no other extra software is required.

Firefox Extensions

When Netscape Communications Corporation lost the browser war, its flagship product, the Netscape Browser, was spun off to a not-for-profit organization called the Mozilla Foundation. The foundation continued to develop a browser, and in 2002 launched a new browser that is now called Firefox (see Figures 10.24 and 10.25).

Although Microsoft's Internet Explorer is still the single most popular browser in the world, many see Firefox as the Web's savior. Its slogan reads, "Rediscover the Web." In 2004, the foundation ran a two-page advertisement in the *New York Times* that listed names of the thousands of people worldwide who contributed to the Mozilla Foundation's fundraising campaign. It carried a blunt message: "Are you fed up with your Web browser? You're not alone. We want you to know that there is an alternative."

One of the major aspects of Firefox is the proliferation of extensions. These add extra features, and are developed by people for free, hacking code as a hobby. Extensions include extra search functionality, advertisement blocking, controls for your favorite music player, and additions for Flickr.

Figure 10.24
The Firefox browser
logo.

Figure 10.25
The Firefox browser on
Mac OS X.

Installing Firefox extensions is straightforward. The Mozilla Foundation provides a Web site listing hundreds of extensions (https://addons.mozilla.org/). You can search or browse through the collection, and when you discover one you'd like to install, you click the *Install* link or *Install Now* graphic. Once the browser is restarted, the extension will be activated.

The Flickr Sidebar offers the ability to search Flickr's public tags (see Figure 10.26). Type in a keyword, and the result returned is just like a tag search from Flickr. After submitting the search, the browser presents Flickr's own tag search results page.

FlickrFox

Searching public tags might not provide the gusto that you require. If you'd like a little more integration with Flickr, then the FlickrFox extension might come closer to matching your requirements.

FlickrFox doesn't just offer a search; it will log into Flickr and display a stream of photographs in a sidebar (see Figure 10.27). You can select any of these photographs and it will load into the browser's main window, allowing you to easily navigate photostreams from everyone: yourself, contacts, friends and family, favorites, and your groups.

Figure 10.26
The Flickr Sidebar extension, enabling a public tag search from the browser's toolbar.

Figure 10.27
The FlickrFox sidebar in action.

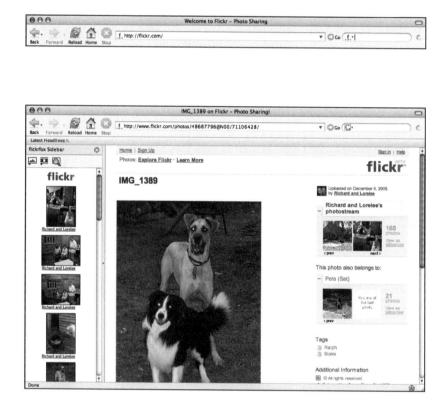

Greasemonkey

So far we've tweaked the Firefox browser. Now it's time to trick it out completely, adding neon lights, cherry bomb mufflers, and mag wheels. After all, if we're going to mod the browser, let's take it to the extreme.

Just like Firefox extensions add functionality to the browser, Greasemonkey is an extension that adds functionality to Web sites or pages that it displays. Add the Greasemonkey extension and there are dozens of scripts that you can install for some dramatic effects to Web pages you might frequent. For example, you can add a script that searches other book vendors for a better price while you surf the Amazon online bookstore.

Once installed, it is not completely apparent that the browser has changed. The only noticeable difference is the small monkey face in the activity bar at the bottom of the browser. However, now you just need to locate scripts to add on to Firefox. Visit http://userscripts.org/ for more than your heart could desire.

I should point out that, although Greasemonkey has many accolades, it has come under a lot of public scrutiny. It presents many pitfalls which include issues of security, legality, and ethicality. However, the scripts that we'll explore here in relation to Flickr are not under suspicion. After all, this is why Flickr has an open API; so others can hack additional functionality around the edges.

There are dozens of Flickr scripts for Greasemonkey. Many add extra buttons and links, which provide a shortcut to existing functionality: add extra features to the batch operation; provide further options in Flickr mail; or add links to photostreams for quick access to e-mail members. Other scripts provide new functionality: a new photostream menu to display images in chronological order; a rating system providing more options.

Google Maps in Flickr

I love the Google Maps in Flickr Greasemonkey script. Once you've started geotagging your photographs (see earlier in the chapter), this addition to Flickr provides a one-click method to explore a world map of your photographs.

Once installed, the script will provide a *Gmap* icon in the Flickr toolbar above every photograph. If the image is geotagged, with the geo:lat and geo:long information, clicking the button will display a Google Map image with a "balloon" marking the location of the photograph, and a speech bubble containing a few of the details (see Figure 10.28).

Just like Google Maps, you can zoom in and out (Figure 10.29 shows the same location zoomed in), and change from an illustration showing street maps, a satellite image, and a hybrid of the two visuals.

Figure 10.28
Using Google Maps in Flickr Greasemonkey script. This shows a photo and map of the house from the movie *Psycho*, at the Universal Studio back lot in Los Angeles.

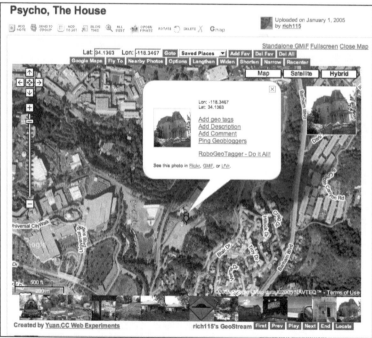

Figure 10.29
A zoomed-in view of the Google Map, and the house from *Psycho*.

WANNA HACK?

For those interested in hacking Flickr (in the traditional use of the word, not the illegal sense) there are groups available. The Flickr API group provides a forum for Application Programming Interface ideas and projects. The Flickr Hacks group is for "non-API ways to get the most out of Flickr."

Hardcore discussions take place in the yws-flickr Yahoo! group, found from the Flickr Services page. Here, members discuss far-reaching ramifications of the API.

Flock

Flock is a new Web browser that is still in early development (www.flock.com). It is based on Mozilla, which is part of the computer code that runs Firefox. However, its name is a reflection of the additional features that it provides, with integration to community-based Web services. You guessed it; that includes Flickr.

The latest concept for the World Wide Web is writing as easily as reading. In other words, people surfing the Web should have the ability to contribute to it just as easily as they receive content. It's been labeled "Web 2.0" or the "Read-Write Web," but essentially services like Flickr make contributing as easy as surfing.

Flock was developed to allow contributions directly from the browser. Instead of the browser being a passive device made to receive Web pages, no matter how complex, Flock provides functions that integrate with these new community-based Web services (see Figure 10.30).

The Flock team is a fan of Flickr for obvious reasons—it's a great service. So Flickr was one of the first additions to the browser. Flock adds a tool called a *Topbar*. This is another window in the browser that is used to display other services. Enter the username for any Flickr member, and their public photographs are displayed in a row at the top of the browser (see Figure 10.31). Click the photo and it will open the photo's page in the main browser window.

Flock also provides a tool to publish posts straight to weblogs. The Blog Editor provides a Flickr Topbar (see Figure 10.32), from which any member's public photos can be dragged and dropped into a weblog post. Not only does it make publishing quick, but because it's as simple as drag and drop, it's easy—without the requirement for other applications.

Flock is still in development, with many features yet to change and additions to be made. However, if you're a blogger who wants a Web browser that makes blogging easy, then Flock is worth trying. If you're constantly adding photographs from Flickr, you're just a drag and drop away.

Figure 10.30
Flock: a new-age Web browser.

Figure 10.31
Flock's Topbar showing
my public Flickr
photostream.

Figure 10.32
Flock's Blog Editor with
Flickr Topbar, from
which you can drag and
drop photos to your
weblog.

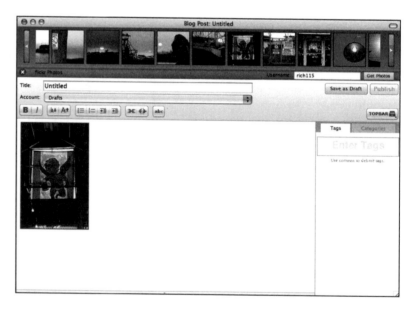

FLOCK AND GREASEMONKEY

Flock is based on Mozilla, the same computer code that provides the
foundation for Firefox. This means that it can leverage some of the same
extensions—for instance, Greasemonkey, which I talked about earlier in the
chapter.

THEANDYFACE

What do you get when you mix a young, high-energy computer programmer with Flickr? A tag that's taken on a life of its own: theandyface.

Andy Smith began a collection of self-portraits with friends and acquaintances. Not content with a standard cheesy smile, he created his own face, now known as the Andy face.

Andy is a programmer, a social software hacker, who helped put together the Flock browser.

His face has now propagated through Flickr, and others have begun their own emulation. At the time of writing there were 274 photographs tagged with theandyface. Do a quick search, practice in the mirror, and then start adding your own to the collection.

BRIAN JOHNSON

Brian Johnson is an expert in Internet-based communications, and was profiled in *Fortune*, *Ad Age*, *PC Week* and *Esquire* magazines. He built the first Web site for CBS News and was the "reporter from cyberspace" for the CBS News program *Up to the Minute*. He continues pioneering computer-based media, and three years ago built and maintained the first corporate weblog.

His Flickr photostream features a neckties set (Figure 10.33), which contains his collection of regular photographs featuring his gesture to civility.

How'd you hear about Flickr?

I follow the doings of smart people who accomplish great and/or interesting things. Ms. Caterina Fake appeared on my list a couple of years ago, so when she started Flickr, I immediately signed up.

What do you like about Flickr?

It's very easy. I use several different digital photo platforms and am happy to report that Flickr is one of the easiest to use and enjoy. When one posts almost daily, this is a very important consideration.

What's the story behind your necktie photos?

It's a rather long story that can be summed up like this: I'm concerned about the decline of civility and style and etiquette, overall and specifically in my world of the Bay Area in the 21st century. I believe that deliberately "dressing up" pays honor and respect to ourselves and the people we come in contact with during our day. My world is rather narrow, but by posting pictures of my necktie on Flickr (see Figure 10.35), I can communicate my little gesture of respect to a far wider audience.

What's one of your favorite photos you've taken and shared in Flickr, and why?

I think that some of my favorite pictures are of my daughters and wife, which might be an obvious choice for any proud parent and infatuated husband. Another favorite set is from my bar mitzvah last calendar year. I'm deep into my middle age, and accomplishing this rite of passage was something that made me very proud.

What's one of your favorite photos from another Flickr user, and why?

I'm a big fan of the pictures Esther Dyson takes of swimming pools, and Heather Champ takes very nice pictures of her life (even her root canal). Perhaps you can see the continuity with my own work. Flickr is my way of looking beyond my life and into a broader world. I immigrated to the Bay Area from NYC, where life was far more varied and there were far more opportunities to see how others live. So, Flickr might be one of the ways I try to fill this void in my experiences.

continued

What is your favorite group, and why?

Moleskine. I contributed to this group for a bit. I like the "frame" of a Moleskine. It's petite. Then, I like to see how others fill in this frame, the variety.

What is your favorite tag, and why?

Amsterdam. It's one of my favorite cities and I like to see how other experience it.

Any interesting stories about Flickr?

What's most fascinating to me is watching relationships and communities form in this new, rather ethereal digisphere. What's a contact? Friend? Even family? How do we decide who these people are, what they mean to us, and what we share with them? Frankly, my own little gesture (my necktie) has reached a far wider audience than I ever expected. Of course, I came to the experience with no expectations, so...

Figure 10.33
Brian Johnson's necktie
on September 6, 2005.

Index

INDEX

N

O

INDEX

T

X

Y

Z